BELLE

Also by Paula Byrne

Jane Austen and the Theatre
Mad World: Evelyn Waugh and the Secrets of
Brideshead
Perdita: The Life of Mary Robinson
The Real Jane Austen: A Life in Small Things

Belle

The Slave Daughter and the Lord Chief Justice

PAULA BYRNE

HARPER ⬤ PERENNIAL

NEW YORK • LONDON • TORONTO • SYDNEY • NEW DELHI • AUCKLAND

HARPER ● PERENNIAL

Also published in the United Kingdom in 2014 by William Collins, an imprint of HarperCollins UK.

HarperCollins books may be purchased for educational, business, or sales promotional use. For information please e-mail the Special Markets Department at SPsales@harpercollins.com.

First U.S. edition published 2014.

Library of Congress Cataloging-in-Publication Data

Byrne, Paula.
 Belle : the slave daughter and the Lord Chief Justice / Paula Byrne. — First Harper Perennial edition.
 pages cm
"First published in the United Kingdom in 2014 by William Collins, an imprint of HarperCollins Publishers"—Title page verso.
 Includes bibliographical references.
 ISBN 978-0-06-231077-4 (paperback) — ISBN 978-0-06-231078-1 (ebook)
1. Belle, Dido Elizabeth, 1761-1804. 2. Racially mixed people—England—Biography. 3. Slaves—England—Biography. 4. Illegitimate children—England—Biography. 5. Mansfield, William Murray, Earl of, 1705-1793. 6. Mansfield, William Murray, Earl of, 1705-1793—Family. 7. Nobility—England—Biography. 8. Antislavery movements—England—History—18th century. 9. England—Race relations—History—18th century. I. Title.
 DA483.B45B97 2014
 941.07'3092'2—dc23 2014007447
 [B]

14 15 16 17 18 OV/RRD 10 9 8 7 6 5 4 3 2

For my godson Dominic

Contents

Illustrations

1

The Girl in the Picture

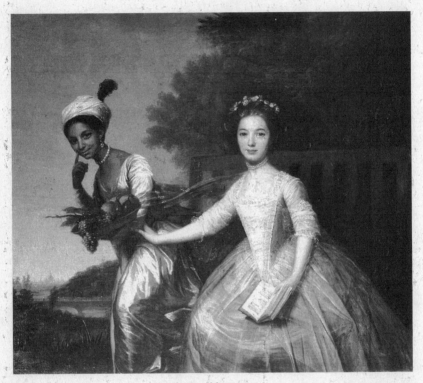

The Double Portrait

A portrait from the late eighteenth century, it depicts two beautiful young girls. The white-skinned, fair-haired one in the foreground sits on a large, green, high-backed bench, and is dressed in pink silk with intricate lace trimmings. She has a garland of pink flowers in her hair and a double strand of pearls around her neck. She is holding a book. She is reaching out to the girl behind her, taking her arm as if pulling her into the frame. She hardly needs to do so, as the eye is drawn irresistibly to this other girl, with the high cheekbones and the enigmatic dimpled smile.

The girl on the left is dressed in sumptuous white and gold satin, and wears a string of creamy large pearls around her neck. She has expensive-looking droplet pear and diamond earrings, and a white and gold bejewelled turban with an ostrich feather perching jauntily at the back. She carries a basket of fruit, and is wearing an

exquisite blue and gold sheer shawl which floats in the breeze as she walks. She is in motion, bursting with vitality and energy. Her knee is bent forward beneath her dress, as if she is about to run as free as the wind. The girl in pink, by contrast, sits still.

The standing girl rests a forefinger quizzically on her cheek as she gazes confidently at the artist. She almost seems to be sharing a confidence. In the conventions of portraiture, a pointing figure may denote a mystery, an enigma, a secret withheld. That may well be the case here, given the knowing look that goes with it. But the gesture also says, 'Look at me. Look at the colour of my skin.' It is as if she is asking, 'Who am I? And what am I, a black girl, doing here?'

The artist must have known that it was an unusual commission. The 'double portrait' has a long and distinguished tradition. Typically, the subject would be a husband and wife, a mother and child, or a pair of sisters. In its composition, this portrait conforms to the model for representing a pair of sisters. One could readily imagine the sitting girl as an older sister, studious, conventional and full of good sense. And the standing one as a younger sister, with a little bit of wildness or rebellion about her, and a great deal of passion – of 'sensibility', as they would have said in the eighteenth century. The rarity, however, comes from the colour of their skin. This is, as far as we know, the only portrait of its era to show a white girl and a black one together in a sisterly pose.

London is in the background. The viewer can readily make out the dome of St Paul's Cathedral. Behind the girls is a garden of mature trees that leads down to a lake with a bridge. The season would appear to be high summer. This is clearly the estate of a wealthy man, of someone who would be proud to show off his daughters. A double portrait of this kind was often painted to commemorate a special occasion – a birthday, a coming of age perhaps, or a party or event held on the estate in the summer months when the gardens were at their very best. But surely if a wealthy man in eighteenth-century England really did have one daughter who was white and another who was black, he would have been ashamed of the fact? There would have been the stain not only of illegitimacy but, even more shockingly for the time, of inter-racial sex. You would have thought that the black girl would be concealed below stairs, not celebrated in a large portrait. To a contemporary viewer, the image would have been startling: a black girl, expensively dressed, and on an almost equal footing with her white companion.

Almost equal, because the white girl occupies the foreground of the painting. But the viewer is left with little doubt that it is the black girl who has captured the imagination of the artist. She is dressed in an exotic style, bearing colours that give the painter the opportunity to show off the full range of his palette. The dress, though as expensive and beautiful as the white girl's, signals her difference. The sheer shawl looks Indian, as do the turban

and feather. Intriguingly, a tartan or plaid shawl is tied around her waist. Could she have Scottish heritage?

The white girl is made to look demure – the wreath of rosebuds in her hair suggests virginity – while her black companion sports one of the most fashionable accessories of the day: an ostrich feather, as popularised by the leading fashion icon of the era, Georgiana, Duchess of Devonshire. Georgiana created her first great stir in 1775, when the British Ambassador in Paris, Lord Stormont, presented her with a four-foot-long ostrich feather, which she contrived to incorporate within a spectacular hairdo. From then on, every fashionable lady wanted an ostrich feather – to the extent that the poor bird was hunted almost to extinction in North Africa. Lord Stormont was the father of the white girl in the picture.

The language of painting in the eighteenth century was heavily symbolic. The basket of exotic produce points to the black girl's foreign background, with the ripe fruits – grapes and figs and peaches – suggesting her lusciousness. At a literal level, she is carrying fruit that she has picked in the orangery or the hothouse for the dinner table of the big house. But at a metaphoric level she is herself being compared to a sweet foreign fruit flourishing on English soil (a wealthy man with an orangery or glasshouse could grow his own pomegranates and pineapples, but even a middle-ranking householder who was prepared to pay could go to Covent Garden market and buy exotic produce that had been cultivated in the Tarring Fig Gardens of

Sussex). The grapes are a mix of black and white, happily entwined in what could be an allusion to some close bond between the girls. Though so physically different, could they share some of the same blood?

We will never know whether the black girl was happy to be dressed this way and to pose as she does. Nor will we know what inspired her pose. The idea seems to be that she is hurrying to the house with the basket of fresh fruit. As she brushes against the green bench on which the white girl sits reading, the latter reaches out a hand and takes her arm. Is she stopping her so as to give an instruction, or to have a sisterly chat? Was it the girls' idea, or the painter's, or the commissioner's, to represent their relationship by means of this encounter? Wherever the conception came from, it is a brilliant evocation of an ambiguous relationship. On the one hand, the white girl is a member of the leisured classes (she sits, she reads, she does not have to work), while the black girl is a servant (she must pick the fruit, take it into the house and then hurry on to her next job). On the other hand, the two girls are companions, at ease in each other's company and equal in their finery. It seems unlikely that an ordinary servant girl, of whatever skin colour, would wear such clothes when picking fruit.

The dark-skinned girl's eyes are shiny and expressive. Whatever she was really feeling, the painter has made her look happy. There is a playfulness to her expression that the white girl lacks. Her hair is sleek, not curly, tamed

beneath the turban. The silk of her dress clings to her lower body as she moves. The trace of her thigh seen under the fabric is highly erotic in an age when even the outline of women's legs was rarely seen in public (except on the stage, when actresses were crossed-dressed in 'breeches' parts). If you look closely, you can see that the girl's left hand rests between her thighs in a provocative gesture, offering a whiff of Georgian England's stereotyping of black women as sexual creatures.

By contrast, the white girl's stiff hoops and petticoats conceal her body. The tight bodice imprisons her. The extra layer of gauze over her full skirt gives a strange, cage-like effect. Her open book suggests that she is fond of reading. It might be a commonplace book with choice extracts pasted into it, or a conduct book, a work of religious piety or a collection of sermons, though one would like to imagine that it is a volume of poetry or a play, or even an example of that very daring and new genre of literature, the novel. The eighteenth century was the first great age of female reading. Young women devoured Samuel Richardson's best-seller *Pamela*, with its daring depiction of a young servant girl who resists her master's sexual advances and eventually becomes his wife. Not to mention his tragedy of *Clarissa*, who is raped by her aristocratic lover and dies. Or Fanny Burney's *Cecilia*, a troubled novel about a wealthy young girl who is badly exploited by her male guardians and temporarily goes mad. The latter part of the eighteenth century witnessed a

flourishing of heroine-centred novels that explored female consciousness and identity. Questions of marriage and money, propriety and property, were constant themes. Some of the fictional heroines were low-born, lacking in wealth and status and connections; but all were white. It would take a little while longer for a pioneering novelist to depict a mixed-heritage girl, a 'mulatto': that is what Jane Austen did during the Regency years in her final, unfinished novel, *Sanditon*.

The white girl's open book is a hint of her education and gentility. Few women in the eighteenth century went to school, but well-born girls were educated at home. A good library was an essential room in a gentleman's country house: the book perhaps also serves to flatter the commissioner of the painting by implying that he has a particularly well-stocked collection.

The sitting girl holds her book in one hand, but our attention is drawn more to the other hand, the one that is stretched out: a white hand gripping the black arm of her companion. In the age of slavery-abolitionist fervour, the motto 'Am I not a sister and a friend' was often emblazoned on ladies' pincushions and hair ornaments. Some modern spectators might feel that the black girl's 'ethnic' costume, her basket of fruit and her sexually charged demeanour are degrading. But the hand gesture suggests affection and equality between the girls. For all the ambiguity of the image, the standing girl is ultimately represented as sister, cousin or friend, not as a servant, slave or

inferior being. She is drawn into the picture as a cherished member of the family.

Portraits tell stories, and this one tells a story of love and sisterhood, unity between black and white, illegitimacy and gentility, vitality and virtue. A story, furthermore, that brings us to the very heart of a larger historical story: the abolition of the slave trade.

In the course of the last two and a bit centuries, this double portrait has moved between Kenwood House on the northern boundary of Hampstead Heath in London, where it was painted, and Scone Palace just outside Perth in Scotland. Kenwood House was, and Scone Palace is, the seat of the Earls of Mansfield. The portrait was commissioned some time in the late 1770s or early 1780s by William Murray, the first Lord Mansfield, Lord Chief Justice and the most admired judge in eighteenth-century Britain. His name was by this time irrevocably linked with the question of slavery and abolition, as a result of his judgement in a famous case of 1772.

But these are not Lord Mansfield's daughters. He and his wife Elizabeth (*née* Finch) were childless. The girl in the foreground of the picture is Lady Elizabeth Murray, his great-niece, who was brought up at Kenwood following the death of her own mother when she was a young child. For much of the twentieth century, the Mansfield descendants believed that the other girl was some kind of household servant. In an inventory of Kenwood taken in 1904, the portrait was described as

'Lady Elizabeth Finch-Hatton with a Negress Attendant', and attributed to the great society artist Johann Zoffany.[1] There was a tradition of portraits of masters or mistresses with a servant or slave in the background. It was assumed that this was a variation on the theme, though with unusual prominence given to the servant. The family did not stop to consider the irony of Lord Mansfield, forever seen as a key figure in the abolition of slavery, commissioning a portrait that might seem to imply that he kept a slave himself. The painting remained little-known.

The old portrait plate at the bottom of the frame is still there today. It records the name of only the white girl – 'The Lady Elizabeth Finch Hatton'. The black girl remains nameless, a blank.

It was only in the 1980s that she was identified. Her name was Dido Elizabeth Belle, and this book tells her story. She was a blood relative of the white girl in pink and the Mansfield family. The outline of Dido's life has been pieced together, but details in the surviving archives are sparse. For a fuller picture of her life, we need to set her story in the wider context of slavery and abolition. The only way of glimpsing her life is through the lives of others.

2
The Captain

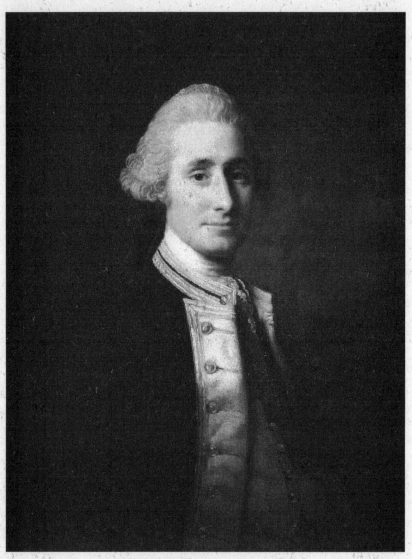

Captain Sir John Lindsay, Dido's father

On 1 June 1760, HMS *Trent* was docked in Portsmouth harbour. Captain John Lindsay, commanding officer, oversaw her substantial refitting.[1] Over the course of the following weeks provisions were brought aboard, the ship's pine was varnished and there were some short trips into the English Channel to test the new rigging. At the end of the month, the *Trent* moved out to Spithead. Lindsay had to deal with a few men for drunkenness and insubordination. Extra sails and small arms were taken on board. An unknown sail was spotted off Portland Bill, and the *Trent* gave chase. She proved herself fully seaworthy. Preparations were finalised for a long voyage. In August she set sail for Porto Santo, then Madeira, then Tenerife. By the end of the month she was at anchor off Senegal, on the west coast of Africa.

Then to Cape Verde, where Lindsay moored in Gorse Road while the crew dried the sails and aired the bread.

Soon they would be off the Gambia, and then out into open water, heading across the Atlantic in squally weather. On 18 October they approached the Caribbean island of Montserrat, and a pilot from a Bristol-based privateer came on board. Five days later the *Trent* engaged with a schooner in French colours and boarded her, only to find the crew gone, but the ship laden with sugar and coffee. They sent the prize to St Kitts. Captain Lindsay and his crew had undergone their initiation on the Caribbean front in the worldwide war between the great colonial powers of Europe.

John Lindsay was born in the year 1737, in the bracing climate of the Easter Ross district of the Scottish Highlands. He was the younger son of a baronet, Sir Alexander Lindsay, who had made a very good marriage to Emilia, daughter of the fifth Viscount Stormont. Emilia was the sister of William Murray, who would later become the first Earl of Mansfield. The choices for the younger sons of the gentry were fairly limited: the Church, the armed forces or a life of idleness. Lindsay went into the navy, which carried more opportunity for adventure than his other options. It was a good decision. He quickly proved himself a fine sailor and a leader of men.

Before the age of twenty he was made a lieutenant and put in command of the fireship *Pluto*. This was a hazardous occupation: fireships were converted merchantmen, filled with flammable materials and explosives, intended to be sent into enemy lines with the purpose of setting the

enemy's wooden vessels on fire. Sister vessels of the *Pluto* included the aptly named *Blast, Blaze, Etna* and *Vesuvius*. The danger of accidental combustion was great enough in peacetime, but Lindsay got his first command in the midst of the Seven Years War, arguably the first global war, during which the European powers – most notably Britain and France – played out their rivalries in their colonial and trade empires. Lindsay's first expedition aboard the *Pluto* was as part of a fleet sent to capture the French Atlantic naval port of Rochefort. The mission was not a success, but Lindsay's contribution earned him a new posting just a few weeks later. Now he had command of the twenty-eight-gun frigate *Trent*, recently constructed out of pine, which was quicker to build with but less durable than the traditional English oak. He served on the *Trent* for the rest of the war, first in home waters and then from the West Indian station.

Reports of his exploits were soon reaching the Admiralty. In February 1759 the *Trent* joined the *Vestal* in giving chase to an enemy ship at the western end of the English Channel. This was a French frigate, *La Bellone*, en route to Martinique. They engaged in a four-hour battle at close quarters. *La Bellone* was duly captured, taken into service and renamed the *Repulse*.[2] After various further exploits, the *Trent* was taken back into dock. A report was filed in the Admiralty: 'The Portsmouth Officers inform us the Trent is touched with the worm but she does not make water and can be repaired and used for about 9 or

10 months on Channel Service. Have approved the Officers' proposal but if she is to go on foreign service she will have to be resheathed.' The need for comprehensive repairs was the reason the *Trent* did not sail for the West Indies until the late summer of 1760.[3]

The refit was clearly an outstanding success. The *Trent* proved herself as fast and effective as any frigate in the fleet. Captain Lindsay's daily log reveals a succession of chases and prizes. On 1 November, a sloop en route from St Eustatia to Martinique; a few days later a Dutch schooner; and on Thursday, 20 November, a sail to the south which proved to be 'a Spanish sloop from Teneriff to St Domingo with Settlers'.

Just before Christmas, the *Trent* joined the *Boreas* in attacking a sloop that was at anchor under the mangroves in Cumberland Harbour, St Iago Island. She was a French privateer, the *Vanquier*. Lindsay and the captain of the *Boreas* sent in a small boat with marines who boarded her after sharp resistance. The French captives were sent on shore a week later at Grand Cayman, where they were exchanged for English prisoners.

All through the following year, Lindsay continued his patrols, sailing hundreds of miles around the Caribbean basin. One day he gave chase to a Spanish man-of-war bound from St Domingo to Havana, the next he attacked *Le Bien Aimé*, a French merchant frigate from Martinique with twenty-two guns, eighty-four men, and a heavy load of sugar and coffee. He took her with only one man killed

and five wounded, to the enemy's twenty killed or wounded.[4] The French prisoners were transferred to HMS *Cambridge*.

There were occasional weeks of respite, when the *Trent* would be moored off Port Royal, Jamaica, for cleaning, caulking, rerigging, the removal of ballast, the supply of fresh water and provisions. Time spent at anchor was troublesome from the point of view of discipline. On one occasion at Port Royal a midshipman was punished for embezzlement, receiving nine lashes alongside every ship in the harbour, with a halter around his neck. Another time, Lindsay had to punish some men for insubordination, making them run the gauntlet through the ship. Then they would be off again: in April 1761 they took a Spanish sloop from Port au Prince laden with sugar; in August a Dutch schooner; in September *La Donna de la Providence*, bound for France – her crew were dispatched to a plantation, where they would be held until the opportunity arose for an exchange of prisoners.

Captain Lindsay's exploits were celebrated in the press back home in England. In January 1762 the *London Chronicle* printed a front-page report from Kingston in Jamaica, dated 31 October 1761 (news travelled slowly in the days before the invention of the telegraph). It announced that:

Thursday arrived from a cruise, his Majesty's ship *Trent*, John Lindsay, Esq; Commander, and brought in two prizes, said to be a Dutch schooner and sloop, both from Cape Francois, which he took in the Bite of Leogan, and were part of a fleet of about fifteen sail, who had been assisting our enemies at the Cape; they are both richly laden with indigo, etc. etc. It is reported, the poltroon commanders of these vessels, had the impudence to give out they would take the *Trent*; though when within sight of their enemy, they thought proper to fly away with all speed, and leave their friends a sacrifice for their presumption.[5]

Clearly, Captain Lindsay was a man of courage and single-mindedness, if not reckless impulsiveness. The prizes were mounting up: every captured ship meant a bounty for the crew, and especially for the captain.

His greatest triumph came at the siege of the castle of Morro, which stood guard over Havana Bay on the key strategic island of Cuba, held by the Spanish. Captain Goostrey of the *Cambridge* was shot dead in action on 1 July 1762, and Lindsay was sent to fill his place, where he 'gave many strong proofs of his valour'.[6] A painting by the naval artist Richard Paton, now in the National Maritime Museum at Greenwich, shows the bombardment of the castle. It gives a vivid sense of the smoke of battle, the ease with which a wooden warship might burst into flames, and the nerves of steel demanded of the captains. The *Cambridge* is shown flying a red ensign in

the mizzen shrouds, as a signal that her captain is dead. In the foreground is a little rowing boat in which Lindsay is being taken from the *Trent* to the *Cambridge*, where he will assume command.

At the end of July a breach was made with mines in the wall of the castle, and this enabled the British to take it by storm. The fall of Havana was now inevitable: it occurred on 11 August. In addition to stores and booty up to the value of £3 million, nine Spanish ships of the line were captured, and two on the stocks were burned. Possession would, however, be short-lived: under the terms of the Treaty of Paris, which ended the war the following year, Havana was returned to the Spanish.

After the taking of Havana, the *Trent* participated in the mopping-up operation. The sick and wounded were transported for treatment, newly arriving Spanish ships – including some slave transporters – were headed off. Then in July 1763 came the order to return home. The *Trent* reached Spithead on 12 August, and ten days later she was moored at Long Reach. Lindsay set about stripping the ship and getting his officers ashore. After a final cleaning, he paid off the men and closed his log on Friday, 9 September. The war was over; the *Trent* had performed her service. She was decommissioned and scrapped, and Captain Lindsay was knighted for his gallantry.

Despite the ending of the war, the colonies still needed to be patrolled, so before long Lindsay was back in the West Indies, in command of another ship. One senses that

he couldn't keep away. The heat and the excitement were a far cry from life in the chilly and dull Scottish Highlands. In 1768 he married a Scottish girl called Mary Milner, daughter of an MP. They had no children, although there is evidence that Lindsay sired one or possibly two illegitimate children in Scotland. His portrait was painted at around the time of his marriage by the leading Scottish society artist Allan Ramsay. He is seen in naval dress uniform, and looks not only handsome and distinguished, but somehow kind. He was soon off abroad again, this time to the East Indies.

One entry stands out in Captain Lindsay's log of his earlier mission to the West Indies. Amidst the chases, the boardings and the prizes, the time at anchor and the set-piece drama of the siege, there is a poignant moment of rescue. It is Saturday, 7 February 1761, and the *Trent* is off Curaçao, one of the southernmost Caribbean islands: 'saw a small boat to the East. Came up with her, found in her 2 English Negroes that Run away from Martinique. One of them dy'd immediately being Starv'd.' The surviving negro, who went by the name of Peter King, was taken aboard and well looked after. Lindsay was clearly a man of compassion as well as purpose.

At some point in his West Indian naval adventures Lindsay met a slave woman, who was almost certainly called Maria. She would be Dido's mother. The story told in England many years later, of which we have only a second-hand account, was that he captured a Spanish

ship and took a fancy to one of the female slaves on board. We have seen from the logbook that the *Trent* did run down several Spanish ships. Perhaps the woman was a slave in service to a Spaniard on board that sloop heading to St Domingo with settlers, or the one coming from Port au Prince laden with sugar for Europe. We cannot, however, be certain that she was in fact on a Spanish ship, and not on one of the Dutch or French ones that Lindsay also captured. The muster rolls of the *Trent* include the names of many prisoners, who were held on board and victualled at two-thirds the allowance of the crew, before being transferred to other ships or put ashore. Among them were 'Thomas a negro', 'James a negro', 'Marique', 'Domingeta', 'Sansauvie', 'Lanset', 'Greto', 'Adam', and many more unnamed negroes. Tantalisingly, none of them is readily identifiable as the 'Maria' whom Lindsay kept as his mistress, although the prisoners from a Spanish sloop taken on 22 April 1761 did include one 'Quainda Mairia'.

Then again, stories of this kind are often garbled in the detail, or embellished for dramatic effect in the retelling. It is not beyond the bounds of possibility that the woman was actually a prize taken on dry land. Could it have been in the aftermath of the capture of Havana? In February 1763 the *Trent* discharged many prisoners who had been captured in Havana onto a place called Belle Island. Perhaps Maria was retained from the group and Dido conceived at this time, the association inspiring the name Belle.

But this is speculation. All we know for sure is that the encounter between Captain Lindsay and Maria was the beginning of Dido's story. There is evidence that Dido was about five years old late in the year 1766. This would suggest a date of birth before the siege of the castle of Morro and the surrender of Havana, and strongly suggests that Dido was conceived in the captain's cabin aboard the *Trent*.

Maria appears to have remained on board the *Trent* until the summer of 1763, when the vessel returned to England and was decommissioned.[7] Lord Mansfield was later reported as saying that the negro woman was with child when the ship returned home, and that Dido was born in England, but a later Murray–Mansfield family tradition has it that she was born at sea. Unlikely as it may now seem, it was not uncommon for wives, mistresses and even babies to be present on Royal Navy warships in the eighteenth century.

Captain Lindsay would have possessed a well-thumbed copy of the *Regulations and Instructions relating to His Majesty's Service at Sea*. Article XXXVIII of the rules for the captain or commander clearly stated that 'He is not to carry Women to Sea, nor to entertain any Foreigners to serve in the Ship, who are Officers or Gentlemen, without Orders from the Admiralty.'[8] The official navy line was that wives could come on board when a ship was in port, but not go to sea. Prior to the Battle of Trafalgar, when the ship of the line HMS *Prince* was in dock in Portsmouth,

one eyewitness reported that 450 women came on board, but that only fifty were actually wives of sailors serving on the ship. In other words, wives, girlfriends and an abundance of prostitutes would pile on board when a ship was at anchor, and there would be an orgy of drunkenness and debauchery. Once the crew's needs had been satisfied in this way, the women were all supposed to be removed.

But the reality was that the rule against seagoing women was very often relaxed, especially for the wives of captains and officers.[9] Estimates vary as to the numbers of women actually at sea with the fleet, but there is ample anecdotal evidence of their presence aboard in the late eighteenth and early nineteenth centuries. One has only to consider the novels of one of English literature's most navally connected novelists, Jane Austen.

Her brother, Captain Charles Austen, took his wife Fanny and their three children to live aboard his ship, the *Namur*. Fanny Austen's surviving letters describe her making clothes for her little girls, reading in the ship's library, and attending the ship's theatre. Whenever she spent time ashore she was anxious to get back to her 'home' on board, 'however uncomfortable that home may be'.[10] One of her daughters suffered from sea sickness, and Fanny discussed the possibility of leaving her to be raised by her aunt Jane, but in the end decided that the family should stay together on board ship.

In Jane Austen's novel *Persuasion* there is a long discussion about the suitability of women living aboard ship.

Captain Wentworth's old-fashioned belief that a ship is no place for a woman is given short shrift by his sister, Mrs Croft, who is married to an admiral and has lived aboard five vessels, including a battleship. 'Women may be as comfortable on board, as in the best house in England,' she says. 'I believe I have lived as much on board as most women, and I know nothing superior to the accommodation of a man of war.' She has crossed the Atlantic four times, and says that 'the happiest part of my life has been spent on board a ship.'[11]

Despite Mrs Croft's protestations, life on board a man-of-war was hard for the wife of a sailor, even a captain. She had to share her husband's hammock or bunk, and his daily ration of salted beef, dried peas, hardtack and cheese. She also had to try to stay out of the way of the ship's daily activities. Outside the captain's cabin, privacy was in short supply on a ship that might carry four hundred sailors and marines.

Childbirth at sea was not unknown, and sometimes a ship's guns would be fired to hasten a difficult birth – a practice that gave rise to the saying 'a son of a gun'. During the Napoleonic Wars, Captain Glascock of the Royal Navy wrote: 'This day the surgeon informed me that a woman on board had been labouring in childbirth for twelve hours, and if I could see my way to permit the firing of a broadside to leeward, nature would be assisted by the shock. I complied with the request, and she was delivered of a fine male child.'[12] Fanny Austen gave birth to her

fourth child on board the *Namur*, but tragically she died two weeks later, as did the baby. The Austen family lamented that she had not been removed to land sooner.

There are even records of women assisting aboard a ship in battle, attending the wounded or carrying gunpowder.[13] Maria the liberated slave may have tended to the wounded during the siege of Morro castle as well as tending to the sexual and domestic needs of Captain Lindsay. At the end of the war he appears to have avoided getting into any trouble for bringing her back to England. And when he returned to sea, he left behind an extraordinary arrangement for the care of his 'mulatto' daughter.

3
The Slave

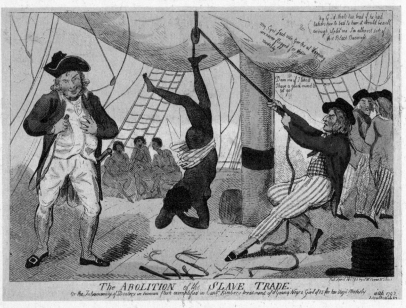

'The Abolition of the Slave Trade': caricature by Isaac Cruikshank of a slave woman being lashed aboard ship

The handsome Royal Navy captain with aristocratic blood in his veins takes his prize, an African slave. Like thousands of other slaves, the terrified woman had been branded with the initials of her former owner. Now, though, she belongs to Captain Lindsay. She knows what to expect: rape and further servitude. Never could she have dreamed that the encounter would bring into the world a daughter who would influence the course of history. Like those of thousands of other women who were taken from Africa and sold into slavery Maria's inner life is unknown to us. We cannot know her, but it is possible to reconstruct the kind of life she lived before being taken aboard the *Trent*.

The enforced removal of Africans as a labour force to work the West Indian sugar plantations was conducted via the slave ship. It has been estimated that through the long history of the slave trade some twelve million Africans

were loaded and transported onto Atlantic slave vessels.[1] Sometimes known as a 'Guineaman', the slave ship is the enduring symbol of the horrors of the transatlantic trade, a floating dungeon whose stench could be smelt from miles away, its wake trailed by dead-eyed sharks awaiting their prey. Cabin boy Samuel Robinson, aboard a slaver in 1800, was terrified by the sight of these predators, and the knowledge of what would happen to anyone unfortunate enough to go overboard: 'The very sight of him slowly moving around the ship, with his black fin two feet above the water, his broad snout and small eyes, and the altogether villainous look of the fellow, make one shiver, even when at a safe distance.'[2]

Before they set eyes on the ocean the Africans had been captured, marched in 'coffles', chained together, and sold at market. Many were bought and sold several times along the way to the coast. The process was brutal and degrading. Families were torn apart, and the captives prodded and poked like animals, assessed for their value and given a price. 'Vendue' (sale) masters knew what they were looking for: good teeth, clear eyes, strong limbs, full height and no obvious signs of disease. Women who were 'long-breasted' were passed over, since this was taken to be an indication of age.[3] Bellies were checked for evidence of pregnancy.

Slave 'surgeons' were brought in for preboarding triage, with painful and humiliating examinations being undertaken. Breasts and genitalia were scrutinised. Thomas Aubrey, an early-eighteenth-century slave surgeon, noted

in his log that 'Sometimes the Men have Gonorrhoeas, or Ulcers in the Rectum, or Fistulas, and the Women Ulcers in the Neck of the Matrix.'[4] Slaves were checked for signs of smallpox, a disease that could wipe out most of the 'cargo.'[5]

Thanks to the testimony of ex-slave Mary Prince we have an eyewitness account, from a female perspective, of the desperate, shameful process of being sold at a vendue market.[6] 'I have been a slave,' she wrote. 'I have felt what a slave feels, and I know what a slave knows.'[7] She was born in 1788, to an enslaved family in Bermuda. When she was a young girl she and each of her sisters was dressed in an osnaburg, a rough linen shroud-like garment, to be taken to the marketplace.

> At length the vendue master, who was to offer us for sale like sheep or cattle, arrived, and asked my mother which was the eldest. She said nothing, but pointed to me. He took me by the hand, and led me out into the middle of the street, and, turning me slowly round, exposed me to the view of those who attended the vendue. I was soon surrounded by strange men, who examined and handled me in the same manner that a butcher would a calf or a lamb he was about to purchase … The bidding started at a few pounds, and gradually rose to 57 … The people who stood by said that I had fetched a great sum for so young a slave. I then saw my sisters led forth, and sold to different owners. When the sale was over, my mother hugged

and kissed us, and mourned over us, begging us to keep a good heart. It was a sad parting; one went one way, one another, and our poor mammy went home with nothing.[8]

Mary Prince was sold to a family in the West Indies. She eventually came to England, secured her freedom and became an important advocate of the abolition movement.

We do not know whether Dido's mother was bought in Africa, then captured by Lindsay while on the way to the Caribbean, or whether she had already been working on a plantation when she came into his hands. In the eighteenth century about six million slaves were carried across the Atlantic to the New World. Fifteen per cent – almost one million Africans – perished during the 'middle passage', the notorious journey from Africa to the Americas.

The triangular trading system saw ships departing from Europe for African markets with manufactured goods such as guns, ammunition, copper, cloth and trinkets, which were traded for purchased or kidnapped Africans, who were transported across the Atlantic as slaves; the slaves were then sold, or traded for raw materials such as sugar, rum and tobacco; which would be transported back to Europe to complete the voyage.

Purpose-built slave ships were built in Liverpool and Bristol. Typically two- or three-masted vessels, their average size was two hundred tons. Ventilation holes in the

sides of the ship below the level of the upper decks were a tell-tale sign of a slaver. Nets were installed around the sides of the ship, to prevent the slaves from throwing themselves overboard.[9]

If Dido's mother was indeed sold to a Spanish trader, we may gain an idea of what Captain Lindsay encountered when he first saw her from a slightly later account by the Reverend Robert Walsh, who was present when a British naval patrol intercepted an illegal Spanish or Portuguese slave ship, the *Feloz*, commanded by Captain José Barbosa, bound for Brazil. Walsh described the ship, with its enormous swivelling gun, and large kettles for cooking – 'the usual apparatus of a slaver' – and witnessed the scene of horror when the vessel was boarded. They found 562 slaves, 'branded like sheep with the owner's marks of different forms ... as the mate informed me with perfect indifference, "burnt with the red-hot iron".[10] Walsh was horrified by the stench, the heat and the cramped conditions. He could scarcely believe

how it was possible for such a number of human beings to exist, packed up and wedged together as tight as they could cram, in low cells three feet high, the greater part of which, except that immediately under the grated hatchways, was shut out from light or air, and this when the thermometer, exposed to the open sky, was standing in the shade, on our deck, at 89 degrees. The space between decks was divided into two compartments 3 feet 3 inches

high; the size of one was 16 feet by 18 and of the other 40 by 21; into the first were crammed the women and girls, into the second the men and boys: 226 fellow creatures were thus thrust into one space 288 feet square and 336 into another space 800 feet square, giving to the whole an average of 23 inches and to each of the women not more than 13 inches. We also found manacles and fetters of different kinds, but it appears that they had all been taken off before we boarded.

The Reverend noted that all of the slaves on board the *Feloz* were naked.

From the moment the female slaves set manacled foot on ship, they were marked out as sexual fodder. Their naked flesh incited the lust of the sailors, who groped them and made choices as to their favourites. The slaver turned abolitionist John Newton recalled how, 'naked, trembling, terrified, perhaps almost exhausted with cold, fatigue and hunger', the women and girls were 'exposed to the wanton rudeness of white savages'. 'The poor creatures,' he saw, 'cannot understand the language they hear, but the looks and manners of the speakers are sufficiently intelligible. In imagination, the prey is divided, upon the spot, and only reserved until opportunity offers.'[11]

On British slave ships, the women were kept in separate quarters from the males. 'From the women there is no danger of insurrection, and they are carefully kept from the men; I mean, from the black men,' noted freed slave

turned abolitionist Ottobah Cugoano. But 'it was common for the dirty filthy sailors to take the African women and lie upon their bodies'.[12] It was not true that women did not ever rebel against their lot. As we will see, female slaves had their own methods of insurrection.

John Newton noted the actions of a sailor called William Cooney, who 'seduced a slave down into the room and lay with her brutelike in view of the whole quarter deck'. The woman (number 83) was already pregnant. Cooney was put in irons as a punishment. 'If anything happens to the woman I shall impute it to him, for she was big with child,' Newton wrote.[13] It was for raping a pregnant woman so brutally that Cooney was punished. In general, the sexual abuse of female slaves aboard ship was simply part of the institutional violence of the Guineamen. Rape was used as a means by which to humiliate African men, who were powerless to protect their wives, mothers and daughters. Women were treated as property by sailors and captains. Sexual compliance was expected of them, and they conformed to expectations. The white males justified their abuse by expressing their belief that black women were promiscuous. If they refused sexual advances they would be flogged, or their children would be punished. Female slaves had to deal with the repercussions of their harassment, and many 'mulatto' children were born aboard the slave ships.

Caricatures of the late eighteenth century conform to racial stereotypes. African women are almost invariably

drawn with large, pendulous, naked breasts, protruding bottoms, thick lips. On the one hand African women were dehumanised, herded naked like animals. But on the other they were clearly also sexually desirable, the objects of unbridled lust.

One of the most compelling eyewitness reports of the slave ships came from the abolitionist campaigner and writer Olaudah Equiano, a freed slave whose *Interesting Narrative of the Life of Olaudah Equiano, Or Gustavus Vassa, The African* was first published in 1789. He had been bought by Michael Pascal, a lieutenant in the Royal Navy who renamed him 'Gustavus Vassa', after King Gustav I of Sweden. Though doubts have been cast on its veracity, his autobiography remains one of the most important 'slave narratives'.[14] He gives a graphic account of the treatment of slave women on internal voyages between the colonies:

> I used frequently to have different cargoes of new negroes in my care for sale; and it was almost a constant practice with our clerks, and other whites, to commit violent depredations on the chastity of the female slaves; and these I was, though with reluctance, obliged to submit to at all times, being unable to help them. When we have had some of these slaves on board my master's vessels to carry them to other islands, or to America, I have known our mates to commit these acts most shamefully, to the disgrace, not of Christians only, but of men. I have even

known them gratify their brutal passion with females not ten years old; and these abominations some of them practised to such scandalous excess, that one of our captains discharged the mate and others on that account. And yet in Montserrat I have seen a negro man staked to the ground, and cut most shockingly, and then his ears cut off bit by bit, because he had been connected with a white woman who was a common prostitute: as if it were no crime in the whites to rob an innocent African girl of her virtue; but most heinous in a black man only to gratify a passion of nature, where the temptation was offered by one of a different colour, though the most abandoned woman of her species.

From the other side of the racial divide, James Stanfield was perhaps the first 'common tar' to write about the horrors of the slave trade. In 1788, just as Equiano was preparing his *Interesting Narrative* for the press, Stanfield wrote *Observations on a Guinea Voyage, in a Series of Letters Addressed to the Rev. Thomas Clarkson*. A year later he published *The Guinea Voyage, A Poem in Three Books*. In both the prose work and the poem, he vividly and compellingly described the terrors of the slaver ships, coining the phrase 'floating dungeon'.[15] Stanfield's writings were serialised in newspapers in Britain and America, and shocked their readers. His evidence that the slave trade was extremely destructive of the morals of English sailors as well as the lives

of African slaves gave an additional argument to the abolitionist cause.

Stanfield's accounts are striking for his depiction of the suffering of the female slaves. Time and again his poem re-enacts the particular abominations heaped on the women. He vividly describes a woman in childbirth, and her sorrow in giving birth to a baby born into slavery; two women who jump overboard arm in arm in a suicide pact; the rape of a nine-year-old girl by a captain; the barbaric flogging of a slave woman tied to a captain's bedpost so he can witness the suffering on her face and hear her scream-ing in agony. Stanfield dressed her wounds.

In an attempt to show a slave ship from an African's perspective, and to emphasise and humanise the suffer-ings of the slaves, Stanfield depicts a beautiful female slave, Abyeda, who has been kidnapped – 'torn from all human ties'. Abyeda is on the point of marriage to her beloved, Quam'no, when she is seized. Trying to save her, he is killed. She is taken to the ship and lashed. As she cries out, her fellow women cry out with her. She is flogged to death: 'Convulsive throbs expel the final breath'.[16] She may have been a fictional invention, but her story was all too real.

John Newton noted how one sailor, disturbed by the sound of an African baby crying, tore the child out of its mother's arms and threw it overboard.[17] The mother was saved, as 'she was too valuable to be thrown overboard'.[18] At night on the ships, the women could be heard singing.

The abolitionist author Thomas Clarkson, who wrote the first comprehensive history of the slave trade, described their powerful lamentations:

> In their songs they call upon their lost Relations and Friends, they bid adieu to their Country, they recount the Luxuriance of their native soil, and the happy Days they have spent there ... With respect to their singing, it consisted of songs of lamentation for the loss of their country. While they sung they were in tears: so that one of the captains, more humane probably than the rest, threatened a woman with a flogging because the mournfulness of her song was too painful for his feelings.[19]

Some women sang songs of resistance. Others resorted to hunger strike, only to face the dreaded 'speculum oris', a metal device employed to open the mouth for force-feeding. A dead slave was no good to anyone, least of all to the slave captain who had purchased her and hoped to sell her for a good price. Clarkson wrote about female slaves who went insane while chained to the ship's mast.

The level of brutality on a slave ship was almost always determined by the conduct and character of the captain. The slaving captains had a vested interest in looking after their slaves, who were after all their property. Mortality rates dropped at the end of the eighteenth century with improved diet and medicine. Concentrated lemon and orange juice became compulsory issue in the British Navy

in 1795, and many slavers followed suit, greatly reducing the prevalence of scurvy. Slaves were even inoculated against smallpox.

But whilst diet and medicine were improved in order to protect the slave traders' investments, the mental and physical atrocities continued, partly because of the fear of insurrection by the slaves – although captains could always claim insurance for slaves who rebelled and were killed in retaliation, and thrown overboard to the hungry sharks.

Many captains were sadists who enjoyed inflicting pain on their slaves. Stanfield's eyewitness account of Captain David Wilson's 'demon cruelty' is shocking in the extreme. Wilson carried a 'parcel of trade knives' to hurl at slaves and crew. He beat his chef to death for burning his meat, and also killed his second mate. He didn't care who he flogged: 'pallid or black', both sailors and slaves were victims of his brutality.

In 1792, slave trader Captain John Kimber was brought to trial for the murder of two female slaves. It was common practice on slave ships to make the slaves dance as a form of exercise (and degradation), usually to the 'music' of the whips. Kimber was alleged to have flogged to death a pregnant fifteen-year-old girl who had refused to dance naked for him. Her courageous, proud refusal cost the girl her life, but her story caught the attention of the abolitionist MP William Wilberforce, who accused Kimber of murder. Although he was acquitted, the story garnered considerable

press in favour of the abolitionist cause. Cartoonist and satirist Isaac Cruikshank's caricature depicts the half-naked 'virjen' girl suspended by her ankle from a pulley while Kimber looks on lasciviously. Three naked slave women sit in the background, while two sailors on the extreme right walk away, saying, 'My Eyes Jack our Girls at Wapping are never flogged for their modesty', and 'By G-d that's too bad if he had taken her to Blackwall all would be well enough, Split me I'm allmost sick of this Black Business' (Blackwall was one of the main shipyards on the Thames in London). The Kimber trial was viewed as a moral victory for the abolitionists, because it established the principle that slave captains could be called to account for murder.

James Stanfield claimed that the mere sight of the African coastline would transform the mildest captain into an enraged madman, bringing out his heart of darkness.[20] The power of the captain was absolute. One vicious captain, facing a 'rage for suicide' among his human cargo, made an example of a female slave by lowering her into the shark-infested waters on a rope: she was bitten in half. Sharks were an ever-present threat to recalcitrant slaves. They circled the ships 'in almost incredible numbers … devouring with great dispatch the dead bodies of the negroes as they are thrown overboard'.[21]

Many of the abolitionists took up the rallying cry that the slave trade degraded both white and black, that the sailors were treated almost as badly as the slaves. Everyone was brutalised.

But there was another side to master/slave relations. William Butterworth, a sailor on the slave ship *Hudibras*, published an account of his travels in which he dwelt at length on his admiration for a slave called Sarah. 'Ever lively! Ever gay!', she was a superb dancer, and charmed everyone with her 'sprightliness' and 'good nature'. She was 'universally respected by the ship's company'. Butterworth's captain, Jenkins Evans, selected Sarah to be one of his favourites, or 'wives'.[22] This was not unusual. On the slaver *Charleston*, the captain and officers took three or four 'wives' each for the journey.[23]

Sarah was suspected of being involved in a plot to overthrow the ship. It was not unknown for slave women and children to be involved in rebel plots against the sailors. Because they were given greater freedom than the male slaves, they were able to take messages and surreptitiously pass weapons to them, allowing them to hack off their shackles and fight back. Despite Sarah's involvement in the plot against Captain Evans, he spared her life.

Other female slaves who were quick to learn English and could help to maintain order were given positions of trust. Known as 'guardians' or 'confidence slaves', some of them became cooks or made clothes, and were given 'wages' of brandy or tobacco.

Sea surgeon Thomas Boulton was mesmerised by a black slave he called Dizia – 'who did my piece of mind destroy', as he wrote in a poem which alleged that she also wielded power over the captain: 'Whose sooty charms he

was so wrapt in,/He strait ordain'd her second captain'.[24] The power exerted by the female slave over her master conformed to the sexual stereotyping of African women. Equally, many white masters raped and seduced female slaves as a way of emasculating, humiliating and punishing male ones: one master was so besotted with his slave lover that he 'cut off the lips, upper lip almost close to her Nose, of his Mulatto sweetheart, in Jealousy, because he said no Negroe should ever kiss those lips he had'.[25]

However, the exceptionally close interaction between white and black, in both the slave ships and the plantation houses, created unusual psychological, moral and ethical situations. Can a relationship between a white captain and a slave woman within the British Empire in the eighteenth century ever be considered anything other than sexual exploitation? Could there ever be a consensual relationship between black and white, slave and captain? The short answer is yes.

When Mary Prince published her 'slave narrative' in 1831 she was advised not to mention her seven-year affair with a white man, Captain Abbot. Prince's editors were keen to present her as an innocent victim, and it's striking that they were uncomfortable with her revelation of this affair. Only later did Prince reveal the details of her liaison with Captain Abbot, which ended when she found her lover in bed with one of her friends. The jealousy she felt shows that she did have feelings for her captain – though there was also another factor, in that she had by this time

converted to Christianity, and her ministers urged her to end the affair.

Thomas Thistlewood, a plantation overseer in Jamaica, lived openly with a female slave named Phibbah, and they were together for thirty-three years. In his will he requested that his executors should buy her and arrange for her to be 'manumitted' (formally freed). She eventually became a property-owner and a woman of means, providing for her extended family. Phibbah was clever and articulate, and managed to negotiate with adroitness the very delicate balance of being the black mistress of a white master. She was highly regarded within both the slave and the white communities. The careful details Thistlewood kept in his diary of their life together as 'husband and wife' suggest a deeply affectionate connection.

Both suffered when they were parted, sent one another presents, cared for each other in illness, cried together when their beloved son 'Mulatto John' died at the age of twenty, and engaged in furious jealous quarrels, although they always made up. Their sexual relationship seems to have been fully consensual: Thomas noted the times that she refused to sleep with him. Other slaves, with less status and power, had no such sway.

Nevertheless, Thistlewood's relationship with his 'wife' Phibbah did not stop him from pursuing other women, who were powerless to prevent his sexual assaults. He abused and sexually exploited many of his female slaves

(and indeed those from other plantations), keeping a careful record of his sexual conquests alongside his notes on sugar production.

Thomas Thistlewood's journal conforms to the stereotyping of black women and their sexuality. In his imagination, black women were sexually insatiable, while white women were passive. Bizarrely, he claimed that African women who ate too much sugar cane became 'loose and open, as tho' they [had] just been concern'd with men'.[26] His own sexual preference was always for black women – as was his nephew John's. John Thistlewood went out to Jamaica to work for his uncle. When he was propositioned by a white prostitute he declined, because he 'much preferred a Negro wench'.[27]

Though Thistlewood lived with Phibbah as his favoured concubine, he was dismissive of other white men's 'infatuated attachments' to black women. His friend William Crookshanks was besotted with his slave lover Myrtilla, and cried when she miscarried his child. They later had a 'mulatto' daughter. The other planters were dismayed by the hold Myrtilla had over him, and it 'weakened his standing within white society'.[28]

Lady Maria Nugent, the wife of Jamaica's Governor General Sir George Nugent, kept a journal during her stay on the island from 1801 to 1807. She noted that white men of all descriptions, married or single, lived in 'a state of licentiousness' with their female slaves.[29] Naturally, the white lady of the Great House resented her slave rival,

particularly when children were born. Molly Cope was the very young wife of a sugar planter, John Cope. She knew that her husband kept a black mistress, Little Mimber, but was powerless to intervene, and so turned a blind eye. Other wives were less tolerant, and would punish their female slaves. Thistlewood recorded in his journal that Dr Allwood's wife flogged to death a black slave, the third that she had killed in this way.

In the absence of documentary evidence about the relationship between Captain John Lindsay and Maria, what we can reconstruct of her life comes down to probability. She probably endured the full horrors of capture in Africa and a transatlantic voyage. She may well have been sexually assaulted – possibly more than once – before Lindsay took her from the Spanish. Their relationship, by contrast, was probably – though by no means certainly – loving and consensual. Lindsay would have been the victim of gossip and disapproval for taking a black 'wife', especially once she became pregnant. But the stories of figures as diverse as Thomas Thistlewood and Mary Prince show that the relationship that gave birth to Dido was by no means unique in the annals of the slave era.

4
The White Stuff

Still life with meat, kettle, cup,
sugar loaf and sugar lumps

All slaves want to be free –
to be free is very sweet

Mary Prince

It is pure, bright, dazzling white, a solid conical shape with a rounded top. It is wrapped in blue paper to emphasise its refined whiteness. Weighing anything from five to thirty-five pounds, this substance can be found in all but the very poorest kitchens in Georgian England, where it is locked away in a box by the lady of the house. Because sugar is expensive, and Georgian England has a very sweet tooth.

A sugarloaf. It is a shop-bought luxury item, purchased with other imported consumables such as tea, coffee and drinking chocolate. The semi-hard sugar cone requires its own hardware: a sugar axe or hammer to break it into

chunks, and sugar nips – plier-like tools with sharp blades – to break off small pieces, which can be transferred into sugar boxes, and then used to sweeten those exotic hot drinks that Britain is consuming with such insatiable thirst.

Sugar had once been the luxury of nobles. Portraits of Tudor aristocrats show their subjects holding precious boxes of sugar as they would white gold. By the mid-eighteenth century, though, the substance was to be found in most middle-class, and many labouring-class, homes.[1] Coffee houses and tea gardens were all the rage, places where polite society gathered to sip hot drinks and gossip.

But sugared hot drinks were most often consumed in the comfort of the home. Tea, in particular, was the soft drug of the English, taken behind the closed doors of townhouses and country cottages. A commentator observed in 1744 that the opening of 'trade with the East Indies brought the price of tea so low, that the meanest labouring man could compass the purchase of it, when sugar, the inseparable companion of tea, came to be in the Possession of the very poorest Housewife, where formerly it had been a great Rarity'.[2] White, refined sugar was seen as a status symbol, a way for the middling classes to be associated with the privileged upper classes. Dark-brown sugar was consumed by the lower classes. Breakfast china sets, teacups, saucers and sugar bowls were bought with matching trays. The famous workshop of Josiah Wedgwood supplied an ever-expanding market with

pottery and porcelain as tea and coffee became affordable by a wider range of people. Wedgwood grew rich on sugar.

In one humble Hampshire cottage, an unmarried daughter was in charge of sugar and tea supplies (locked in a box, of course, to prevent pilfering). In 1808 her mother had purchased a 'silver tea-ladle and six whole teaspoons which make our sideboard border on the Magnificent', and she was given a Wedgwood breakfast set as a present in 1811 – we learn this from the tea-loving daughter, whose name was Miss Jane Austen.[3] It was Jane's job to make breakfast, and every morning she could be found presiding with domestic pride over the large copper teakettle in the dining room. The taking of tea is frequently mentioned in her novels. Miss Bates, the gossip in *Emma*, is one of the female characters who loves her cup of tea: 'No coffee, I thank you for me – never take coffee – a little tea if you please.'[4]

Sugar was also used in cakes, puddings and preserves. British people loved sugary desserts: trifles, fools, sylla-bubs, apple pies, milk puddings, ice cream. Thanks to drinks and puddings, Britain consumed four times as much sugar in 1770 as in 1710.[5]

Yet few people, sipping their hot, comforting cup of tea in the mid-eighteenth century, stopped to consider where the white stuff came from, or how it was produced. Nor would many of the sugar addicts have known of the personal cost to the people who produced it: the violence, the exploitation, the horror. Any qualms they might have

had were well disguised under the veil of patriotism. Drinking sugared tea supported British colonies, and the moral efficacy of sugared drinks was celebrated: 'the cup that cheers but does not inebriate'.[6] If one did pause to consider the cost, then how would Britain deal with its sugar addiction? Perhaps it was better not to think at all.

> I pity them greatly, but I must be mum,
> For how could we do without sugar and rum?
> Especially sugar, so needful we see?
> What? Give up our desserts, our coffee, and tea!

In this poem of 1788, entitled 'Pity for Poor Africans', William Cowper, the most popular and admired poet of the day, raises the uncomfortable truths behind the production of what was at the time the most powerful commodity on earth. The consumption of sugar was rendered possible through the exploitation of Africans captured and sold as slaves to work the plantations in the West Indies. Cowper begins with this stanza:

> I own I am shock'd at the purchase of slaves,
> And fear those who buy them and sell them are knaves;
> What I hear of their hardships, their tortures, and
> groans
> Is almost enough to draw pity from stones.

Cowper was writing at a time when the abolition movement was under way. Previously, few people stopped to consider that England's addiction to sugar came at a terrible human cost. When the women of England purchased their hard white phallus of sweetness, they probably wouldn't have known that it was once sticky, black, viscous molasses, refined to look and taste palatable, stripping it of its nutrients and vitamins.

Sugar growers had discovered that cane was best grown on relatively flat coastal land where the soil was naturally yellow and fertile, and the temperature mild and sunny. The Caribbean provided the ideal climate and conditions. In the last decades of the eighteenth century, four-fifths of the world's sugar came from the British and French colonies in the West Indies.[7] From Barbados, Jamaica, Martinique, Grenada, Saint Croix, the Leeward Islands, St Domingo, Cuba, Guyana and many others. As Europeans established their sugar empire in the Caribbean, prices fell, especially in Britain.

Sugar cane was produced on plantations, which were large-scale, artificially established terrains. After being harvested, the cane was taken to purpose-built distilleries where it was crushed, boiled and refined, then packed into barrels to be shipped to Europe. This was demanding, backbreaking work, carried out in the harshest of conditions.

Over the decades, the sugar plantations became larger and larger. Wherever sugar could be grown, there was a

need for a labour force – a labour force that was strong and numerous, that was resistant to diseases such as yellow fever and malaria, that could work well in the heat and humidity. African slaves – men, women and children – became the dominant source of plantation workers.

Jamaica was one of the largest and most brutal slave societies of the region, and the most productive of the sugar islands. In 1805, Jamaican sugar production peaked at over 100,000 tons for the year. The island was the jewel in Britain's Caribbean crown. This came at a price.

The death rate for black slaves in Jamaica was higher than the birth rate.[8] The main causes for this were over-work and malnutrition. Field slaves worked from four in the morning to sundown, in blazing heat. The workforce on each plantation was divided into gangs determined by age and fitness. On average, most estates had three main field gangs. The first comprised the strongest and most able men and women; the second those no longer able to serve in the first; and the third older slaves and older children. Some estates had four gangs, depending on the number of children, who started working as young as three or four years of age.[9]

The field slaves were required to cut down the canestalks, which were two inches thick and up to fifteen feet high. The field slaves were supervised by demanding masters, who gave them little medical care and beat them indiscriminately. They were flogged if they failed to work quickly enough. They were flogged if they were discov-

ered sucking the calorific, sweet sap released by the cane when it was cut. No allowances were made for pregnant women or those with tiny babies strapped to their back. Life expectancy for a field slave was seven years.[10]

The cane had to be milled quickly before its sap dried out. It was taken to the crushing mill, where it was hand-fed into huge rollers to squeeze out the dark-brown juice, which then flowed through a trough into the boiling house. It was repeatedly boiled to remove impurities before being poured into cooling tanks. The next stage was to pack the sugar into hogsheads or earthenware cones to dry and crystallise in loaf form. The molasses dripped through a hole at the bottom of the barrel or cone, leaving the sugar purer, and of course paler. The golden sugar would then be packed into hogsheads for exportation. Once in England, it was further refined and whitened by 'claying', a process whereby it was cured in ceramic moulds with clay tops. The moisture seeped through the cones, leaving the muscavado pure white, and shop-ready.[11]

The Caribbean boiling houses were extremely danger-ous for the (usually female) workers in them. The clarifi-cation process involved heating and reheating the sugar at ferocious temperatures, and many slaves were scalded and burnt. Often they worked eighteen-hour days, becoming so tired that as they fed the cane through the huge rollers they could be dragged into them and crushed to death. Overseers kept a machete handy so they could hack off

trapped limbs. As a result many slaves had missing hands or fingers. In Voltaire's *Candide* (1759) a maimed slave explains, 'When we work in the sugar mills and we catch our fingers in the millstone, they cut off our hand; when we try to run away, they cut off a leg; both things have happened to me. It is at this price that you eat sugar in Europe.'[12]

Again we must turn to Mary Prince, whose *History* gives a unique account of plantation life from the perspective of a female slave. As a house slave on a Bermuda plantation, she was frequently abused by her owners. 'To strip me naked – to hang me up by the wrist and lay my flesh open with the cow-skin [whip], was an ordinary punishment for even a slight offence.'[13] Usually the floggings were administered by slave foremen called 'drivers', who were often related to the workers they were called upon to punish. Mary Prince wrote of the particular horror when a driver would 'take down his wife or sister or child, and strip them, and whip them in such a disgraceful manner'.[14]

One of the most extensive and disturbing accounts of plantation life can be found in the journal of Thomas Thistlewood, who as we have seen lived with his black slave Phibbah as his 'wife' for over thirty years. An inveterate diarist and note-keeper, he left over a million words detailing his life in Jamaica from 1750 to 1786. They build a day-to-day picture of plantation life, of what it was like to be a British owner living with his sugar slaves. Thistlewood was educated and well-read, arriving in

Jamaica with the poets Milton, Chaucer and Pope, and the essayist Addison in his luggage, and continuing to build his library during the years in which he lived there. In preparation for his life as an overseer he read a manual by his neighbour, Richard Beckford, about how to manage a sugar plantation. Beckford was the biggest sugar baron in the West Indies, owning more than a thousand slaves. His manual advised that it was best to treat slaves with 'Justice and Benevolence', but he also warned about the need to guard against insurrection. Thistlewood took more heed of the latter than the former advice. He was told by other sugar planters to take a tough line with his slaves, and in his early days he was sent the severed head of a runaway slave to display as a warning to his field gangs.

In just a short time, Thistlewood became acclimatised to the planter's way of life. Showing none of Beckford's proposed 'Justice and Benevolence', he brutalised and tortured his slaves, flogging them for insubordination, rubbing lime juice, pickles, salt and bird pepper into the gashes for added effect. In order to prevent them from sucking the sweet cane juice, he devised a sickening punishment that he called 'Derby's Dose'. 'Had Derby well whipped,' he records in his journal, 'and made Egypt [another of his slaves] shit in his mouth.'[15]

He sexually exploited his female slaves, keeping a detailed account of every encounter in schoolboy Latin. 'Last night *Cum* [with] Dido' was one of his typical diary entries. (This is not our Dido – the name was commonly

given to female slaves.) Thistlewood's journal shows how institutional violence characterised sugar plantations, how slavery brutalised everyone.[16] But there was another side to him, which was developed when he fell in love with Phibbah and became the father of a mixed-race boy. His relationship with Phibbah sheds light on the highly complicated matter of inter-racial pairings.

Thistlewood's sugar plantation was in the south-east of the island. He would probably have known Sir Thomas Hampson, who also owned a plantation in Jamaica. Hampson was Jane Austen's cousin twice-removed,[17] and the shadow story of her novel *Mansfield Park*, in which Sir Thomas Bertram owns a sugar plantation in Antigua, is the slave trade. Many people in Georgian England were connected in some fashion with West Indian plantations.

Indeed, the character of the West Indian planter became a staple in British fiction and drama during the period. One of the most popular comedies on the eighteenth-century stage was Richard Cumberland's *The West-Indian* (1771). Its hero, Belcour, is a wealthy young scapegrace fresh from his sugar estates in Jamaica, 'with rum and sugar enough belonging to him to make all the water in the Thames into punch'. His entourage includes four black slaves, two green monkeys, a pair of grey parrots, a sow and pigs and a mangrove dog.

The fine ladies and gentlemen of England piled into the Theatre Royal Drury Lane to see the exploits of this

kind-hearted fictional sugar baron. They would have laughed at his bewildered account of arriving from Jamaica at a bustling English port crammed with sugar casks and porter butts. Belcour is depicted as a harmless libertine, who chases English girls until he is as thin 'as a sugar cane' – the mild stage image of such a man was a far cry from the reality of Thomas Thistlewood, with his rapes, his floggings and his sadistic punishments.

Georgian high society was a world away from the sugar islands, where all that mattered was efficient production on the plantations, whatever the human cost. As one wit remarked, 'Were beef steaks and apple pies ready dressed to grow on trees, they would be cut down for cane plants.'[18] But in the words of the eminent food historian Elizabeth Abbott, 'So many tears were shed for sugar that by rights it ought to have lost its sweetness.'[19]

Sugar was indubitably the main engine driving the European slave trade. England was not the first country to trade in human flesh, but due to its maritime power it became the dominant transatlantic transporter of enslaved Africans. It has been estimated that British ships transported between three and four million Africans to the Americas. The Caribbean islands became the hub of the British Empire, the most valuable of all its colonies. By the end of the eighteenth century, £4 million-worth of imported sugar came into Britain each year from its West Indian plantations.[20] Britain was growing rich on the white stuff. Its impact was epic and irreversible.

5

'Silver-Tongued Murray'

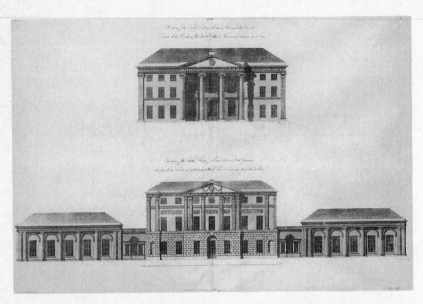

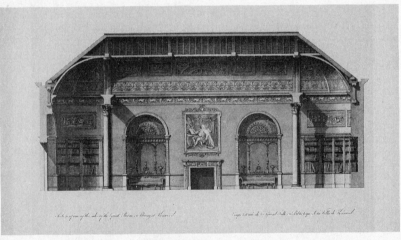

Elevations of the north and south fronts of Kenwood House, and the interior of Lord Mansfield's Library, by Robert and James Adam

William Murray was born on 2 March 1705, at Scone Abbey in Perthshire, Scotland. He was the fourth son of the fifth Viscount of Stormont and his wife Margaret, and one of fourteen children. Though he was born to Scottish nobility, it was an impoverished line, and he was forced to make his way in the world by his intelligence and hard work. He attended Perth Grammar School, where he mixed with boys from different social backgrounds and was taught Latin, English grammar and essay-writing skills. He later said that this gave him a great advantage at university, as those students educated in England had been taught Greek and Latin, but not how to write properly in English. When he was eight his parents moved away, and left him and his younger brother Charles in the care of his headmaster.[1]

In 1715, when William was in his tenth year, the recently formed political union between Scotland and

England was shaken by the first 'Jacobite' rising, otherwise known as the 'Fifteen'. This was an attempt, led from Scotland, to overthrow the newly installed Hanoverian King George I and restore the Stuart monarchical line that had come to an ignominious end with the deposition of King James II in 1688. Perceived to be returning the country to Catholicism, James was deposed and exiled when a group of powerful Protestant aristocrats invited William of Orange to come to England with an army. The Dutch invasion came to be known by Parliament as the 'Glorious Revolution'; among its consequences were a strengthening of Protestantism, Whig supremacy and a limitation of royal powers. The Jacobites took their name from the Latinised form of 'James', and their ambition was to bring back 'the king over the water', James II's eldest son, James Francis Edward Stuart, who became known as 'the Old Pretender'. His son, 'Bonnie Prince Charlie' or 'the Young Pretender', would lead another, more substantial, Jacobite rising thirty years later, in 1745. Both would end in military defeat. Scottish nationalistic resentment over the union and English suspicion of Jacobite tendencies were unavoidable contexts for the lives of families such as the Murrays, which had to make a choice between Scotland and England, Edinburgh and London.

On 15 March 1718, young William Murray set off for London on horseback to take up a place at Westminster School, where he hoped to win a scholarship. He was just thirteen. He stopped at Gretna Green for an overnight

stay, then continued south despite problems with his horse, which fell lame in the first leg of the journey, meaning he had to walk part of the way. The distance from Perth to London by road is over four hundred miles. To have completed this trip was a mark of Murray's tenacity and determination, and a testament to his great energy, which would be remarked upon throughout his life.

He never saw Scotland again.[2] It was apropos Murray, by then Lord Mansfield, that Dr Johnson remarked to James Boswell, 'Much may be made of a Scotchman, if he be caught young.'[3] Not a single letter survives from Murray to his parents, and it seems unlikely that he kept in contact with any of his siblings.[4] For some of his critics, he was distancing himself from unsavoury Jacobite connections. His father openly supported James Stuart, as did several of his siblings, including his brother James, who was secretary of the Old Pretender's court in exile in France.

Murray adored Westminster School, and made lifelong friends while he was there. In order to be made a King's Scholar he had to take part in a strenuous oral test known as 'the Challenge', which lasted for several days. It took place in the presence of the head of the school and the heads of Christ Church, Oxford, and Trinity College, Cambridge – the colleges most closely connected to Westminster. Murray was successful. As one of the special King's Scholars he became part of a group of forty boys who lived together and were given an allowance. The King's Scholars put on a Latin play every year, a tradition

that began in the time of Queen Elizabeth I and continues today. In 1722 William Murray recited the Prologue to Terence's *Eunuchus* (*The Eunuch*). In later life, when he was rich and successful, he gave a dinner on the second night of the play each year. His later remarkable achievements would not have been possible without the connections he made at school, where he was considered 'one of the finest scholars'.[5]

The school stood in the precincts of Westminster Abbey, which served as its chapel, and students were permitted to listen to the debates in the nearby Houses of Parliament whenever they liked.[6] William visited the courts at Westminster Hall to hear the lawyers and the judges, and Westminster would remain at the centre of his life. He was for a time a highly successful Member of Parliament, and as Lord Chief Justice he would preside over the King's Bench in the splendour of Westminster Hall. After being made an Earl, he would become a member of the House of Lords. And in his will he specified that he should be buried at Westminster. The middle passage and Westminster: the two principal characters in our story could hardly have emerged from more different environments.

William Murray was admitted to Christ Church, the largest and grandest of the Oxford colleges, as a commoner in June 1723. The records state that he came from Bath rather than Perth, supposedly because the person recording the names of the new students was unable to

understand Murray's Scottish accent. Though little is known of his Oxford years, at university he would certainly have honed his debating and oratorical skills. He also made a lifelong enemy in William Pitt the elder, whom he vanquished in a university poetry competition.[7]

At Christ Church, Murray read the works of the philosopher John Locke, a former student of the college and another Westminster boy. Despite his own personal involvement in the Royal Africa Company, which traded and gathered slaves on the west coast of Africa, Locke was an opponent of slavery. He began his *First Treatise of Government* (1690) with a powerful denunciation that was to have an impact on Murray in his famous ruling of 1772: 'Slavery is so vile and miserable an Estate of Man, and so directly opposite to the generous Temper and Courage of our Nation; that 'tis hardly to be conceived, that an *Englishman*, much less a *Gentleman*, should plead for't.'[8]

Murray was originally destined for the Church, but his family decided that he would be better suited to a career in the law. However, qualifying for the English Bar was extremely expensive, and it was only possible for Murray through the patronage of Thomas Foley, the father of a schoolfriend, who gave him £200 a year to live on. His most recent biographer, Norman Poser, describes 'his extraordinary ability to cultivate people who could further his career' – the father of another schoolfriend later bequeathed him an estate of five hundred acres in the Midlands, worth around £10,000.[9] The young William

Murray clearly made a great impression, with his intelligence, conversation and appetite for hard graft.

He was called to the Bar on 23 November 1730, taking a set of chambers at 5 King's Bench Walk. He was introduced to the poet Alexander Pope around this time. The poet helped him with his oratory, making him practise gestures and phrases in front of a mirror. He became a father figure to the aspiring lawyer, and dubbed him 'silver-tongued Murray'.[10] Pope compared the young Murray to the Roman poet Ovid, and later celebrated him in one of the less elegant rhyming couplets in his 'Imitations of Horace' (1737): 'Grac'd as thou art with all the power of words/So known, so honour'd, at the House of Lords'.

Pope came from a humble background. His family was Roman Catholic. He suffered from almost constant ill-health. He was derided by his enemies in the literary establishment. And he was only four and a half feet tall. It was a friendship that gave Mansfield a lifelong sympathy for the underdog and the outsider, and they would remain friends until Pope's death in 1744. Pope wrote to Jonathan Swift that he valued the friendship of young people because they were more likely to be honest, and praised Murray as a man 'I would never fear to hold out against all the corruption in the world'.[11]

Murray fell in love with a beautiful young woman called Clara, whom he may have met at Pope's house in Twickenham. But his uncertain prospects outweighed his persuasive tongue, and despite her favourable interest in

him, her parents prevented the match. Pope consoled him with more verses: 'To *number five* direct your doves,/ There spread round Murray all your blooming loves' (number five was the address of Murray's chambers).

Pope's words soon came true, as Murray quickly bounced back from his rejection and married Lady Elizabeth Finch, the daughter of Daniel Finch, seventh Earl of Winchilsea and second Earl of Nottingham, at Raby Castle in Durham in 1738. A portrait of Murray by Jean-Baptiste van Loo painted at this time, probably to celebrate the nuptials, shows a lively and expressive face with bright brown eyes and long auburn hair. The match was seen by some as a politically advantageous piece of self-advancement, but it is clear that theirs was a happy marriage. Murray wrote from Raby Castle: 'I am sure I shall be happy and nothing in my power shall be wanting to make Lady Betty so,'[12] and he was as good as his word for the rest of his life.

At the age of thirty-three when she first met Murray, Lady Betty would have been considered by Georgian standards to be on the shelf. Other wealthy, aristocratic men had expressed a romantic interest in her, but by yoking herself to this ambitious young lawyer, she showed a certain spirit and independence. One of her friends, the society beauty Lady Mary Wortley Montagu, commented that the marriage had caused eyebrows to be raised: 'People are divided in their opinion ... on the prudence of her choice. I am amongst those who think ... she has happily disposed of her person.'[13]

Lady Betty's circle of friends included the famous 'blue-stocking' Mary Delaney, her close friend the Duchess of Portland, Margaret Bentinck, and Henrietta Howard. She clearly felt great pride in her husband's achievements, and supported his ambitions, becoming his chief ally and confidante. The letters that survive show that she also took an interest in politics. In 1757 she wrote: 'The present administration seems in a tottering condition. Shou'd it continue as it now is three months longer, I shall think the time I have employ'd in studying Politicks was all thrown away.' She ended the letter: 'I'm now at the end of paper as well as the end of my Politicks.' Other letters describe a change of government and appointments to Cabinet posts, and rumours of William Pitt combining forces with the Duke of Newcastle – 'half a loaf is better than no bread', she added wryly.[14]

Short in stature but full of energy, Murray set to work raising himself to a status (and a degree of financial prosperity) appropriate to an earl's son-in-law. The Murrays made their first home in Lincoln's Inn Fields, near the Inns of Court. Lady Betty and Murray were very sociable, and held regular Sunday-evening parties, at which they made important contacts. James Boswell was a friend, and left a vivid description of Murray: 'He himself sat with his tye wig, his coat buttoned, his legs pushed much before him, and his heels off the ground, and knocking frequently but not hard against each other, and he talked neatly and with great vivacity.'[15] Boswell, however, also noted that

there was another side to Murray: 'his cold reserve and sharpness were still too much for me. It was like being cut with a very, very cold instrument.'[16]

In the year of his marriage, Murray's career reached a turning point when he was involved in a *cause célèbre*. He was junior counsel for a young man called William Sloper in a lawsuit involving the actor, playwright and poet Theophilus Cibber. Theophilus was the son of the far more famous Colley Cibber. Poet Laureate, manager of the Drury Lane Theatre, a fixture of the social scene at all the spa resorts, still acting in cameo comic parts though he was nearly seventy years old, Colley Cibber was arguably the greatest celebrity of the age. His name was never out of the newspapers and the pamphlet wars. He was a hard act to follow, and poor Theophilus was always in his shadow, and always short of money. For some time he and his wife Susannah Maria (a much-fêted actress and singer) lived in a *ménage à trois* in Kensington with William Sloper. In return for access to Susannah Maria's bed, Sloper paid the rent and the household expenses. But when Theophilus slipped away to France to escape his creditors, Susannah Maria wrote to say that she was leaving him for Sloper. Cibber responded by suing Sloper for 'criminal conversation', or adultery. A country squire of not insubstantial means, Sloper was able to hire a powerful legal team, but it was the junior, William Murray, who made the most memorable summing-up of the defendant's case:

The Plaintiff tells the servants the Defendant is a romp, and a good-natured boy; and he makes a boy of him. He takes his money, lets him maintain his family, resigns his wife to him, and then comes to a Court of Justice and to a Jury of gentlemen for reparation in damages … it would be of the utmost ill-consequence if it should once come to be understood in the world that two artful people, being husband and wife, might lay a snare for the affections of an unwary young gentleman, take a sum of money from him, and when he would part with no more, then come for a second sum to a Court of Justice.

Murray went on to make careful distinction between the moral and the legal issues of the case. He explained that he by no means desired to be regarded as an advocate for the immoral actions of Sloper, 'but this is not a prosecution for the public, or to punish the immorality, this is only a question whether the Defendant has injured the Plaintiff; and certainly the Plaintiff cannot be injured if he has not only consented but has even taken a price'. The scrupulous separation of the enactment of justice according to the law from the larger questions of public morality would later be of great importance in Mansfield's dealings with the slave trade. In conclusion he suggested, with wit and panache, that 'if it should be thought requisite to find a verdict for the Plaintiff, we had not a denomination of coin small enough to be given him in damages'.[17] The judge responded by granting Cibber a paltry £10 in damages.

'Henceforth,' Murray recalled, 'business poured in upon me from all quarters, and from a few hundred pounds a year, I fortunately found myself in receipt of thousands.'[18] Old Colley Cibber was not pleased at his son's humiliation. Long an enemy of Pope – who would immortalise him in *The Dunciad* as the 'King of Dunces' – he responded by parodying the couplet about Murray being graced 'with all the power of words': 'Persuasion tips his tongue whene'er he talks' is followed by the bathos of 'And he has chambers in the King's Bench Walks.'[19]

Four years later Murray was made Solicitor General – deputy to the Attorney General, who was the chief legal adviser to the government and the Crown. He also entered Parliament. He became a bencher (senior member) at Lincoln's Inn, and the government came to rely on him more and more for decisions on litigation, answers to questions on technicalities of both domestic and international law, and the drafting of legislation. In 1753, however, he was involved in an accusation that nearly ended his career. It was a reminder to Murray of the dangers of slander. He was accused by a former school-friend of being a dangerous Jacobite, who as a boy had made a toast to the Old Pretender. Also supposedly involved had been Murray's great friend Andrew Stone, who had gone on to become a tutor to the Prince of Wales. The King dismissed the matter as mere gossip, but it was formally investigated by the Cabinet. Murray gave a moving and powerful denunciation of the charges against

him, emphasising his loyalty to the Crown, and the fact that he had taken an oath of allegiance at Oxford.

In his speech, described by Horace Walpole as 'an incomparable oration', Murray said: 'My great ambition is to go through life with the character of an honest man. I am not afraid of calumny. I had rather be the object than the author of it.'[20] Despite these stout words, the case made him aware of the power of whispers around Court, Parliament and Chambers. Murray was found innocent of any wrongdoing, but the rumours that he was a Jacobite continued to dog him – despite the fact that he had been involved in the prosecution of the leaders of the uprising of 1745. Fear of Jacobite associations was probably one of the reasons he never returned to Scotland. Coming from north of the border, and having been subject to smears and false allegations, had given him an understanding of the position of the outsider and the victim. This made him all the more determined to listen to both points of view, and not to prejudge a case.

Murray's most recent biographer, Norman Poser, provides strong evidence that casts doubt on his supposed rejection of Jacobitism. As a young man, Murray wrote two letters offering his support and loyalty to the Old Pretender, whom he called 'the King'. By doing so, Murray, usually so careful and cautious, had made himself extremely vulnerable. Those letters were a time bomb, and could have put an end to his career if they ever came to

light. Poser attests to an important contradiction in Murray's character: 'his inclination to present a persona to the outside world that was not necessarily consistent with his real thoughts'.[21]

Nevertheless, his name officially cleared, in 1754 he was elevated to the position of Attorney General. He and Lady Betty had moved from Lincoln's Inn Fields to Bloomsbury Square, but now he needed a residence worthy of his new status – somewhere close to Westminster, but sufficiently rural for him to relax and live the life of a country gentleman.

He found the perfect place, on the edge of Hampstead Heath: Kenwood House. It would be Murray's country retreat, a glittering symbol of his success and how far he had come. Bloomsbury Square was convenient enough when Parliament and the law courts were sitting, but Kenwood would be his home. It was a gleaming white villa, sitting high on a hill in 112 acres of lush parklands surrounded by an ancient wood. Across the Heath one could glimpse the dome of St Paul's Cathedral. As a young man, Murray had walked with Pope on Hampstead Heath, and had seen and coveted Kenwood, little imagining that one day it would be his.[22]

In 1756 Murray reached the pinnacle of the legal profession, becoming Lord Chief Justice, which made him the head of the judiciary and President of the Courts of England and Wales. He was created Lord Mansfield,

Baron of Mansfield.* As befitted his newly elevated status, he commissioned the Scottish Adam brothers, the foremost architects of the day, to expand and remodel Kenwood. They added a third storey, and stuccoed the entire façade. An Ionic portico was added to the house's entrance, to make it suitably classical. Entrance hall, staircase and ante-room were all created with supreme elegance. Robert Adam also remodelled the south front rooms, Lord Mansfield's dressing room, the breakfast room, Lady Mansfield's dressing room and the housekeeper's room. In the 1770s he published an account of his work at Kenwood in a series of eight lavish engravings with accompanying texts. He wrote that Mansfield 'gave full scope' to his ideas, and that his brief was to preserve a similitude between the old and the new.[23]

Robert Adam added a neoclassical library, which would also serve as a receiving room, to balance the orangery that was already attached to one side of the house. It would come to be regarded as one of his most splendid interiors. In a letter to Mansfield the Duke of Newcastle said that he longed to see 'your improvements and particularly your great room, which I hear is a very fine and agreeable one'. Kenwood's walls were hung with beautiful and expensive paper, depicting Indian and Chinese figures, while huge mirrors and Venetian paintings lined the walls.[24] It was a house built to impress.

* From this point on, we shall refer to him as Mansfield.

Mansfield purchased neighbouring land, increasing the house's already extensive grounds. He replaced the formal gardens with a more 'landscaped' look, in accordance with the latest fashionable taste. Some of the fishponds were merged to become Wood Pond and the grandly named Thousand Pound Pond, presumably to reflect its exorbitant cost. A mock stone bridge made of wood was also erected. The estate had its own farm and dairy, and an avenue that would be described by the poet Coleridge as 'a grand Cathedral Aisle of giant Lime Trees'.[25]

Mansfield was a great tree-planter, especially favouring beech and oak. He was also fond of exotic plants, which he grew in the orangery. In 1785 he erected a new hothouse, sixty feet long, in which peaches and grapes were grown – prize specimens of those very fruits carried by Dido in the painting that was by then hanging in the big house.[26] The gardener, Mr French, supplied Mansfield with a daily 'nosegay of the finest oder and richest flowers which he took with him to the bench'.[27] This presumably helped him overcome the stench of London, which was another reason for having a second, more rural, home. Despite Kenwood's convenient proximity to Westminster Hall, it was a tranquil and restful haven. 'The whole scene,' wrote Robert Adam, 'is amazingly gay, magnificent, beautiful and picturesque.'[28]

Lady Mansfield wrote to her nephew in May 1757: 'Kenwood is now in great beauty. Your uncle is passion-

ately fond of it. We go thither every Saturday and return on Mondays but I live in hopes we shall soon go hither to fix for the summer.'[29] The one thing that the house lacked was children.

That was soon to change.

6

The Adopted Daughters

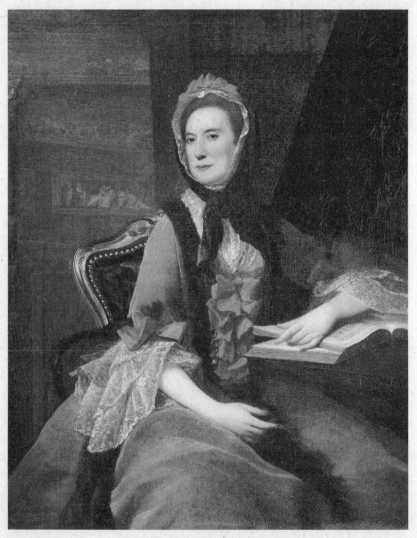

Lady Mansfield, Dido's adoptive mother,
by Sir Joshua Reynolds, 1776

To explain how it was that Dido came to grow up amid the beauties of Kenwood instead of on a slave plantation in the West Indies, we must return to the circumstances of her birth. What options were available to Captain Lindsay when he discovered that Maria was pregnant with his child?

Though colonial law stated that inter-racial liaisons were illegal, the many mixed-raced children were testament to its inefficacy. We know little of the relationship between Captain Lindsay and Dido's mother, but his care and public recognition of their mixed-race baby daughter suggests that he felt at least some sort of emotional connection to his lover. So how unusual was it for a white master to protect his mixed-race child, to recognise that beneath the different skin colour was the same blood?

House or domestic slaves in plantation great houses were often lighter-skinned, or mixed-race, known as

'mulattoes'. They were considered to be superior to field slaves, and were often given better treatment. They worked as housekeepers, cleaners, cooks, seamstresses, nurse-maids, often as wet-nurses to white children. They could be given presents and treats, including cast-off clothes and jewellery. Often their lives were closely entwined with those of their white masters.

Wherever there are males and females living and working in close quarters, there will be sexual relations; particularly so when women are considered as part of a man's property. Some female house slaves slept willingly with their masters; others refused, and were raped and flogged for doing so.

Thomas Thistlewood's journals record instances of rape, including the gang rape of a female domestic slave. He also records Creole (mixed-race) women offering themselves in return for privileges and presents. There was sometimes the hope that a mulatto child would raise their status. A pregnancy could even be a step towards manumission, as planters often wanted to set their own children free. Some house slaves were the progeny of white sugar planters and overseers. It was often glaringly obvious that a light-skinned slave serving at dinner was waiting on his or her own half-siblings, such was their resemblance to their father. Some white mistresses turned a blind eye to their husband's black children. Others beat the children as an outlet for their own frustration and rage. Some masters gave the impression of feeling a

stronger attachment to their mulatto children than to their legitimate progeny.

Thomas Thistlewood and his slave 'wife' Phibbah had a son called 'Mulatto John', who was adored and spoilt by his parents. He was manumitted at the age of two, was educated and entered into an apprenticeship as a young man. Thistlewood's nephew John was propositioned by a slave called Lettice, who wanted to have a 'child for a master'.[1] He agreed to meet her in the sugar distillery, where he was supervising the labour of the slaves. A Barbadian planter called Jacob Hinds left property to his offspring by three of his black slaves, saying in his will: 'I would call them my children but that would not be legal as I never was married!'[2]

Lighter-skinned slave women sometimes rejected black men as sexual partners so that they could secure a white man who might raise their status. A Jamaican planter noted that 'the *brown* females ... seldom marry men of their own colour, but lay themselves out to captivate some white person, who takes them as mistresses, under the appellation of housekeepers.' This was known as 'nutmegging'.[3]

Mulatto women could exercise a degree of power and control over black slaves, whom they regarded as inferior. Mary Prince described in her *History* the ill-treatment she received at the hands of a mulatto slave who was put into a position of responsibility: 'I thought it very hard for a coloured woman to have rule over me because I was a

slave and she was free … the mulatto woman was rejoiced to have power to keep me down.'[4]

White masters in the sugar islands developed a bizarre system of classification to define the 'new race' they had created. A 'mulatto' was the offspring of a white and black pairing; a 'sambo' was the offspring of a mulatto and a black; and a 'quadroon' was the offspring of a mulatto and a white.[5] In Jamaica, the birth register made a careful note of each category of mixed-heritage child.

If Captain Lindsay had left Maria in the West Indies, perhaps setting her up with a domestic position on one of the big plantations, Dido would not have looked anything out of the ordinary. She would have been just another of the many mulatto girls, assumed to be the offspring of a master and a slave. Clearly of great physical beauty, she could well have grown up to become the mistress of a plantation owner. Far from the prying eyes of the mother country, of English moral outrage, the sugar barons were making their own rules. In England, as we will see, it was quite a different matter to be a mixed-race child.

We simply don't know whether Dido Belle was conceived by force, by mutual consensual passion, or as a 'duty' that might bring material benefits to her power-less mother. The only thing we can know for sure is that Captain Lindsay took a bold and unconventional step in arranging for his small daughter to be brought up in England, entrusted to a family member to be raised

as a young lady. Not only that, but the man she was entrusted to was by this time one of the most powerful and famous in the land: Lindsay's uncle, Lord Chief Justice the Earl of Mansfield, master of his domain at Kenwood.

According to the only report that survives, 'Sir John Lindsay, having taken her mother prisoner in a Spanish vessel, brought her to England, where she was delivered of this girl, of which she was then with child.'[6] The lack of detail is tantalising. How accurate is this story? Was Maria pregnant on arrival in England, or was Dido actually born at sea or in the West Indies? Where did Lindsay lodge his pregnant black mistress when she first disembarked onto British soil – and their baby, if she was born by this time? How did he broach with Lord and Lady Mansfield the prospect of their taking a mulatto child into their household? How old was Dido when she was brought to Kenwood? What happened to Maria after that? How long did Lindsay keep her? What happened to her after he married? Did she die in childbirth? Or become a servant somewhere in England? Or return to the West Indies? And what would have been the reaction of innkeepers, lodging-house mistresses, servants, neighbours, people in the street, to the sight of the handsome naval captain making arrangements for his pregnant black slave? Or to a black woman with a young baby? Did a servant or junior officer work on his behalf? Was a midwife present to assist with the delivery of the child?

We do not have answers to any of these questions, though we can get a glimpse of popular attitudes, and perhaps even fantasies, by looking to the London stage, the place where the moral and social questions of the day were played out before a vociferous, hungry public. One of the most famous and successful dramas in late-eighteenth-century England was Samuel Arnold and George Colman's comic opera *Inkle and Yarico* (1787). Inkle is an English slave trader who is shipwrecked in America and rescued by a beautiful black slave, Yarico. She is as dark and as elegant as a 'Wedgwood teapot'. They fall in love, but as soon as he arrives in Barbados, Inkle betrays Yarico and tries to sell her into slavery. It is Inkle who is presented as the barbarian, and condemned for his callous inhumanity. In the end, though, he is reunited with Yarico, who forgives his treachery and fickleness. 'It's amazing how constant a young man is in a ship!' remarks one character, who knows all too well that sailors cast aside their black mistresses when they touch land.

Captain Lindsay may or may not have abandoned Maria, but he didn't abandon his daughter.

The only blemish on the happy marriage of Lord and Lady Mansfield was their inability to have children. Given that Elizabeth Finch was thirty-four – at the time, this would have been considered well past the ideal marriageable age – when she married William Murray, their childlessness could not have been entirely a surprise. We do

not know whether Elizabeth ever miscarried, or whether there was simply a failure to conceive.

The great sculptor John Michael Rysbrack made a bust of Lady Mansfield in 1745. The cold marble gives an air of severity to her demeanour, which is at odds with the lively sense of humour and the great warmth of heart revealed in her surviving letters. But one cannot help feeling that Rysbrack has captured a certain sadness in her. When she sat for Rysbrack she had been married for seven years, and she was still childless. By the time Lord Mansfield's nephew Captain Lindsay had his daughter, Lady Mansfield was in her mid-fifties. She was, perhaps, looking for a surrogate grandchild to stand in for the child she never had. In the event, she and her husband received two girls – though we do not know which of them arrived first.

In eighteenth-century England the question of inheritance was all-consuming among those with titles and land to their name. Lord Mansfield was not the kind of man to contrive to get rid of his wife and find a younger woman to give him an heir. Once it was apparent that he would never have a child of his own, he settled his estate on his nephew David Murray, who upon the death of Mansfield's eldest brother in 1748 became Viscount Stormont and Lord Scone. David, born in 1727, was extremely close to Lord and Lady Mansfield, and they treated him as a son. Like his uncle he attended Westminster and Oxford, after which he travelled abroad. A few letters survive from

Lady Mansfield to her nephew, and they suggest a warm and close relationship. When her husband was made a peer in 1756 she wrote to her nephew, with a nice mixture of pleasure and humility: 'Though I'm now at the fagg end of the Peerage, and by being so, have lost the Pas [manuscript unclear] of many, No one can rejoice more than I do that your Uncle Amidst all the confusions etc is now gott safely into Port or rather If you please into the Haven where I have long Earnestly wish'd him to be.'[7]

David was generous, and liked spending money. In 1757 his aunt wrote to him teasingly, chiding him for his profligacy: 'Money certainly burns in your Pocket to lay it so out as you have lately done in purchasing Dresden China for me were you within reach of hearing (which by the way I am very very sorry you are not) you would not fail having a good scold, but as that unfortunately is not now the case I return you many thanks for that which you must allow me to call an Unnecessary token of remembrance, and which I never shall or can want to put me in mind of l'aimable Mi Lord.'[8]

Lord Stormont's brilliant career can be credited to the influence of his uncle. He recognised that, with his Scottish background and the Jacobite associations of the family, he was unlikely, as he put it, to 'make my way at home.'[9] Accordingly, he prepared himself for a career in diplomacy, assiduously writing a manuscript history of the development of the European state system since the treaty that in 1648 had brought the Thirty Years War to an

end. He was duly rewarded, thanks to Mansfield's influence, with the position of Envoy-Extraordinary to Saxony-Poland, where he was based in Dresden and subsequently in Warsaw. He was then appointed Ambassador to the Habsburg capital of Vienna, a position he held from 1763 to 1772.

In Warsaw in 1759 Lord Stormont married a beautiful young widow, Henrietta Frederica de Berargaard, daughter of a senior Saxon diplomat, Graf Heinrich von Bünau. This was a very unusual match, undoubtedly the result of a grand romantic passion rather than a piece of political or financial manoeuvring. The following year Lady Stormont gave birth to a daughter, Elizabeth (the favoured Murray family female name). Four years later they had another daughter, named Henrietta after her mother, who died in infancy. In 1766 Lady Stormont herself died, aged just twenty-nine, leaving her devoted husband bereft – indeed, he seems to have suffered some sort of nervous breakdown. Still standing in the chapel at Scone Palace today is a neoclassical monument erected in memory of Henrietta. Its Latin inscription describes her virtues, and unabashedly proclaims Lord Stormont's misery at her death.

Elizabeth inherited her mother's fair complexion and beauty, and she must have been a constant reminder to David of the loss of his beloved. She was just six years old at the time of her mother's death, and it was impossible for her father to care for her while engaged in high diplomatic

affairs in Vienna. The half-German girl was accordingly brought to Kenwood to be cared for by her great-uncle and great-aunt.

Lord Stormont, benefiting once more from Mansfield's powerful influence, went on to win the plum job in the diplomatic service, that of Ambassador to France. He held this position from 1772 until 1778, becoming a confidant of Louis XVI and Marie Antoinette. He also remarried. No doubt feeling the absence of a son and heir, his choice fell on the teenage daughter of a fellow Scottish diplomat. The Honourable Louisa Cathcart was thirty years his junior, and she duly provided him with five children, including four boys. When Lord Stormont returned to Britain from France in 1778 he became an active member of the House of Lords, and Lord Justice General for Scotland. The family made their homes in London and at Scone Palace in Perth. Elizabeth did not join her father and her half-siblings, but remained at Kenwood, in the company of Dido.

It is possible that Dido was brought into the Mansfields' home as a companion for Lady Elizabeth Murray. Or perhaps she was the first little girl to fill the place of the much-longed-for child in the Lord Chief Justice's household. The two girls were near-contemporaries, but Elizabeth's mother only died when she was six. That would place her arrival at the Mansfields' home some time in 1766, when Dido would have been four or five. Lindsay's obituary in the *London Chronicle* just over twenty years

later says that Dido was raised by the Mansfields 'almost from her infancy'.[10] It is hard to know how literally to take that 'almost'. There is, furthermore, the intriguing evidence of a baptismal record.

St George's, Bloomsbury, was the last of the exquisitely proportioned London churches to have been designed by Nicholas Hawksmoor, the former assistant of Sir Christopher Wren and master of Georgian neoclassical architecture. Consecrated in 1730, it stands between Little Russell Street and Hart Street, a stone's throw from Bloomsbury Square. This was Lord and Lady Mansfield's parish church when they were at their house in town. In the church's baptismal register for November 1766, signed by the rector, Charles Tarrant, Doctor of Divinity, there is a curious entry. All the other entries on the page record the parents as a married couple and the child's date of birth as being close to that of the baptism. But between Bridgett, daughter of James and Ann Hills, and James, son of James and Lucy Sutton, we find '20th Dido Elizabeth D[aughte]r of Bell and Maria his Wife Aged 5 y[ears]'.[11] It stretches the bounds of credibility to suppose that this could refer to any child other than Dido. 'Dido' was a highly unusual name in England, and she was known in later life as 'Dido Elizabeth Belle'. Bloomsbury was the Mansfields' parish. And the record gives us reason enough to believe that Dido's mother was called Maria.

It was customary in eighteenth-century England to baptise a baby as soon as possible after birth, for fear that

the child would go to Limbo rather than to Heaven in the all-too-common event of an early death. The logical conclusion to be drawn from the fact of Dido's baptism into the Church of England at the age of five must be that no one bothered to baptise her when she was born, because she was illegitimate and the daughter of a slave. Dido Elizabeth must have been baptised a Christian at the behest of Lord and Lady Mansfield. So what would have been the occasion of the event? The baptismal date in the autumn of 1766, eight months after the death of the first Lady Stormont, strongly suggests that this was at the time when little Elizabeth Murray was brought to the Mansfield household by the distraught Lord Stormont. This was surely the moment when it was agreed that the two little girls would be brought up together.

Who, then, was the mysterious 'Bell', the purported father of Dido Elizabeth? The fact that he is listed without a forename suggests that he was absent from the baptism, and it is possible that this was a mere pseudonym, made up in order to avoid naming Sir John Lindsay as the father. Or there might really have been a man named Bell who had some involvement in Dido's upbringing in her first five years – it is possible, though unlikely, that Maria really did marry a man named Bell after Captain Lindsay returned to sea.

Dido may have arrived in the Mansfield household in her infancy, or she may have remained with her mother or a nurse until she was five. It is not impossible that she was

brought as an infant, with the intention that she should have a 'below-stairs' life, but that on the arrival of their other great-niece the Mansfields decided to baptise her and raise her status.

In official documents, she would always be called 'Dido Elizabeth Belle'. The slave registers of the British Caribbean make it graphically clear that slaves had only one name – not their original African name, but a Christian name given to them by their owner. 'Dido' was a particular favourite for female slaves. It was an allusion to the beautiful Queen of Carthage who distracted Aeneas from his mission to found Rome, and who committed suicide when he deserted her – the slave-owners would have been thoroughly drilled in Virgil's *Aeneid* at school. Perhaps Dido was a name that the cultivated Lindsay especially liked; or perhaps Maria had a particular friend called Dido. It could well be that 'Elizabeth' was added, as a proper British Christian name, when she was baptised. If so, it would have been a powerful sign of her adoption into the Mansfield family. Now there were three Elizabeths in the household: Lady Mansfield (born Elizabeth Finch), Miss Elizabeth Murray (daughter of David Murray, Lord Stormont), and Dido Elizabeth. Being illegitimate, she could not be called Dido Elizabeth Lindsay. Though her father's surname is given as 'Bell' in the parish register, it was always subsequently spelled 'Belle'. Since she grew up to be beautiful, it also seems fitting that she should be called Dido Elizabeth Belle.

The two girls were half-cousins by blood, and were now companions in a great household. The double portrait strongly implies that they became firm friends, despite the fact that they were physical opposites: Elizabeth with her flaxen hair, pale skin and blue eyes; Dido with her mischievous dimple, her cappuccino skin, huge liquid brown eyes, straight nose and exquisite bone structure.

Lord Mansfield, it would become clear to visitors, grew to dote on his two adopted daughters. He was always at his most relaxed at Kenwood. The eighteen-year-old Lady Louisa Stormont visited in 1776, the year in which she became the second wife of the heir to the Mansfield title and estate. We have no record of her impression of Dido, or of the teenage girl who was now her stepdaughter despite being only two or three years younger than herself, but she was captivated by Mansfield's charm and charisma, writing in a letter: 'You did not see enough of Lord Mansfield to know how diverting he is, he says with the gravest face the most comical things imaginable.'[12] This is not the image of the great judge that the public was accustomed to, but it chimes well with the opinion of his friends, such as James Boswell and the playwright Richard Cumberland, who remarked upon his 'happy and engaging art ... of putting the company present in good humour with themselves.'[13]

There is every reason to suppose that, like her half-cousin Lady Elizabeth, Dido was brought up to be an

educated and accomplished young woman. This befitted their status as Lord Mansfield's wards. Like other well-to-do girls in the late eighteenth century, they would have learned elocution (by committing passages of poetry and eloquent prose to memory), French, some history and geography. There would have been a strong emphasis on Christian devotion, but they would also have learned to draw, to play a musical instrument and to dance. Horse-riding was considered beneficial to health, and no doubt they would have spent many hours walking in the grounds of Kenwood. Certainly in the case of Elizabeth, there would have been the expectation that she would make a good match when she reached marriageable age, so her accomplishments were a necessary part of her dowry.

Dido's illegitimacy placed her in a more awkward position, though as far as Lord and Lady Mansfield were concerned, she still had Murray blood running through her veins. 'Natural' daughters were a common fact of Georgian life, and there was much less stigma attached to illegitimacy than would be the case in the Victorian era. Novels and plays abounded with beautiful 'natural' daughters estranged from their families.

We know this from Jane Austen's warm and humorous depiction in *Emma* of the illegitimate young Harriet Smith, who is deposited in a boarding school by her father and befriended by the wealthy, well-born Emma Woodhouse. Several of Austen's early works of fiction,

written when she was a young girl, parody the clichéd trope of a 'natural' daughter who sets off in search of her father, and discovers that she is the child of a wealthy aristocrat. In Dido's case, no such measures were necessary. She knew that her father was a Murray, and a highly respected naval officer: in 1770 Captain Lindsay was appointed a Knight of the Bath.

There is no evidence that Lindsay ever returned to see his daughter, but he had ensured that she was raised in the best of hands. One wonders if Dido ever considered the fate of her mother, Maria. Every time she looked in a mirror she would have been reminded of her ancestry. Yet she was a ward of Lord Mansfield, living a life of luxury and privilege.

What was her status in the household? Once again, Jane Austen's fiction can perhaps give us an idea. In *Mansfield Park*, the young Fanny Price is taken from her crowded and chaotic home to be raised in her relatives' elegant country house. Her status is somewhat uncertain. She is a niece of Sir Thomas Bertram, and 'must be considered so', but she is certainly not a 'Miss Bertram', a daughter of the house. She comes to occupy a status above that of a servant, but below that of a fully *bona fide* family member. An unpleasant aunt, Mrs Norris, never hesitates to remind her of her inferiority and her (undeserved) good fortune in being taken into the great house. As it happens, the low-born Fanny Price becomes the most

loved and cherished 'daughter' of Sir Thomas Bertram, and marries his younger son.

In certain respects Fanny's story echoes that of Dido. While Lady Elizabeth was the daughter of the heir to the title, and a legitimate Murray, it is Dido who appears to have captured Lord Mansfield's heart.

7
Black London

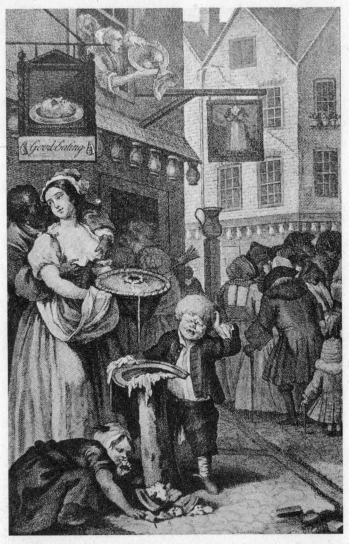

Detail from 'Four Times of the Day: Noon', engraving of a London street scene by William Hogarth, showing, to the left, an amorous black London resident

Baptised in Bloomsbury, Dido Elizabeth Belle was an authentic London immigrant. Contrary to the popular image of London as all-white before the mass immigration of the years after the Second World War, there were about 15,000 black people living in the city in the late eighteenth century.[1] Their traces are visible in portraits, caricatures, literature, newspapers, and on the stage of the London theatres. Moreover, they were creating their own cultural identity, forming musical societies, joining church groups, holding exclusive 'Black Balls', writing their memoirs and forming support groups for runaways. There were stories of noble African princes who had come to England for their education and been betrayed into slavery, and of servants who had escaped their brutal masters and were seeking their freedom. There were all-black brothels, which catered to the nobility.[2] The black community was the subject of news, and was gossiped

about in polite society. Its members were a vital presence in London, and they were not going to go away.

Maria could have ended up in this world, but her daughter Dido would never be a part of London's black community. She was assimilated into upper-class white society, and carefully protected by the Mansfields. But being well educated, she could read newspapers and books, and attend plays. As she travelled back and forth between Bloomsbury and Kenwood House in her uncle's fine carriage, she would have been able to look out of the window and see liveried black servants attending to their masters and mistresses.

Strangers who saw Dido when she was a child would have assumed that she was a servant. Eighteenth-century portraits often included little black page boys or alluring African serving girls. In some quarters a black attendant was viewed as a must-have fashion accessory, like an exotic ostrich feather in one's hair. Ladies of quality adored black servants, especially as their blackness accentuated their own white skin, which was invariably leadened to make them look even whiter. Black children were seen as adorable pets, and dressed in brightly coloured silks and satins with turbans. Little surprise that when they grew older and lost their 'cuteness' they were often sold back into slavery, and sent to work on plantations.[3]

The Duchess of Queensbury – said to be the most beautiful woman in Europe – was devoted to her 'young Othello', a black servant called 'Soubise'. She educated him

to a high standard, pampered him, taught him to ride and to fence, to play the violin. He was taught oration by no less a master than David Garrick, the greatest actor of the age. Spoilt and reckless, Soubise grew up to become a noted dandy, seducing women and running up enormous debts, which were always paid off by the doting Duchess. One of the people she appealed to for help in trying to discipline him was Ignatius Sancho, the best-known black man in London.

Sancho, perhaps like Dido, was born on a slave ship. He became butler to the Duke and Duchess of Montague, and was a well-read, intelligent and articulate man – because of his corpulence he jokingly called himself 'the black Falstaff'. He made his name as a writer and composer, eventually becoming a property-owning householder in Westminster, which entitled him to vote. His *Letters* were published after his death, and bear testament to his education. He was a great favourite of Garrick, and corresponded with Laurence Sterne and other notable writers and intellectuals. Sancho was fiercely opposed to the slave trade: 'the unchristian and most diabolical usage of my brother Negroes – the illegality – the horrid wickedness of the traffic – the cruel carnage and depopulation of the human species'.[4] He gained a degree of acceptance in London society, but was always regarded as a curiosity: when he visited Vauxhall pleasure gardens with his black daughters, he wrote, 'we went by water – had a coach home – were gazed at – followed, &c &c – but not much abused'.[5]

Sancho married a West Indian woman of African descent. A mixed-race marriage across the class divide would have been a breach of propriety that would have cost him his position as a kind of black mascot for white society. When it came to relations between the races, there were strict barriers. A black footman might marry a white maid, for example, but not a cook.[6] In the comic opera *Inkle and Yarico*, the inter-racial love affair between the two main characters is mirrored by that between Inkle's servant Trudge and Yarico's servant Wowski. Though Inkle rejects Yarico because he is ashamed of her, and tries to sell her into slavery, the lower-class Trudge is fiercely loyal to Wowski: 'I won't be shamed out of Wows. That's flat.'

In London life, as on the London stage, marriage between black and white was acceptable so long as it did not cross the class divide. There was a profound cultural fear of black sexual potency: hence the fascination with the figure of Shakespeare's Othello, the Moor who came from North Africa to Venice. At a more mundane level, casual racism abounded. Black people were routinely represented as having voracious sexual appetites: William Hogarth's engraving of a London street scene at noon shows a black man groping the exposed breasts of a serving girl outside a tavern.

The limits of what was possible for even the luckiest and most talented people of colour in late-eighteenth-century European society may be illustrated by the case of

Joseph Boulogne, Le Chevalier de Saint-George, which would have been well known to Lord Stormont during his time as Ambassador to the court at Versailles, when his young daughter Elizabeth was being brought up with Dido. Saint-George was a handsome, elegant, cultivated young man. A superb sportsman, he was regarded as France's finest fencer, a gifted equestrian, and renowned for such exploits as swimming the Seine using only one arm. He was also a musical virtuoso, playing the violin as a child on the French Caribbean island of Guadeloupe. Like Dido, Saint-George was the product of a union between a slave mother and a well-born father. And as with Dido, his father had him brought up as an aristocrat, but did not marry his mother.

He rose to become a composer and conductor, and taught music to Marie Antoinette. He commissioned Joseph Haydn to compose six major pieces, at a time when Haydn was struggling to find work. Louis XVI named him director of the Royal Opera, though he was forced to revoke the appointment after protests from singers who refused to perform under the direction of a 'mulatto'.[7] He became known as '*le Mozart Noir*', writing five operas, twenty-five concertos for violin and orchestra, string quartets, sonatas and songs. He was given equal billing with Mozart when his concerts were advertised.

Women adored Saint-George, and rumours abounded about his close relationship with Marie Antoinette. According to gossip, his pillow was stuffed with the pubic

hair of his numerous lovers. But he never married, as inter-racial marriage was banned in France. After the Revolution his connection to the royal court made it difficult for him to find work, and he died in obscurity in 1799, at the age of fifty-four.

There were far fewer black women than men in England. Servitude or prostitution was their usual fate. Dido was in every way the exception to the rule. Despite the few such as Soubise and Ignatius Sancho who successfully assimilated into English society, the majority of black people living in London were poor, and denied the most fundamental of rights.

One such young black man was Jonathan Strong. Like many Africans living in London, he had been brought to England from a sugar plantation (in Barbados) with his master. In 1765 Strong was beaten half to death by his owner, David Lisle, and thrown onto the streets. He had been pistol-whipped about the head, and was almost blinded. Stumbling to a doctor's surgery in Mincing Lane, he met the doctor's brother, Granville Sharp. This chance encounter would change Sharp's life, being instrumental in making him one of the leading lights of the abolition movement, and thus transforming the lives of thousands of black people in England. It would also bring him face to face with one of the most powerful men in the land: Lord Mansfield.

8

Mansfield the Moderniser

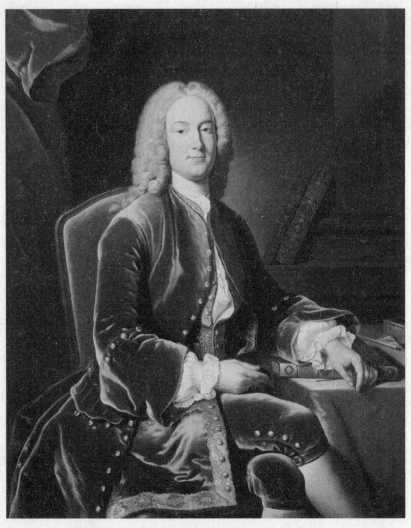

William Murray, later the first Earl of Mansfield, portrait by
Jean-Baptiste van Loo, which in Mansfield's will he asked to be
hung in Dido's room

Lord Mansfield was an innovator. Over his long tenure of thirty-two years as Lord Chief Justice, he modernised both English law and the English court system. His rulings changed English and Commonwealth nations forever, and he was also a strong influence on the laws of the United States of America.[1] His influence cannot be overestimated.

Mansfield's great hero was the ancient Roman lawyer, philosopher and orator Marcus Tullius Cicero. He would, for pleasure, translate Cicero into English and then back into Latin, and he memorised volumes of his works. Cicero had said that 'True law is right reason in agreement with nature; it is of universal application, unchanging and everlasting.' In the full-length portrait of Mansfield that now hangs in the hall of his *alma mater*, Christ Church, Oxford, his hand rests on a copy of Cicero.

The three common law courts (the courts of King's Bench, Common Pleas and Exchequer), as well as the

Court of Chancery, were crowded together in Westminster Hall. A huge, noisy, bustling building, Westminster Hall housed not only the law courts, but also a variety of market stalls selling books, prints, millinery, legal stationery, spectacles, jellies and sweetmeats. The atmosphere was that of a fashionable meeting place, and spectators lined up to witness sensational cases, especially those involving brilliant lawyers. It was a theatre. Outside Westminster Hall, 'men of straw' sold their services as witnesses, sticking a piece of straw in their shoes to identify themselves.

Mansfield's court was the King's Bench, and such was his success and reputation there that the other two courts fell by the wayside. He attracted a vast amount of legal business to the King's Bench, giving him 'a princely income'.[2] His bywords were equity and common sense. Justice could only be achieved when equity leavened the law. He strongly felt that the sclerotic legal system was completely unsuited to Britain's position as 'the greatest manufacturing and commercial country in the world'.[3] He was determined to speed up court procedure, especially in cases where there was very little doubt. Lawyers who had become used to long delays and postponing decisions were surprised to find that they now had to apply to the court, and give good reasons why they wanted a delay.

One of his first acts as Lord Chief Justice was to change the system for submitting 'motions', requests for civil cases to be heard. When the court was in session, all barristers

were invited to submit motions, in order of their seniority. The chances of junior barristers being heard were thus very slim, and all the work went to the seniors, who were overworked and often didn't have time to read their papers in advance.[4] Mansfield changed the system so that barristers were allowed to submit only one motion a day, and that if not all barristers had been heard by the end of the day, they could continue where they left off the next morning. He also changed the rules of 'reserved judgment', which meant that if a court had no doubts over the evidence presented to it, a judgement was to be made immediately, rather than being given at a second hearing, after the judge had had time to consider further in the light of precedent case-law.

He was particularly attentive to law students, reserving a special courtroom for them. Sometimes he would stop proceedings to explain a nice point of law to the students who came to soak up the atmosphere and learn about legal and court procedures. Attending his court was the best education they could have.

Mansfield's other great reform was in mercantile law. His fellow judge and great friend Francis Buller called him the 'founder of English commercial law'.[5] Mansfield's aim was to update outmoded English merchant law to European standards. In Europe, there was a principle that a merchant was bound by his promises, not just his signed legal documents. This principle was based on the assumption of good faith on the part of the merchants,

something completely lacking in English law. In Mansfield's landmark English contract case, *Carter v Boehm*, he established the duty of utmost good faith (*uberrimae fidei*) in insurance contracts. He also equated non-disclosure to fraud. He was an ardent believer in free trade, so much so that when he was Solicitor General he had opposed a proposal to forbid English firms from insuring enemy ships in wartime. The French had traditionally insured their ships with English companies, and Mansfield feared that if they developed their own insurance industry during the war, this would have a detrimental effect on English insurers in peacetime.

Mansfield believed that mercantile disputes ought to turn upon 'natural justices and not upon the niceties of the law', and that commercial contracts must have a liberal interpretation. In a world where the rules had changed, precedent, the bedrock of England's common law system, was not always his priority. 'The law of England,' he said, 'would be a strange science indeed if it was decided upon precedents only.' Mansfield suggested to his friend the actor David Garrick that 'a judge on the bench is now and then in your whimsical situation between Tragedy and Comedy, inclination drawing him one way and a long string of precedents the other'.[6]

He believed in collaboration within the judicial process, and wanted to use the knowledge and experience of experts. He introduced special juries of merchants – known as 'Lord Mansfield's jurymen' – to sit in his

courtroom. They were invited to dine with him in his house in Bloomsbury, and held him in high esteem. In the case of *Barwell v Brooks*, Mansfield said that 'as the usages of society alter, the law must adapt itself to the various situations of mankind'.[7] He was said to be a hundred years ahead of his time. Entire books were written on his decisions, in such areas as *Elements of Insurance Law* (1787), *Marine Insurance* (1787), *Bills of Exchange* (1789) and *Merchant Shipping* (1802).

Another groundbreaking ruling in 1777, known as 'Lord Mansfield's Rule' and still in use today, laid down that a child born into a marriage was a legitimate product of that marriage. In his own words, 'the law of England is clear, that the declarations of a father or mother, cannot be admitted to bastardize the issue born *after* marriage'. This law protected children, making husbands responsible for their wives' offspring even if they believed the child to have a different father.[8]

Mansfield was respected for his ability to cut through procedural red tape. He was impatient with long-winded barristers and courtroom inefficiency. In order to discourage waffle, he would take out his newspaper and start reading. He is sometimes depicted as a rather humourless man, but nothing could be further from the truth. One of his trials involved an elderly woman accused of witchcraft. He ruled that she should be allowed to return home, and 'if she did so by flying, no law prevented that'. On another occasion, a man had been accused of stealing a

ladle. The case was thought to be particularly serious, because he was a lawyer. 'Come, come, don't exaggerate matters,' said Mansfield. 'If the fellow had been an attorney you may depend upon it, he would have stolen the *bowl* as well as the *ladle*.'[9]

Mansfield was famous not only for the wit of his judgements, but also for his prodigious memory. He memorised volumes of Cicero's works, and seldom wrote things down or spoke from notes. He inspired hero-worship, even amongst men who were politically opposed to him, such as the philosopher Jeremy Bentham and the lawyer and politician John Dunning. The latter told the painter Sir Joshua Reynolds that as a student he always went to hear Murray speak: 'This was as great a treat to me, Sir Joshua, as a sight of the finest painting by Titian or Raffael would be to you! Sometimes when we were leaving the court, we would hear the cry, "Murray is up" and forthwith we rushed back, as if to a play, or other entertainment.'[10]

James Boswell would attend court whenever he could, just to hear Mansfield, writing that he was 'charmed with the precision of his ideas, the clearness of his arrangement, the eloquent choice and fluency of his language, and the distinct forcible and melodious expression of his voice'.[11] In a wonderful analogy, Boswell described Mansfield's unique ability to cut to the quick in a tricky and complicated dispute: 'The cause was like a great piece of veal or other meat. The Court of Session could not find the joint. It was handed about through the fifteen [judges],

and they tried at it but it would not do. Lord Mansfield found the joint at once and cut with greatest ease, cleanly and cleverly.'[12]

Another brilliantly resolved case involved a beautiful and talented teenaged singer, Ann Catley, who was apprenticed to a music teacher who then 'sold' her to a rakish young baronet, who kept her as his mistress, and took the profits of her public engagements. Mansfield cut through the allegations and counter-allegations, ignored the whispers of scandal, and dealt out appropriate fines.

Nothing, it seems, could faze Lord Mansfield. Not even *Hayes v. Jacques*, the *cause célèbre* of 1777. The case involved the famous Chevalier d'Eon de Beaumont, who, though highly competent in all manly skills, had been dressed as a girl during his childhood. He retained a taste for female clothes throughout his life, even collecting a scrapbook of material on the subject of hermaphroditism. When his appearance in female dress at a masquerade ball in Paris was noticed by the Prince de Conti and King Louis XV, they decided to hire him as a spy to engage in secret diplomacy while disguised as a woman. In 1756 he was sent to Russia in the guise of 'Mademoiselle Lia de Beaumont', and became a confidant to the Empress Elizabeth. He resumed male costume a year later, and was awarded by King Louis for services rendered, and made a captain of dragoons. He continued working for the secret service, and as a member of the French Embassy in London from 1763 was involved in many political

intrigues. From this period, numerous rumours spread to the effect that the Chevalier d'Eon really was a woman. In 1775 Louis XVI granted him a large state pension in return for the recovery of some state papers, on condition that d'Eon henceforth dress in the garments of the female sex.[13] This transaction prompted a fever of speculation. In the eighteenth century, people would gamble on anything. So it was that on 2 July 1777, the following report appeared in the *Morning Chronicle*:

> Yesterday came on to be tried in the Court of King's Bench, before Lord Mansfield and a special jury at Guildhall, an extraordinary cause, wherein Hayes was Plaintiff, and Jaques Defendant. The Plaintiff had paid the Defendant *one hundred guineas*, for which the Defendant had signed a policy of insurance to pay the Plaintiff *seven hundred guineas* whenever he could prove that the Chevalier D'Eon was a female. Mr Buller opened for the Plaintiff, and concluded he should prove *he* was a woman, which occasioned a good laugh. Mr Wallace opened at large, and though he said he could not go so far as his friend required, he should prove that the person called the Chevalier D'Eon is a woman.

After lengthy legal wrangling and the cross-examination of various witnesses, including a French medical man who had supposedly examined the Chevalier's body but unfortunately could not speak any English,

Lord Mansfield, with his usual delicacy of precision, expressed his abhorrence of the whole transaction, and the more so, their bringing it into a Court of Justice, when it might have been better settled elsewhere, wishing it had been in his power, in concurrency with the Jury, to have made both parties lose; but as the law has not expressly prohibited it, and the wager was laid, the question before them was, *Who had won?* His Lordship observed, that the indecency of the proceeding arose more from the unnecessary questions asked, than from the case itself; that the witnesses had declared they perfectly knew the Chevalier D'Eon to be a woman; if she is not a woman, they are certainly perjured; there was, therefore, no need of enquiring how and by what methods they knew it, which was all the indecency.

He then told an anecdote about a wager for £100 entered into by two gentlemen in his own presence, regarding the dimensions of the celebrated statue the Venus de' Medici. His 'facetious, pointed' manner of telling the story 'set the whole Court, which was very full, in one universal fit of hearty laughter and good humour, beyond all that the indelicate part of the trial had done'. He then found for the Plaintiff.

The Chevalier d'Eon spent the rest of his life in England, conducting public fencing matches dressed in women's clothing. When he died in 1810 it was discovered that, though his body had certain female attributes, it also had

the all-important male one. So, strictly speaking, Mansfield had got it wrong, but in very delicate circumstances he had managed to deliver a skilled judgement that enhanced respect for both himself and the legal process. We can imagine a very jolly evening back home in Bloomsbury when he regaled the household with the story of his day. Deciding on a wager involving a transvestite must have been light relief from the complex insurance cases to which he devoted so much of his time on the King's Bench – let alone the great question of the legal status of slaves in England.

9

Enter Granville Sharp

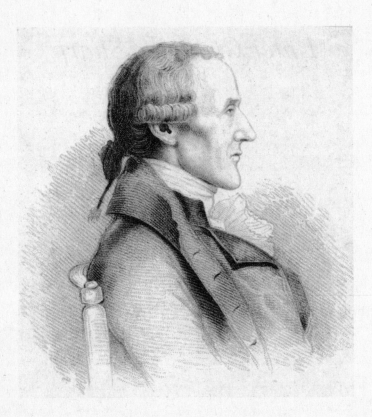

Granville Sharp, drawn by George Dance

On the face of it they were as different as two men could be. Lord Mansfield was by now one of the most famous men in the land. Wealthy, titled and powerful, equally known for his verbal brilliance and his fair-mindedness. Perceived as the founding father of modern commercial law, so vital to the new world of international trade and its necessary underpinning, insurance. But a man who would never let his personal associations get in the way of his professional life, as was seen from his prosecution of Jacobite leaders who were family friends.

Granville Sharp, by contrast, was a humble civil servant, a clerk in the Ordnance Office in the Tower of London. He came from a clergy background. He was the youngest of fourteen children, had little formal education and was largely self-taught, studying Greek and Hebrew out of a passion for the Bible and the classics. He was a very accomplished musician, playing a variety of instruments

and possessing a strong bass voice. The whole Sharp family was musical, and would become famous for their concerts on a barge on the Thames. Granville – or 'Greeny' to his family – often signed his name with the musical notation G#.

Sharp was to become one of Britain's leading abolitionists. He was also to become a thorn in the side of Lord Mansfield. But they will forever be united in history as the men who freed British slaves.

On the fateful day when Jonathan Strong was beaten up by his master, Greeny had been visiting his brother William's surgery in Mincing Lane. The location was at the heart of London's financial district, and the home to many slave traders. Coming out of his brother's surgery, Sharp was astounded to find the young black man in a pitiful state. The Sharp brothers tended to him, found him a bed in hospital and secured him a job after his recovery. There the story might have ended. But two years later, in 1767, Jonathan Strong, recovered from his ordeal, was spotted by his former owner, David Lisle. He seized him, had him thrown into prison and set about selling him to a sugar planter. Strong appealed to numerous people for help, and in desperation sent a message to Granville Sharp.

At the heart of Strong's appeal was his firm conviction that he was no longer a slave. There was a strong belief among the black communities in England that freedom was automatically conferred once you set foot on English

soil. Others also believed that Christian baptism could manumit them. Many slaves escaped, and it was the work of slave-catchers to roam the streets in pursuit of them. Rewards were posted, and if the runaways were caught they would be resold and sent back to the sugar islands, or to Charleston in South Carolina, where the new cotton and tobacco plantations of the American South were creating huge demand for slave labour.

Jonathan Strong's friends, to whom he appealed for help, were frightened off by Lisle, who was a lawyer. But Granville Sharp was made of sterner stuff, and would not be bullied or deterred. He took immediate action, and arranged a hearing that took place in September. Strong was released. Lisle started an action against Sharp and another of his brothers, claiming £200 for depriving him of his property.

When Sharp consulted his lawyer, he was told that the case would probably go against him because of the Yorke–Talbot ruling of 1729, which had 'opined' that a slave's status did not change when he came to England, that a slave could be compelled to return to the colonies from England, and that baptism would not manumit a slave.[1] Many slave-owners invoked Yorke–Talbot, though, as Sharp insisted, it was an 'opinion' and not a 'ruling': only a formal ruling could stand as a legal precedent.

Sharp was also told that Lord Mansfield had upheld this opinion on more than one occasion. But he refused to accept that 'the law of England was really so injurious to

natural rights as so many great lawyers for political reasons had been pleased to assert'.[2] With his love of learning and his strong sense of social injustice, Sharp immersed himself in English law to determine whether slavery was illegal in England. His legal advisers confirmed that as the law stood, it favoured a master's rights to his slaves as property, that a slave remained the chattel of his master even on English soil, and could be removed at will.

Once again, Granville Sharp was not to be deterred. He set about finding any possible ambiguity or chink in the armour of the law in order to prove that slavery was illegal on English soil. He was determined to force a definitive legal ruling on whether slaves could be compelled to leave the country. He discovered that as far back as 1569 there had been a legal judgement which stated that 'England was too pure an air for slaves to breathe in.'[3] This was later to become the motto of the abolition movement. He also cited the 1706 opinion of Lord Chief Justice Holt that 'as soon as a Negro comes into England, he becomes free.'[4]

There was a more recent case, in 1763, which, oddly, Sharp overlooked. An ex-slave, Harvey, had appeared as the defendant in *Shanley v Harvey*. He had been brought to England as a child, and his owner, Shanley, had given him to his niece, who had him baptised and changed his name. On her death she left Harvey a sum of money, which Shanley tried to recover. Lord Henley, the Lord Chancellor, dismissed the action, with costs against

Shanley. In his judgement he held that as soon as a person set foot on English soil, he or she became free, and that a 'negro' might maintain an action against his or her master for ill usage, together with an application for *Habeas Corpus* if detained. A writ of *Habeas Corpus* ('may you have the body') requires a person under arrest to be brought before a judge or into court.

Deep in his legal studies, Sharp was encouraged by William Blackstone's definitive *Commentaries on the Laws of England*. Blackstone, the Vinerian Professor of English Law at Oxford, stated that the 'spirit of liberty is so deeply implanted in our constitution, and rooted even in our very soil, that a slave or a negro, the moment he lands in England, falls under the protection of the laws, and with regard to all natural rights becomes *eo instanti* ["at that moment"] a freeman'.[5] After the first, highly successful, edition of his *Commentaries* was published in 1765, Blackstone refined his views on slavery. In the third edition (1768–69), the end of the final sentence was revised (after 'laws') to: 'and so far becomes a freeman; though the master's right to his service may probably still continue'.[6]

Having read only the first edition, Granville Sharp wrote to Blackstone, expecting his support. But Blackstone backtracked in his reply, carefully insisting that he had not challenged the legitimacy of a master's right of ownership. He warned Sharp that he faced 'uphill work in the King's Bench'.[7]

Sharp knew very well that Blackstone was a friend of Lord Mansfield. They had mutual friends, James Boswell and David Garrick among others. Sharp may also have known that Mansfield had adopted a little black girl, the daughter of a slave and Mansfield's nephew, whom he was bringing up as his own child. Others in London who were connected with the question of slavery certainly knew this. On the other hand, he also knew that Mansfield was a friend to British merchants, and would be wary of alienating the sugar interest.

To his disappointment, Sharp soon realised that Lord Mansfield was reluctant to make a clear legal decision regarding the issue of slavery in Great Britain.[8] The two men now became regularly involved in legal disputes, with Sharp accusing Mansfield of putting commercial interests above those of black freedom.[9] But he may have held out hope that an emotive appeal regarding the inhumane treatment of black people would catch at Mansfield's Achilles' heel – as we will see, gossip was circulating around London that the Lord Chief Justice was in thrall to the black girl who lived with his family.

In 1769 Sharp published *A Representation of the Injustice and Dangerous Tendency of Tolerating Slavery or even Admitting the Least Claim of Private Property in the Persons of Men of England*, the first tract in England attacking slavery. In it he argued that the forcible removal of slaves was a contravention of the 1679 *Habeas Corpus* Act, and that the Yorke–Talbot 'opinion' was trumped by

that of Lord Chief Justice Holt. The most important principle, however, was that under the common law of England, there could be no property in persons, and that all persons (irrespective of colour) were subject to the protection of the King's laws. As for slave-owners, 'they usurp an absolute authority over their *fellow men*, as if they thought them mere *things*, horses, dogs etc'.[10] For Sharp, 'the plea of *private property* ... comparing a man to a beast is ... unnatural and unjust'. This was about the '*humanity*' of the negro. Sharp was stepping it up.

While the Jonathan Strong case was pending, Sharp became involved in another case, that of John Hylas, whose wife had been captured and sold into West Indian slavery. The verdict was in favour of Hylas, and Mary's owner was ordered to return her. Sharp hoped that this case might settle the issue of the legality of slavery in England, but it was not to be. The judge presiding, Lord Wilmot, did not address the matter.

Another case looked more promising, that of *R* [*Rex*, i.e. the Crown] *v Stapylton*. In 1771 Sharp was visited by a Mrs Banks, who hurried to see him after a man called Thomas Lewis was seized by two men on behalf of his former master, Robert Stapylton, and dragged on board a ship. The intention was to transport him and sell him to a Jamaican planter. Sharp and Mrs Banks obtained a writ of *Habeas Corpus* demanding Lewis's return. Time was of the essence, as the ship had already set sail, and was heading for the Downs, off the coast of Kent.

Just in time, a servant of Mrs Banks delivered the writ to the ship, where Thomas Lewis was chained to the mainmast. He was set free. Sharp and Mrs Banks initiated a criminal prosecution against Stapylton and the two men who had helped to kidnap Lewis. The defendants claimed that Lewis belonged to Stapylton, who could therefore do what he wished with him. The case went to trial at the Court of King's Bench, with Lord Mansfield presiding. Mrs Banks bore the expense.

The question that the case hinged upon was whether Lewis had ever been free. He himself insisted that he was a free man, and had never been a slave, but a servant of Stapylton's, and had always received wages. Mrs Banks's lawyer, John Dunning, repeatedly tried to air the question as to whether there could be such a thing as property in persons, but Mansfield kept bringing the case back to whether Lewis could be proved to be free or not.

There was a serious concern that Mansfield might disqualify Lewis as a witness because he was a slave: 'You don't prove his being free by himself,' Mansfield interjected at one point. The *Habeas Corpus* writ extended to 'any person or persons', and the worry was that a black might be seen not as a 'person', but as the 'property' of his owner. If so, that would be the end of the case.

The turning point came when Mansfield suddenly and unexpectedly invoked the ancient principle of English liberty, directing the jury: 'I shall presume him free unless they prove the contrary.'[11] He then went even further,

saying that unless the jury found that Stapylton was the legal owner of Lewis, 'you will find the Defendant [Stapylton] guilty'. The jury cried out, 'Guilty, Guilty!', finding that Lewis could not be transported against his will, as they had no evidence to prove that he had ever been bought. Mansfield turned to the jurors and said, 'I think you have done very right to find him not the property, for he was not the property, and you have done right.'

However, in the course of his summing-up, Lord Mansfield had been careful to say that 'whether they [slave-owners] have this kind of property or not in England has never been solemnly determined'. In other words, the case must stay specific, and must not address the wider question of the ownership of slaves in Britain – though that of course was precisely the issue that Sharp wanted to force open. Mansfield's summing-up showed more than a hint of exasperation:

> Lord Hardwick and Lord Talbot [two other senior judges] had several discussions concerning the rights of property in Negroes ... I don't know what the consequences may be if they were to lose their property by accidentally bringing them into England ... it is much better it should never be finally discussed or settled ... for I would have all masters think [their slaves] free and all Negroes think they were slaves because then they would both behave better.[12]

As Lewis moved to leave the building, Dunning made one last request of Mansfield: that Lewis should be protected. Mansfield ordered, 'If anybody dares to touch the boy as he is going out of the Hall especially now as the jury have found the boy not the property of the defendant, tell the officer to take them into custody and bring them before me.'[13]

Conventionally, four days elapsed between verdict and sentence. During that time, Mansfield appeared somewhat troubled. He confessed that 'Ever since that trial I have had a great doubt in my mind, whether the negro could prove his own freedom by his own evidence.' He also believed that Lewis had been led 'into the evidence improperly', and began to doubt whether a 'slave may be a witness to prove himself free'.

When Stapylton did not even turn up for sentencing, the case began to look like a fiasco. Because Mansfield doubted that Lewis could prove his own freedom, he fell back on a break in the chain of ownership to prove that Lewis was not Stapylton's slave. Furthermore, Mansfield was backing off from sentencing Stapylton for attempted kidnapping. No action was taken regarding his contempt of court in not appearing for sentencing. None of the men who kidnapped Lewis was sentenced. By leaving the case in this sense unresolved, Mansfield appeared to be hedging his bets. It seems that he had become alarmed that this case would set a precedent, and was worried about the financial implications for slave-owners if all black people

in England were set free. It was the old question of the rights of property against those of liberty.

Granville Sharp was furious that Lewis had been presented as the criminal and not the victim, that Mansfield had admitted during the trial that he had indeed issued writs of *Habeas Corpus* to return slaves to their masters, and that the kidnappers had not been sentenced. The way Sharp saw it, while Mansfield was happy to let Lewis go free, he was unwilling to punish the kidnappers. This to him was not a useful compromise, but rank hypocrisy. In his own record he wrote: 'He seems to think the bare mention of *a Doubt in his mind* a sufficient excuse, without assigning any, at the least, probable Grounds to justify *an Arrest of Judgment*.' Sharp was not to be deterred. He continued: 'I am the more solicitous to protest against this precedent because I had the mortification to hear the *same judge* upon *the same trial quote some precedents of his own making which are equally contradictory to the Spirit and meaning of the English Laws*.'[14]

During the trial a highly dramatic incident had taken place when Lewis's lawyer, Dunning, unwittingly made a comment that provoked the deep-rooted racism of a witness. Dunning remarked that 'all this would have happened if he had been your son', leading the witness to shout out in rage: 'My son a Negro! What! A Negro my son!'[15] The idea that the witness could have a black son was clearly anathema to him, yet this distasteful scene took place in the presence of a judge who indeed was

adoptive father to 'a Negro'. Scenes such as this must have made Mansfield even more aware of the discrepancy between his personal and his public lives. One way or another, he surely knew, after *R v Stapylton*, that things were coming to a head. He could not evade the issue forever. And perhaps he didn't want to.

10
The Somerset Ruling

Of this Case only a Statement of the Facts, and Mr. Hargrave's learned Argument were inserted in the former edition of this Work. I have here added the other Arguments, and the Judgment of the Court, from Lofft's Reports, in which is a Note of the Case under the name of Sommersett against Stewart.

ON the 3d of December 1771, affidavits were made by Thomas Walklin, Elizabeth Cade, and John Marlow, that James Sommersett, a negro, was confined in irons on board a ship

called the Ann and Mary, John Knowles commander, lying in the Thames, and bound for Jamaica; and lord Mansfield, on an application supported by these affidavits, allowed a writ of Habeas Corpus, directed to Mr. Knowles, and requiring him to return the body of Sommersett before his lordship, with the cause of detainer.

Mr. Knowles on the 9th of December produced the body of Sommersett before lord Mansfield, and returned for cause of detainer, that Sommersett was the negro slave of Charles Steuart, esq. who had delivered Sommersett

* The very important matters which this case involved, viz. first, The rights over the person of a negro resident here, claimed by another person as the owner of the negro; and, supposing such rights to exist, secondly, The extent of them; and thirdly, The means of inforcing them, were, I believe, never, except in this case, made the subject of a suit at law in England. But in Scotland two cases of this sort have occurred before the Court of Session; 1, That of Sheddan against Sheddan, A. D. 1756; 2, That of Knight against Wedderburn. A. D. 1775—1778.

" Joseph Knight, a Negro, against John Wedderburn.—January 15, 1778.

" The commander of a vessel, in the African trade, having imported a cargo of negroes into Jamaica, sold Joseph Knight, one of them, as a slave, to Mr. Wedderburn. Knight was then a boy, seemingly about twelve or thirteen years of age.

" Some time after, Mr. Wedderburn came over to Scotland, and brought this negro along with him, as a personal servant.

" The negro continued to serve him for seve-

Report of the Somerset case

Granville Sharp was ready for battle. He wanted to compel Lord Mansfield to stop dithering and make a definitive judgement on the great question. He was lucky in the timing.

The very day that Mansfield finally finished with the Lewis case, in which he refused to sentence Stapylton, a petition for *Habeas Corpus* arrived in court. It was on behalf of an African slave called James Somerset who had been brought to England by his master, Charles Stewart. Somerset had run away, but had been recaptured by Stewart and sold to John Knowles, the captain of the slave ship *Ann and Mary*, which was ready to sail for the West Indies. He could immediately have ruled that Somerset was a piece of property and not a person, and was therefore not entitled to a writ of *Habeas Corpus*. But he did not.[1] Instead, he signed the order for Captain Knowles to produce Somerset at Chambers. Perhaps, exasperated by

the unsatisfactory outcome of *R v Stapylton*, he was ready to resolve the issue once and for all.

A woman called Elizabeth Cade now became a key player in the case. She had been a witness to Somerset's capture, and it was she who had secured the writ of *Habeas Corpus*. She knew Somerset, and had offered to be his godmother at his baptism in February of that year. Her behaviour throughout was heroic. She paid for Somerset's bail, and he called on Granville Sharp and persuaded him to become involved. It was the case Sharp had been waiting for. This time he was determined to force Mansfield's hand.

Initially, Mansfield once again attempted to duck the main issue by seeking to persuade Elizabeth Cade to buy Somerset's freedom. She refused, on the grounds that to do so would 'be an acknowledgement that the plaintiff had a right to assault and imprison a poor innocent man in this Kingdom and she would never be guilty of setting so bad an example'.[2] He also tried to persuade Charles Stewart, Somerset's former owner, to set him free. It seems that both sides wanted the case to be heard, and the law to be made clear. Stewart upped the stakes by serving a 'return to the writ', claiming that by running away Somerset had robbed him and Captain Knowles.

Sharp was livid. He retained senior counsel for Somerset at his own personal expense, at a cost of six guineas. The principal was William Davy, an advocate so

brilliant that he had gained the status of serjeant-at-law*
only ten years after being called to the Bar. He was
renowned for his quirky humour and quick repartee, and
numerous stories about him circulated around the legal
profession. Once, when Lord Mansfield interrupted him
in argument, saying, 'If this be law I must burn all my
books, I see,' Davy had instantly replied, 'Your lordship
had better read them first.' On another occasion, when
Mansfield proposed to sit on Good Friday, Davy is said to
have reminded him that he would be the first judge to do
so since Pontius Pilate.[3] A young barrister called Francis
Hargrave offered his services for free, as did four further
lawyers, including one James Mansfield (no relation). It
was a formidable team.

Public opinion in support of slaves was growing. The
case dominated the news in the first half of 1772, with the
press reporting on the speeches made in court and
publishing letters and articles on the issue of slavery.
Granville Sharp, believing (rightly) that his presence in
court only served to rile Lord Mansfield, stayed away, but
worked at a furious pace behind the scenes. He published
an appendix to his *Representation of the Injustice and
Dangerous Tendency of Tolerating Slavery* which drew on

* An ancient rank of distinction within the legal profession –
though it had been declining in importance since the introduction
of the even more prestigious status of Queen's Counsel in the reign
of Elizabeth I – which provided the exclusive right to argue before
the Court of Common Pleas.

the cases he had brought previously, and implicitly criticised Lord Mansfield. In a bold move, he sent Somerset in person to deliver a copy to Mansfield.[4] One wonders what the young Dido Belle would have made of it, if she had found and read it.

In the tract Sharp wrote: 'if the present Negroes are once permitted to be retained as Slaves in England, their posterity … the mixed people or Mulattoes, produced by the unavoidable intercourse with their white neighbours, will be also subject to the like bondage with their unhappy parents'.[5] Was this extraordinary passage deliberately aimed at Mansfield, written in the knowledge that he was bringing up the mulatto Dido as his adopted daughter?

On the other side of the fence, the West Indian planters rallied around Stewart, determined that this should be a test case which would confirm that 'negro slaves' were chattel goods, and that Somerset was a slave according to the laws of both Africa and Virginia (they liked to invoke the precedents of their fellow slave-owners on the American mainland).

Mansfield initially postponed the hearing. The arguments dragged on for months. Finally, in May, the *Gazetter and New Daily Advertiser* announced that 'Last Saturday came on in the King's Bench, before Lord Mansfield, and the rest of the Judges of the Court, the much talked cause of Somersett, the black, against Stewart, Esq, his master.'

Davy pulled no punches in making it clear what the case was really all about. He recalled the case of the

Russian slave in Queen Elizabeth I's time, when 'it was resolved that England was too pure an air for Slaves to breathe in'. He added mischievously, 'I hope, my Lord, the Air does not blow worse since.'

James Mansfield put on a theatrical performance, adopting the persona of Somerset: 'It is true. I was a slave, kept as a slave in Africa. I was first put in chains on board a British ship and carried from Africa to America ... I am now in a country where laws of liberty are known and regarded and can you tell me a reason why I am not to be protected by those laws, but to be carried away again to be sold?'[6]

But the man who stole the show was the baby-faced young barrister Francis Hargrave, who achieved overnight fame after delivering a forceful, brilliant presentation. He asked the question 'not whether slavery is lawful in the colonies ... but whether in England? Not whether it ever has existed in England, but whether it be not now abolished?'[7] Beating the patriotic drum, he argued that allowing foreign laws (whether Virginian, Turkish, Polish or Russian) to govern English laws was untenable: 'it is contrary to the genius of the English law to allow any enforcement of agreements or contracts by any other compulsion than that of our courts of justice'.[8]

The issue, once again, was the conflicting rulings on slavery between Holt's 1706 judgement, which was unequivocally anti-slavery, and the 1729 'Joint Opinion' of Yorke and Talbot, which was generally felt to have

greater weight. Lord Mansfield threw a small hand grenade into the proceedings when he made his first public statement on the Joint Opinion: 'the case alluded to was upon a petition in Lincoln's Inn Hall, after dinner, therefore, might not ... be taken with much accuracy'. Here he was effectively agreeing with Sharp, who had argued that the Joint Opinion was an 'opinion', not a considered judgement made in court. This was hugely significant.

The retaliation from the merchants was to emphasise the financial losses that would ensue if more than 14,000 British slaves were set free. Stewart's lawyers argued that freeing slaves would have catastrophic effects, as slaves would try to escape to England. If one side was to invoke patriotic traditions of English liberty and claims about not heeding foreign laws, the other would tap into British prejudice about the nation being overrun by blacks.

At last it was left to the four judges to reach their conclusions. Usually they would come to a quick and unanimous decision, but not this time. 'The matter will require some deliberation,' said Lord Mansfield. Capel Lofft, the reporter of decisions, wrote that Mansfield said that 'the prime, nay the only question properly before us, is whether the colony slave-laws be binding here, or if there be established usage or positive law in this country'. Once again, Mansfield was ruminating anxiously on the consequences of his ruling: if it went wholly in favour of Somerset, and as a result every slave in Britain was freed,

he judged the loss to the proprietors as being more than £70,000.[9] He mused about how the law would stand in respect to such financial settlements as would follow.

The press urged Mansfield to come to a decision, no matter 'how disagreeable the consequences'. 'Should judgement be given in favour of the master, it would be establishing by law a species of slavery, hitherto unknown in England, and abhorrent to the free constitution of this country', said the *London Evening Post*. On the other hand, if the case 'be determined in favour of the Negro … it might be very detrimental to our plantations abroad and our sugar trade'.[10] Other newspapers goaded Mansfield for his procrastination, describing him as a 'timid soul'. In an open letter, an anonymous writer called him a 'Mean-spirited; pitiable old Man! callous to every generous sentiment – dead to every feeling but the base passions of Avarice, fear or lust'.[11]

'A lover of humanity', meanwhile, published a letter to the *Post* making an emotional plea to Mansfield's humanity (and vanity): 'Are not all born *equal* by the laws of nature? … why then should a shade in complexion, which is the accident of climate, alter [nature] to establish a rule? Is it consistent with either the laws of Christianity, civilization, or even common humanity, to encourage … the purchase of human beings in an open market like oxen?' The writer challenged this 'important' judge to 'speak freedom to millions in despite of a few narrow political inconveniences'.[12]

And what of the sugar planters and slave merchants who had always believed Mansfield to be sympathetic to their concerns? Whispers abounded on the plantations and in the polite drawing rooms of London that the decision would be affected by the judge's relationship with his black niece, Dido Belle.

When Lord Mansfield entered Westminster Hall at eleven o'clock on the morning of Monday, 22 June 1772 the chamber was crowded, and not just with the great and the good of London: there was a group of dignified black faces waiting tensely to hear the judgement. Mansfield knew exactly what was at stake. Despite his concerns about the consequences of his ruling, Mansfield was aware that a clear statement of the law was essential. Neither emotion nor economics could influence him: 'Compassion will not, on the one hand, nor inconvenience on the other, be to decide; but the law … *Fiat justitia, ruat coelum*' (Let justice be done, though the heavens fall).

And then? Unfortunately, we don't know exactly what he said. There are several versions of Mansfield's final judgement, some of which have their own spin, such as Granville Sharp's triumphant account.[13] The *Morning Chronicle* reported the next morning that his speech was as 'guarded, cautious, and concise, as it could possibly be drawn up'.[14] But there is no evidence that there ever was a written or prepared speech. No text has ever come to light. There are, indeed, at least seven versions of this

historic ruling, all based on memory of what Mansfield said in court.

Several accounts record that he used the word 'odious' to describe the state of slavery: 'it's so odious, that nothing can be suffered to support it, but positive law', or '[Slavery] is so odious that it must be construed strictly.'[15] Perhaps the most reliable version is that of court reporter Capel Lofft:

> The state of slavery is of such a nature that it is incapable of being introduced on any reasons, moral or political, but only positive [written] law ... it is so odious that nothing can be suffered to support it but positive law. Whatever inconveniences, therefore, may follow from a decision, I cannot say this case is allowed or approved by the law of England, and therefore the black must be discharged.[16]

Later critics have argued that the ruling was partial and limited, but there is no doubt that in the courtroom at that moment the victor was James Somerset. Mansfield had done the unthinkable. Somerset was a free man.

Whatever the precise wording, there is no question that this was one of the most significant rulings in English legal history. Granville Sharp and his followers were ecstatic, and certainly viewed it as a victory. But Benjamin Franklin, who was in court that day, was scathing about 'the hypocrisy of this country, which encourages such a

detestable commerce by laws for promoting the Guinea trade; while it piqued itself on its virtue, love of liberty, and the equity of its courts, in setting free a single negro'.[17]

The newspapers recorded a poignant aftermath. In the pregnant silence that followed Mansfield's words, the 'Negroes in Court … bowed with profound respect to the judges and shaking each other by the hand, congratulated themselves upon their recovery of the rights of human nature and their happy lot that permitted them to breathe the free air of England'.[18]

The wider black community was triumphant, and a ball was held for two hundred at a public house to celebrate the victor. A toast was made to Lord Mansfield.

Meanwhile, the sugar planters were furious. One Jamaican planter predicted that hordes of slaves would immediately make their way to England, copulate with lower-class women, and 'mongrelise' the English so that they would eventually look dark-skinned like the Portuguese.[19]

The press reported that Mansfield had outlawed slavery in England. The *Morning Chronicle* spoke of how slaves could now 'breathe the free air of England'. This would become an essential part of the rhetoric of the abolition movement. William Cowper, in his widely read 1785 poem *The Task*, invoked the image:

We have no slaves at home – then why abroad?
And they themselves, once ferried o'er the wave
That parts us, are emancipate and loosed.
Slaves cannot breathe in England; if their lungs
Receive our air, that moment they are free,
They touch our country and their shackles fall.
That's noble, and bespeaks a nation proud
And jealous of the blessing.[20]

Though Lord Mansfield did not actually use the phrase 'breathe the free air' in his judgement, it was generally felt that the principle had been adhered to. The great abolitionist Thomas Clarkson would later write:

The great and glorious result of the trial was, that as soon as ever any slave set his foot upon English territory, he became free … the names of the counsellors Davy, Glynn, Hargrave, Mansfield, and Alleyne, ought always to be remembered with gratitude by the friends of this great cause.[21]

The Somerset ruling was truly the beginning of the end of a terrible era. Just a month before the case came to court, a black woman, named Bell or Belinda, had been deported from Scotland to Antigua to be sold as a slave as punishment for murdering her baby. She would be the last person to be legally sold back to slavery from the British Isles, though stories abounded (and made their way to Granville

Sharp) of slaves still being sold in England many years after the Somerset case.

But the tide of public opinion had changed. A great moral question had been resolved. On English soil, no man was a slave. Mansfield, whether he liked it or not, was perceived as the man who had made slavery illegal in England. It was the first step towards emancipation.

Was Mansfield's ruling affected by his relationship with Dido Belle? She was only a child at the time, though a much-loved child. In his darkest moments he may have contemplated the genuine possibility that she could be abducted in London and sold into West Indian slavery. The owners and merchants, who were furious with him, certainly gossiped that his ruling was affected by his love for Dido. When the impending judgement was being discussed, the owner of one estate in Jamaica remarked that Mansfield would rule against them: 'No doubt [Somerset] will be set free, for Lord Mansfield keeps a Black in his house which governs him and the whole family.'[22]

This gossip about Dido and the Mansfield family's affection for her is of great significance. The anonymous Jamaican planter and his kind feared – and history would prove their fears well-grounded – that this was the beginning of the end. After confirmation that there could be no such thing as slavery in England, the next step would be the abolition of the slave trade, and ultimately of slavery itself. They could see the argument about freedom on

English soil and in English air being extended to English ships, and even British colonial territories.

The muttering in London about Mansfield's decision being swayed by his relationship with Dido makes his ruling all the more extraordinary, given how determined he always was to separate the personal from the professional, and to refuse to allow his own prejudices and connections to influence his legal judgements. He had shown this when prosecuting the leaders of the Jacobite rebellion of 1745, a 'painful task' in the light of his family connections, but one that he had performed without favouritism or leniency, doing his duty 'with firmness and moderation'.[23] Equally, he had experienced the anguish of a slur on his reputation in the business of the alleged toast to the Old Pretender. There would have been many advantages for him in siding with the planters. Nobody could then have said that he was under the influence of little Dido. Mansfield dined with British merchants in his London home (which may be how the Jamaican planter got to hear about Dido's presence in his household), and we have seen that he included them in his courtroom to advise in many commercial cases, and that he was regarded as being hugely favourable to their economic interests. Yet he did not flinch from coming to the judgement that the gossip-mongers said he would. In doing so he was perceived to have chosen the cause of his own black niece over that of the merchants and planters who had made the nation rich.

Little wonder that, some years later, Mansfield endeavoured to minimise the impact of his ruling: 'Nothing more was determined, than that there was no right in the master forcibly to take the slave and carry him abroad.'[24] He remained deeply concerned about the public misinterpretation of his ruling. But by then it was too late. Both sides, the slaves and the planters, thought he had made slavery in England illegal.

A Bristol merchant, John Riddel, wrote to Charles Stewart telling him that he had lost one of his slaves as a result of the ruling: 'he had rec[eive]d a letter from his uncle Sommerset acquainting him that Lord Mansfield had given them their freedom & he was determined to leave me as soon as I had returned from London which he did without even speaking to me'.[25]

Granville Sharp had stayed away from the Somerset trial for fear of antagonising Mansfield. He wrote in his diary that Somerset came to tell him the great news that 'judgment was today given in his favour'. Sharp noted: 'Thus ended G. Sharp's long contest with Lord Mansfield, on the 22nd June, 1772.' This was not to be.

11
The Merchant of Liverpool

'Am I not a man and a brother': anti-slavery pendant
designed by Josiah Wedgwood, now at Kenwood House

Throughout this large-built Town every Brick
is cemented to its fellow Brick by the blood
and sweat of Negroes.

William Bagshaw, 1787

The cold wind whipped across the River Mersey as young
Billy Gregson set off to work as a rope-maker in the town of
Liverpool. It may not have been the most glamorous of jobs,
but it paid a wage, and rope-makers were very much in
demand in a city of shipbuilders. Ships of all sizes lined the
Mersey, most of them exporting coal, salt, lead, iron and
textiles to Ireland, others carrying vast quantities of cheese
to London.[1] Billy walked past the Custom House,
Blackburne's saltworks and the glasshouses to reach the
ropewalk. Ropewalks were harsh sweatshops, and frequently
caught fire, as hemp dust forms an explosive mixture. It was

153

back-breaking, dangerous work, but Billy had plans. One day he would own his own ropewalk, and be his own master.

Billy Gregson came from humble origins. His father John was a porter, but Billy would rise to become Mayor of Liverpool, and a wealthy merchant and banker. His sons would carry on his legacy. He loved Liverpool, and he never left. It was a place where you could escape your past and recreate yourself. Liverpool, with its mercantile, cosmopolitan edge, looked firmly to the future.

From its humble origins as a small fishing village, Liverpool had become a large, elegant Georgian town with fine streets and houses, looking out on the River Mersey. It was a booming, lively place, with grand shops, pleasure gardens and parks. It boasted sea baths and a tree-lined 'Ladies' Walk'. The Theatre Royal was one of the finest outside London. There were libraries, numerous coffee houses and drinking clubs. One visitor described it as 'London in miniature'.[2] A local guide called it the 'first town in the kingdom in point of size and commercial importance, the metropolis excepted'.[3]

Perhaps the most impressive building in town was the new Liverpool Exchange, designed by John Wood, now Liverpool Town Hall. By the 1750s, Liverpool's trade had burgeoned to such an extent that a new town hall was decided upon, both to accommodate the needs of its merchants and as a demonstration of their prosperity. It

was to be the heart of the city, town hall, exchange and assembly rooms combined.[4]

The Exchange was a huge stone rectangular building constructed around a central courtyard surrounded by Doric colonnades. Most of the building was destroyed by a fire in 1795, and today it is surmounted by a large dome. The interior was multi-purpose, with commercial business on the ground floor, while the higher storeys housed the mayor's office, courtrooms, council chambers and two elegant ballrooms and drawing rooms. A carved frieze on the exterior illustrates Liverpool's trading routes and includes lions, crocodiles, elephants. But in the centre of the frieze is a chilling reminder of Liverpool's guilty past. There, set in stone, alongside the exotic animals, are African faces. Liverpool's Georgian renaissance, its wealth, architecture and culture, was mostly built on slaves.

By the mid-eighteenth century the city had made itself the capital of the slave industry, overtaking rival ports London and Bristol to become the most successful slaving port in the Atlantic world, dispatching more than a hundred ships to Africa annually. It is now estimated that in total almost 1.4 million captives were taken from Africa on Liverpool slave ships, with more than 200,000 of them dying during the voyage into slavery.[5]

The world's first commercial wet dock was built in Liverpool in 1715.[6] The trade in slaves and ships brought huge economic prosperity to the area, with workers

engaged in occupations such as rope-making, shipbuilding, carpentry, ironwork, sailmaking and painting. There was ample work, too, for clerks and runners in the offices of insurance agents, brokers and customs officials. It was a city where men such as Billy Gregson could rise to the top. By the time he was forty he was one of the foremost merchants of Liverpool. He would make his vast fortune in the slave trade, and would be a major figure in one of the most notorious stories surrounding the trade in human flesh.

Liverpool was ideally situated for exporting manufactured goods to be bartered for slaves in Africa: it had excellent transport connections, principally through rivers like the Mersey and Weaver, and through the growing canal network to Manchester, Lancashire and beyond to Yorkshire, and south to the growing industrial Midlands. Textiles came from Lancashire and Yorkshire, copper and brass goods from Warrington, north Cheshire and Staffordshire, guns and ammunition from Birmingham. Metal handcuffs, leg irons, chains and manila hemp were exported to be used on slave ships and in sugar plantations.

Liverpool began custom-building slave ships around 1750. They were expensive, and it was not unusual for slaving voyages to be funded by syndicates of 'part-owners' who invested a portion of the necessary capital to buy and/or fit out a ship, in return for a percentage of the

profits from the return cargo. Venture syndicates like these also ensured that the cost of failure was shared.

The slave trade relied heavily on credit, and its risks meant a growth in maritime insurance, focused at Lloyds of London. Regional banking emerged at precisely this time, with Liverpool slave-trading merchants forming Heywoods Bank, which later became part of Barclays. By the time Billy Gregson became Mayor of Liverpool in 1762, he owned his own ropewalk and was an insurance broker involved in two firms.[7] By 1779 these two insurance partnerships had dissolved. Gregson moved into banking, and had his own bank by 1790. His four sons followed him into the business, while his only daughter married into another Liverpool merchant family.

Tragedy struck the family in 1781, when Billy's eldest son, also named William, died on passage to Lisbon, where he was going to recover his health.[8] That very same year, via a syndicate, Gregson bought a slave ship called the *Zorg*.

12
A Riot in Bloomsbury

The Gordon Riots, 1780

On Friday, 2 June 1780 a young aristocrat glanced into his looking-glass and made the final adjustments to his hat, pinning a silk blue cockade to its brim. He then set off for St George's Fields, where he found a crowd beginning to gather. Its members wore the same blue rosettes, and carried large blue flags with the words 'No Popery' emblazoned on them. They cheered when they saw their leader. He was Lord George Gordon, a radical politician and head of the London Protestant Association, and in his hand was a petition for the repeal of the Catholic Relief Act of 1778, which had removed some of the restrictions on Catholics, and which many saw as dangerous. The crowd, by now between 40,000 and 60,000 strong, marched on the Houses of Parliament. As they went, their numbers swelled. They attempted to force their way into the House of Commons, but without success.

There followed an orgy of plunder and arson in London. Ignatius Sancho, one of London's most famous Africans, had his own shop, selling sugar, tobacco and tea, at 19 Charles Street, Westminster, just a few hundred yards from the Houses of Parliament. He was shutting up at five o'clock on the evening of 6 June when the 'lunatic' Gordon and the mob rushed past his shop with a clatter of swords and shrieks of 'No popery!' Sancho commented on 'the worse than Negro barbarity of the populace'.[1]

The rioters sacked and burned religious buildings. They stormed Newgate Prison and released its inmates. Then they turned to private houses and individuals. High on their list was Lord Mansfield. And they wanted him dead. They took a rope to hang him with.

Mansfield was known for his religious toleration, once stating, 'My desire to disturb no man for conscience's sake is pretty well known.'[2] He was thought to have been influenced by his surrogate father, the poet Alexander Pope. Pope's parents were converts to Roman Catholicism, and Pope saw himself as a Catholic humanist. There was a common perception that Mansfield favoured Dissenters and Roman Catholics, and some accused him of being not only a Jacobite but a Papist. At the time of the Catholic Relief Act there had been numerous caricatures associating him with Papist sympathisers. The rioters had made him one of their chief targets, and they intended to show no mercy.

In the early hours of Tuesday, 6 June, a mob marched to Mansfield's townhouse in Bloomsbury. They smashed the windows, broke down the door and stormed through the house, flinging his elegant furniture into the street, where they made a bonfire and set it alight. While the crowd outside chanted 'Huzza', the intruders hurled out manuscripts, notebooks, papers and deeds from Mansfield's precious law library. They ransacked the library shelves, flinging thousands of volumes into the flames. The fine pictures that hung on his walls were grabbed and torched. As a final act of insult, they hurled his wig and court robes into the fire, again shouting 'No Popery!'[3] They looted Mansfield's fine wine cellar, distributing the bottles to the populace. Some of the looters made off with Lady Mansfield's brand-new set of china. Others took silver and tried to sell it to the nearest pawnbrokers.

Lady Mansfield and her adopted daughter Elizabeth escaped through the back door. Newspapers failed to mention Dido's presence in the house – as so often, she was airbrushed out of history. But there is no reason to doubt her presence, given her role as companion to young Elizabeth. The young women must have been utterly terrified, and have dreaded what might happen to their adoptive father: Mansfield refused to be cowed, and resolved to stay put.

His loyal manservant Dowse knew better. He could see how angry the crowd had become. They were carrying blazing torches, stopping every carriage in the street,

smashing their windows and insisting that those within declare their allegiance with an oath of 'No Popery'. Dowse insisted that his Lordship leave without delay, and begged him to disguise himself in an old greatcoat. In his hurry, Mansfield forgot to change his wig, and was immediately recognised. 'There goes that old rogue Mansfield,' the mob cried, and ran to spread the word. Mansfield remained cool, waited for his opportunity and managed to escape 'without being thrown into the flames'.

Furious that Mansfield had escaped, the rioters set off for Kenwood to torch his house, but the militia was waiting for them, and 'received them so fiercely that they desisted'. The man who had sent the troops in was none other than Elizabeth Murray's father, Lord Stormont.[4] He had returned from his ambassadorial posting in Paris by this time, and was now a government minister. At the height of the riots he wrote to King George III with a report from the front line, explaining that his uncle's townhouse had been ransacked and his own London home was threatened. Furthermore, 'Knowing that Kenwood is threatened with the same Destruction I have wrote to Lord Amherst for a Detachment of Light Horse to be sent there to guard the Avenues.'[5] He clearly knew not only that the house that would one day be his, but also his own daughter and her cousin, were in dire danger. Fortunately, though, there was some local loyalty to the Mansfields in Hampstead. The proprietors of the Spaniards

Inn, close to Kenwood, kept the mob supplied with ale until the dragoons arrived to protect the house.

It was generally agreed that Lord Chief Justice Mansfield had been one of the prime targets of the rage of the mob, and that in destroying the papers and manuscripts of the great judge, 'the whole work and labour of his life',[6] they had created an irreparable loss. If there ever was a written speech for Somerset's case, it would have gone up in flames that night.

The army was called in to quell the riots, by the end of which around five hundred people were estimated to have died. Thirty of the rioters were executed, and Lord George Gordon was clapped into the Tower and tried for high treason. Thanks to a strong defence by his cousin Lord Erskine, he was acquitted on the grounds that he had had no treasonable intent. Remarkably, Lord Mansfield presided over the trial, and steered the jury to consider that the circumstances were favourable to Gordon, instructing them that if there was any doubt he should be set free. Mansfield waived his right to indemnity for his losses – which were reported to have exceeded £30,000. He explained that, 'Besides what is irreparable, my pecuniary loss is great. I apprehended no danger and therefore took no precaution. But, how great soever that loss may be, I think it does not become me to claim or expect reparation from the state.'[7]

Once again, Mansfield had shown his ability to separate the personal from the political, the private from the

public. In a debate on the King's Speech at the opening of the next Parliament, he joked, 'I have not consulted books; indeed I have not books to consult!'[8]

Despite his apparent unconcern, the loss of his library was a heavy blow. His only consolation was the safety of his beloved wife and adopted daughters.[9]

Ignatius Sancho, who knew how much his race owed to the Somerset ruling, wrote with relief that Mansfield's 'sweet box at Caen Wood escaped almost miraculously' from the ravages of the mob.[10]

13

A Visitor from Boston

'Caen Wood in Middlesex, Seat of Earl of Mansfield', engraving by James
Heath, after a drawing of 1786 by Richard Corbould

He knows he has been reproached for
showing fondness for her

Thomas Hutchinson

Kenwood was now Dido's permanent home. Lady
Mansfield was considered 'one of the most domestic
females in the Kingdom'. Newspapers reported the pleasure she took in her gardens and her farm, and that she
always rose at six o'clock to spend time in the purpose-built dairy before breakfast.[1] Dido would nearly always be
there with her.[2]

In the immediate aftermath of the Gordon Riots, and
Lord Mansfield's brush with death, Lady Mansfield's health
became precarious. She suffered a long and serious illness
in the winter of 1781–82. With intimations of mortality,
Mansfield made out his own will, dated 17 April 1782.

He made sure that Dido was well provided for, specifying that she should come into an annuity 'after the decease of my dear Wife'. The clear intention was that Dido would remain as a companion for whichever of the Mansfields outlived the other, and then be rewarded with enough money to keep herself comfortably for the rest of her days. Over the years he added codicils to the will, increasing her inheritance. The original will of 1782 also specifically requests that his wife's intimate friend the Dowager Duchess of Portland should bequeath Dido his portrait by van Loo, to 'hang in her room, to put her in mind of one she knew from her infancy, and always honoured with uninterrupted confidence and friendship'.[3] The phrasing here is astonishing: for a Lord to have stated in his will that *he* honoured a young black woman with his 'uninterrupted confidence and friendship' would have been remarkable enough, but for Mansfield to say that Dido *honoured him* with her confidence and friendship gives an intimation of the deep affection and respect in which he held her.

Equally importantly, in this document of 1782 he made a striking and sobering statement: 'I confirm to Dido Elizabeth Belle her freedom.' This of course was an acknowledgement of the fact that as the daughter of a slave, she was herself technically a slave. But it was also an admission that his famous judgement in Somerset's case a decade earlier might not necessarily be universally applicable. The statement shows that he was still troubled not

only about the force and interpretation of the judgement, but also about the possible tension between his pronouncements on the bench and his affections at home.

Mansfield threw himself into more improvements for the house. He may have lost his library in Bloomsbury, but his Adam library or 'Great Room' at Kenwood was one of the best in the land. The house was now considered to be the 'finest country residence in the suburbs of London'.[4] Perched on the edge of Hampstead Heath, Kenwood was a very visible house, and it drew many admirers to view its Adam architecture and landscaped gardens. Mansfield's fame as Lord Chief Justice also attracted sightseers hoping for a glimpse of the great man. Jeremy Bentham, who kept a picture of Mansfield 'as a great treasure', once wrote that 'at the head of the Gods of my idolaltry had sitten the Lord Chief Justice', and recalled that he 'frequently went to Caen Wood, as a lover to the shrine of his mistress, in the hope that chance might throw him in his way'.[5] Perhaps some visitors also hoped for a peek at Kenwood's most intriguing inhabitant, Dido Belle.

Having lost so many of his paintings in the riots, Mansfield set about commissioning more to hang at Kenwood. An artist called Richard Corbould provided him with classical landscapes, one including a temple and another a lark. Corbould also drew some sketches of the house and grounds. One of them shows gardeners at work in the foreground, the landscaped lake with a small boat

moored at its edge, and the house in the background, with its elegant orangery to one side and the library to the other. An engraving of it, executed by the prolific James Heath, was published in May 1793 by Harrison and Co. of Paternoster Row in London, and appeared in various magazines. Right in the middle of the print, three people are standing on the lawn, two men and a woman. The man to the left bears a ceremonial sword. These are clearly 'above stairs' figures, contrasting with the labouring gardeners in the foreground. The woman in the centre appears to be wearing a white turban and white Indian-style pantaloons, seemingly with a gauze-like dress above them. Her face is represented by black shading, in contrast to the white of her dress and head-dress. Examining the figure under a magnifying glass, one is led irresistibly to the conclusion that this could well be a representation of Dido.

The habit of visiting other people's houses had become well established by this time. Then as now, people visited stately homes when they were on holiday, as may be seen from Jane Austen's *Pride and Prejudice*, when Mr Darcy's housekeeper proudly shows Elizabeth Bennet and her uncle and aunt around his home, Pemberley.[6] In 1792 the novelist Fanny Burney visited Kenwood to see the house and pictures. She was shown around by the knowledgeable housekeeper, and was especially interested in the pictures, especially a self-portrait by Pope, which for a time was feared to have been burned in the Gordon Riots.[7]

From the entrance hall, visitors would proceed to the ante-chamber, where – tired, perhaps, from the climb up the hill – they could glimpse the magnificent view across the park and lake towards the London skyline, and even ships passing up and down the River Thames.[8] They would then go through to the magnificent Adam library, or 'Great Room', which had been built as a receiving room for company. A central marble fireplace was flanked by symmetrical curved recesses, with elegant sofas for visitors. Handsomely carved bookshelves lined the room, above which was an elaborate frieze of lions and deer. One of the best features was a superb ceiling, with stucco work by Joseph Rose. The ceiling panels were painted in softly tinted pinks and greens by the Venetian painter Antonio Zucchi, who also executed the ceiling paintings. Fanny Burney spent 'a good deal of time in the library', where she admired 'first editions of almost all of Queen Anne's classics, and lists of subscribers to Pope's *Iliad*'.[9]

An inventory of Kenwood that was taken in 1831 reveals the full vastness of the house and its treasures. There were over eighty rooms, including a music room, a schoolroom, a nursery, the Japan room, the clock room, the Long Gallery, as well as numerous bedrooms – the white room, the red room, the blue room, the pink room, the Chintz room, the French bedroom. The house was stuffed with antiques, Turkish rugs, mahogany furniture, oil paintings, Sèvres china.[10]

The Kenwood inventory also reminds us of the vast

machinery of service that was needed to run a large household. There was a kitchen, scullery, pantry, larder, brewhouse, bakehouse, still room, steward's room; there were maids' rooms, footmen's rooms, under-butler's room, servants' hall, valet's room, second coachman's room, head groom's room, kitchen maids' bedrooms, housekeeper's room, servants' side room, young ladies' maids' rooms. Kenwood was a community of people living and working together, and Dido, who seems to have moved with ease between upstairs and downstairs, a very special figure at its centre.

As magnificent as the interiors were, Kenwood's greatest beauty lay in its location and grounds. It was in the early 1780s that Lord Mansfield commissioned the portrait of his two wards: the girls he loved in the grounds of Kenwood House, the place he loved. It is a glorious testament to his paternal affection and to the friendship between the girls and the life they had formed at Kenwood.

Lord and Lady Mansfield were good and generous hosts, and received numerous visitors over the years. Some time before the Gordon Riots, Thomas Hutchinson, an American loyalist living in exile in London, had dined with them at Kenwood. He had been Governor of Massachusetts, and was Acting Governor in Boston in 1773 when a group of colonists, protesting against British taxation, boarded three East India Company ships and dumped their entire cargo of tea into Boston harbour – the famous event later known as the Boston Tea Party.[11]

Hutchinson, who had unsuccessfully insisted that the duty be paid and the tea landed, was one of the most reviled men in America as a result of his loyalty to the Crown, considered a traitor by many American colonists. He would never return to Boston, and died in London in 1780.

Hutchinson kept an extremely full diary. We therefore have a unique record of a dinner party at Kenwood. It took place in August 1779. The Mansfields had invited another guest, Lord Manners. Hutchinson was impressed and charmed by Lord and Lady Mansfield. Lord Mansfield 'at 74 or 5 has all the vivacity of 50'.[12] Of Lady Mansfield he wrote that, although elderly, she 'has the powers of her mind still firm'. He noted with approval her dignified and elegant appearance, and her simplicity of dress, unlike that of another aristocrat, Lady Say and Sele ('of the same age I saw at court with her head as high dressed as the young Duchesses etc. what a caricature she looked like!'). In comparison, he noted how 'pleasing because natural' was Lady Mansfield's appearance.

Hutchinson was a frightful snob, obsessed with personal appearances and the latest fashions in hair and dress. He was astonished when, after dinner, the eighteen- or nineteen-year-old Dido came into the drawing room to take coffee with the guests. He noticed every move that she made, from the moment she walked in, sat down with the ladies and took up her cup and saucer. After coffee, the ladies left the company to walk in the gardens. To

Hutchinson's evident horror, one of the young ladies, almost certainly Lady Elizabeth, walked arm in arm with Dido. His discomfort is evident from every line he writes about the black girl's presence.

One of the most striking things about this journal entry is Hutchinson's disclosure that he already knew of Dido's place in the household, and of her story: 'I knew her history before, but My Lord mentioned it again.' It is clear from this remark that her presence in the Mansfield family was an open secret. Yet she seems to have been kept out of the newspapers, other than one brief but flattering reference after her father, Sir John Lindsay, died in 1788.

Dido was not invited to dinner with the company, though this does not prove that she was normally excluded from family meals. It may well have been that the family were keen to protect her from stares and questions – or worse, the contempt of people who might look down on her for her colour and illegitimacy. The fact that Hutchinson knew the gossip about her 'history' shows that she was an object of fascination in London society. Nevertheless, the fact that she joined the company for coffee suggests that Lord and Lady Mansfield were not ashamed of her, and wanted to show visitors that she was part of the family. No mere servant would ever have been seen drinking coffee anywhere near their masters.

It is clear from Hutchinson's tone that he took an instant dislike to Dido: 'A Black came in after dinner … She had a very high cap and her wool was much frizzled in her

neck, but not enough to answer the large curls now in fashion. She is neither handsome nor genteel – pert enough.' The fact is, Dido *was* handsome and genteel, and that left the American visitor thoroughly discomposed. 'Pert' is a most suggestive word: Hutchinson means 'impertinent' or cheeky, acting and especially speaking in a way unbecoming to her lowly station ('Pamela, don't be pert to his Honour,' says Mrs Jervis to the uppity servant girl in Samuel Richardson's hugely influential novel[13]).

Apart from the obvious and crude racial slurs, Hutchinson's comments are extremely interesting. His reflections are not just on Dido's physical appearance (we know from the double portrait of her and Elizabeth that she was extremely beautiful), but on her vivid and strong personality. This was the age of politeness, when young ladies were expected to be meek and timid, and to observe propriety. To sit quietly and wait to be spoken to. The picture that emerges of this unique young woman is of someone who is simply not prepared to be intimidated ('pert'), who is confident enough to wear the latest fashions (her 'very high cap'), who is lively and bubbly ('not genteel'), and who is comfortable in the drawing room sipping a cup of coffee (sweetened with sugar) and on equal terms with her adoptive family (walking arm in arm with her aristocratic cousin). Her energy fizzes from the page, despite Hutchinson's intention to damn her.

When he toured the gardens after dinner with Lord Mansfield and Dido, Hutchinson noticed the particular

closeness between them. Mansfield proudly recounted her responsibilities: 'She is a sort of Superintendant over the dairy, poultry-yard etc which we visited.' As they walked and talked, Hutchinson noted that 'she was called upon by my Lord every minute for this thing and that, and shewed the greatest attention to everything he said'. It was obvious that they doted upon one another. Mansfield was proud of Dido and was clearly showing her off, tacitly letting Hutchinson know how much she was valued.

While they were having coffee, Mansfield had been keen to explain the circumstances of Dido's birth. He emphasised that she was the daughter of a distinguished man, Sir John Lindsay, that she had been educated, that she had been taken into his care as a small child. Hutchinson sneered, '[he] calls her Dido, which is I suppose all the name she has'. That, of course, was a slur on her birth: she was a slave, so she must have had only one name, and further, as a 'natural' daughter she had no right to her father's name. Hutchinson was evidently surprised by Lord Mansfield's candour in revealing that Dido's mother was 'taken prisoner' by his nephew and brought to England while she was 'with child'.

Hutchinson goes even further, intimating a more sinister relationship: 'He knows that he has been reproached for showing fondness for her – I dare say not criminal.' His phrase 'I dare not say criminal' alludes to the legal idiom 'criminal conversation', which is to say adultery. Hutchinson is deviously suggesting what he purports to

deny: he cannot bear to imagine an innocent, loving, familial relationship between Mansfield and Dido, so he fantasises that it all comes down to sex – a vile thought, given that Mansfield was seventy-four at the time, and Dido a teenager. The slur also feeds into a bigoted view of the sexual voracity of black women: she is 'pert', she hangs on every word that Mansfield says, she controls him. It shows Hutchinson in a deeply unpleasant light, but it also reflects the common eighteenth-century predilection for objectifying African women as sexual creatures.

Hutchinson's insinuation that Dido has somehow, by her arts, bewitched the family into submission chimes with the gossip circulating in London society, to the effect that the highly respected Lord Chief Justice showed favouritism in court to the black cause because of his relationship with Dido.

In the very month of Hutchinson's visit to Kenwood, Lord Mansfield presided over a case involving a free black sailor called Amissa. A Liverpool slave captain had hired Amissa and paid him part of his wages in advance. But when the ship reached Jamaica, the captain sold him and told his relatives that he had died. Three years later, Amissa was found to be alive, and was brought to London, where he was redeemed (set free). Amissa was awarded the large sum of £300 in damages, with Mansfield telling the jury that such cases should be determined by 'good policy and humanity'.[14]

'He gave me a particular account of his releasing two

Blacks from slavery, since his being Chief Justice,' wrote Hutchinson. In the course of the evening at Kenwood, Lord Mansfield discussed two cases with him, that of James Somerset and that of 'the Two Princes of Calabar', which had some similarities to the Amissa case. Their story was extraordinary. The two African princes were called Little Ephraim Robin John and Ancona Robin Robin John, and they were related to the ruler of Old Town in Old Calabar (in present-day Nigeria), Grandy King George. In 1767 they were captured during an ambush and sold into slavery. Having survived a massacre in Old Calabar they were sold in Dominica to a French doctor. After several months they escaped with the help of a ship's captain, but he double-crossed them and sold them to a merchant in Virginia. Five years later they came across two countrymen from Old Calabar, who had sailed to America on a Bristol ship called the *Greyhound*. The men recognised the princes, and the ship's captain, Terence O'Neil, agreed to help them, so they escaped yet again and boarded his ship. But once they arrived in Bristol, O'Neil betrayed them, and tried to sell them. Little Ephraim wrote of his 'great surprise and horror … when they came to put on the Irons we then with tears and trembling began to pray to God to helpe us in this Deplorable condition'.[15]

This is where Lord Mansfield entered the story. It was just fifteen months after the Somerset case. Although the princes were imprisoned by O'Neil, they managed to

write to Thomas Jones, a Bristol slaver they knew from Old Calabar. Initially he failed to respond, and the princes reconciled themselves to their fate. Then, at the last minute, as one of them recorded, 'The Lord as good as stayed the wind which prevented our sail then I write agin to Mr Jones which moved him to pity.'[16] Jones applied for a writ of *Habeas Corpus*, arguing that the princes were being held prisoner 'in order to be conveyed out of this Kingdom to Virginia against their consent and in order to be made slaves'.[17] This all sounds very like the Somerset case. Mansfield agreed to the writ, and the men were set free. However, they were captured yet again, and thrown into the lock-up house (temporary jail), and then a house of correction. In the meantime, Captain O'Neil had them arrested for 'a pretended Debt for their said passage to England'.

Little Ephraim wrote to Lord Mansfield, who 'sent to fetch us to London where we was examined then Discharged'. The princes argued that they had never been slaves: 'we were free people ... we had not done anything to forfeit our liberty'. Mansfield was troubled because, unlike Somerset, and indeed Thomas Lewis and Jonathan Strong, the Robin Johns had never lived in England: 'the whole transaction was beyond sea', and thus more legally complex. After a delay of some days the parties settled, a compromise being reached in which the alleged Virginia owner was reimbursed for the princes 'as purchase money or value of the two said Africans', and they were allowed

to go free. In a very surprising turn of events, the man who originally captured the Robin Johns was forced to pay £120 to the Virginia owner. The details of the arrangement were formally accepted by the court, Lord Mansfield presiding.

That he had a special interest in the case is suggested by the diary of Thomas Hutchinson, who said that it had given 'particular pleasure' to Mansfield, who was 'much pleased at their relief'.[18] This revelation is striking, as this is the only surviving evidence of Lord Mansfield expressing his private thoughts on the slave trade. He is not the judge here; he is not at Westminster, where all eyes are upon him. Here we see Lord Mansfield's evident pride in his 'releasing two Blacks from slavery'. And that pride is expressed on an evening when he drinks coffee with Dido and walks with her in the grounds of Kenwood.

Striking, too, is the fact that the Robin Johns appealed to Mansfield in the first place. This suggests the wide-reaching repercussions of the Somerset case, despite the fact that Mansfield always emphasised that it did not abolish slavery as such in England. Rather, it prevented masters from forcibly removing slaves against their wishes. Hutchinson wanted to discuss this sensitive issue, which had had such repercussions in England and America: 'I wished to have entered into a free colloquium and to have discovered ... the nice distinction [Mansfield] must have had in his mind, but I imagined such an altercation would be rather disliked and forbore.'[19]

One of Mansfield's enduring concerns about the possible effects of the Somerset case was the economic implications both for the owners who had lost their 'property' and would seek compensation, and for the freed slaves who would be rendered homeless and destitute, with the result that they would seek parish relief. In the courtroom he had asked the question, 'How would the law stand with the respect to their settlement; their wages?'

Charlotte Howe was a slave brought to England by her owner in 1781. Following his death, she was baptised and considered herself to be free. She applied to two parishes for poor relief, but neither would grant it, as the poor law only applied to hired servants. This case exposed Mansfield's very real concern about who would take responsibility for destitute former slaves. He ruled that the 'case was very plain … the statute says there must be a hiring, and here there was no hiring at all. She does not therefore come within the description.'

Furthermore, in a pamphlet published in 1786, it was reported that Mansfield used the Charlotte Howe Case to clarify his Somerset ruling:

> Lord Mansfield very particularly took occasion to declare, that the public were generally mistaken in the determination of the court of the King's Bench, in the case of Somersett the negro, which had often been quoted, for nothing more was then determined, than that there was no right in the master forcibly to take the slave and carry

him abroad … nor was it held … that on setting foot in
this country he instantly became emancipated.[20]

The dinner at Kenwood with Thomas Hutchinson is of
supreme importance, as it shows how Mansfield was torn
between the ethical questions of black emancipation and
his concerns about its financial implications. Once again,
he was agonising over the old question of the rights of
liberty versus the rights of property.

But could a human being ever really be reduced to the
status of nothing more than an item of property?

14
The Zong Massacre

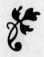

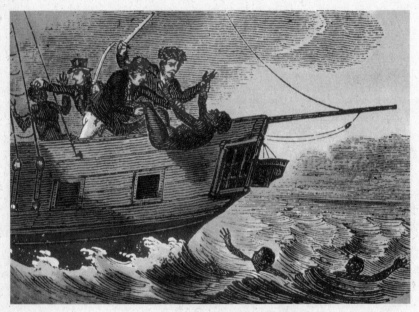

The *Zong*: slaves being thrown overboard

This atrocious and unparalleled
act of wickedness

Thomas Clarkson

On 19 March 1783, Granville Sharp noted in his journal: 'Gustavus Vasa a Negro called on me with an account of 130 Negroes being thrown Alive into the sea from on Board an English Slave Ship.'[1]

William Gregson was undoubtedly one of the most successful slave merchants in Liverpool. He owned a large number of slave ships. During the course of 152 slave voyages his vessels shipped 49,000 Africans to plantations in the Americas.[2] In 1769 he named his latest slave ship after himself, marking his incredible rise. The *Gregson* was the last of his ships to sail before the American War of Independence put a stop to trading for three years. In

1780 he re-entered the trade with a new ship, the *William*. Her captain was John Hanley, a trusted and experienced master. In 1781 Hanley saw an opportunity that he could not pass over.[3]

In February of that year a ship, the *Zorg*, had been captured from the Dutch by the British navy. She was a relatively small slaver of 110 tons. Typically a ship of that size would carry about 190 Africans, but the *Zorg* came loaded with 244 slaves on board. On behalf of the Gregson syndicate, Hanley bought the ship and renamed her the *Zong* (or perhaps the name was misread, and then taken for granted). Gregson immediately took out insurance 'upon the whole of the ship and on Goods ... valuing slaves at £30 Sterling per head.'[4]

Captain Hanley, who was already in charge of the *William*, appointed his surgeon Luke Collingwood as captain of the *Zong*. This step would have severe repercussions. Hanley instructed Collingwood to buy more slaves, and on 18 August he left Africa with 442 Africans on board, bound for Jamaica. The ship was dangerously overcrowded, and Collingwood was an inexperienced captain.

What happened next has been the subject of much debate, conspiracy theories, inconsistencies of evidence and confusion in the telling. The *Zong* overran her intended destination. Water supplies had dwindled, and an epidemic had broken out on the overcrowded ship. On 29 November 1781, Collingwood made the decision to 'jettison' a portion (roughly one-third) of his human

cargo into the waters of the Caribbean. He calculated that it would make more sense economically to kill the slaves and claim the insurance money. When Gregson and his syndicate made their claim of £30 for each of the slaves who had been killed, they stated that the ship's water supply had run out, and the captain had taken the 'necessary' step of sacrificing a few for the many.[5]

No reconstruction of these horrific events can ever be fully accurate, for two reasons. First, the captain, who had fallen ill, died a couple of days after the ship reached Jamaica. Second, the ship's logbook went missing, and has never been found. The insurers later accused Gregson of destroying it. He claimed that it was with Collingwood when he died in Jamaica, and was mislaid. But it would have been highly irregular for the logbook to have left the ship. Without it, the events were reconstructed by the testimony of a passenger on the ship named Robert Stubbs. Later, first mate James Kelsall wrote an affidavit putting across his own version of what happened. Neither source is necessarily to be trusted.

We will never know the full truth of what happened, but we do know that the circumstances of the *Zong* were highly unusual. As Luke Collingwood was a slave surgeon who had been promoted to the role of captain, doubts were later voiced about his capability.[6] While it was not unusual for a surgeon to be raised to captain, Collingwood was acting as both surgeon and captain of a very overcrowded ship. Usually the ship's surgeon would keep an

independent record or log, but because he was carrying out both roles, another vital piece of documentation was not kept.

Most slave ships carried twice the amount of food and drink they would need for the dreaded middle passage. As first mate, James Kelsall was responsible for loading and storing food. He took on fifteen or sixteen butts of water (162 gallons each), but failed to check the supplies at the point of departure or during the passage.

At some point in the voyage Collingwood fell sick, and was unable to command the ship. He appears to have suspended Kelsall, and given command to the passenger Robert Stubbs. This is another strange twist in the story. Stubbs, the only witness asked to give evidence at the *Zong* trial, was an ex-slaver captain (of the *Black Joke*), and former Governor of Anomabu, a small slave-trading post on the Gold Coast of Africa. He had a reputation as a drunk and a scoundrel. It's unclear exactly what part he played: he later claimed that he was an innocent bystander.

On 21 November the water supplies were checked, and it was discovered that many of the butts were not full. The crossing had been slower than expected, and it appeared that a large amount of water had leaked from the butts in the lower tier. At this stage there didn't seem to be anything to worry about, as the ship had enough water for thirteen days, and Jamaica, their destination, was only eight days away. For a Liverpool slave ship such as the *Zong*, the usual allocation of water was four pints per

person per day. Unfortunately, no one suggested the wise measure of limiting the rations for slaves and crew.

Then a serious navigational error was made. The *Zong's* crew sighted Jamaica, but believed it to be the French-held St Domingo, so they sailed away from shore. Because the captain was sick and the first mate suspended, it is unclear who made the mistake. By the time it was recognised, the ship was three hundred miles from Jamaica. Kelsall was reinstated as first mate, but the ship only had enough water for four days, and it would now take between ten and fourteen to return to Jamaica.

On 29 November the suggestion was made to destroy part of the slave cargo in order to protect the rest. That evening, at 8 p.m., fifty-four women and children were pushed through cabin windows into the sea. Two days later, forty-two men were thrown overboard. Ten jumped voluntarily. On the third day a final group of thirty-six men was dispatched. One man clambered back aboard the ship.

James Kelsall later stated that the slaves were fit and healthy, but this would be disputed by many abolitionists.

Between the first and last massacre, on 1 December, heavy rain fell, replenishing the water supplies. At one point, a slave appealed for their lives to be spared, but he was ignored.

One of the most horrifying massacres in the terrible history of the slave ships had occurred. But nobody would have heard of it had the Gregson syndicate not made the

tactical mistake of claiming insurance for the 'cargo' that had been jettisoned. The insurers refused to pay up, and the case went to court. There was never a case for murder. It was an insurance claim. And insurance was Lord Mansfield's speciality.

15
Gregson v Gilbert

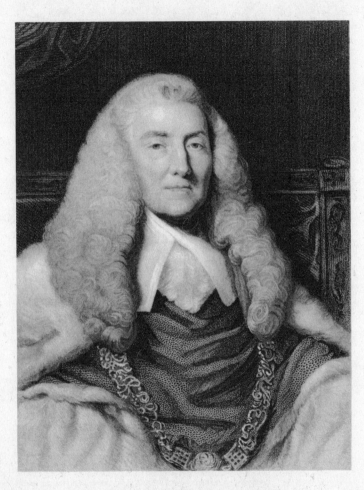

Mansfield as Lord Chief Justice, engraving after a
portrait by Sir Joshua Reynolds

The life of one Man is like the life of another
Man whatever the Complexion is,
whatever the colour

Mr Pigot, counsel for the insurers

When the news of the *Zong* massacre reached England, the Gregson syndicate immediately set about claiming compensation from their underwriters for the loss of the slaves. Legal proceedings began when the insurers refused to pay up. The dispute was initially tried before a jury at the Guildhall in London on 6 March 1783. Overseeing the trial was Dido's adoptive father, Lord Chief Justice the Earl of Mansfield, the world expert on maritime insurance.

The question centred upon whether Collingwood had or had not jettisoned his (human) cargo as a matter of necessity, under 'perils of the sea'. Eighteenth-century

slave ships could be insured against several forms of 'perils of the sea', including shipwreck, piracy, arrest and shipboard rebellion, but the death of slaves owing to what was deemed 'natural death' (that is, through sickness, or want of water or food) was uninsurable.

If the slaves had died onshore, the Gregson syndicate would have had no redress from their insurers. But if some slaves were jettisoned in order to save the rest of the 'cargo' or the ship herself, then a claim could be made under the notion of 'general average'. This principle held that a captain who jettisoned part of his cargo in order to save the rest could claim for the loss from his insurers.

At this trial the jury decided in favour of Gregson, that the insurers (Gilbert) were liable to pay compensation for the 132 Africans 'jettisoned' from the *Zong*. The freed slave and well-known London figure Olaudah Equiano went to see Granville Sharp on 19 March, and the following day Sharp sought legal advice on the possibility of prosecuting the ship's crew for murder.

In the meantime, Gilbert fought back and asked for a retrial, and on 21–22 May there was a two-day hearing at the Court of King's Bench at Westminster Hall to review the evidence.[1] Almost all the information we have about the *Zong* case derives from this hearing, as Lord Mansfield's notes for the original trial in March are missing.[2] Once again, Granville Sharp was to prove a thorn in the side of Mansfield. He appeared at the May hearing alongside his secretary, who transcribed the whole proceedings.

As Lord Mansfield stated in his opening remarks, the *Zong* was 'a very singular case'. The first thing he did was to emphasise that this was an insurance claim, not a murder trial, but it was clear that much was at stake. In his summing-up of the March trial, he made a comment that has (unfairly) been used to smear his reputation: 'The matter left to the jury, was whether it was from necessity: for they had no doubt (though it shocks one very much) that the Case of Slaves was the same as if Horses had been thrown over board. It is a very shocking case.'[3] Some historians are convinced that this statement shows Mansfield's personal opinion,[4] though it seems clear that he is in fact stating the views of the jury.

Robert Stubbs appeared as the only witness, claiming that there was 'an absolute Necessity for throwing over the Negroes', because the crew feared that all the slaves would die if they did not throw some into the sea.[5] The insurers argued that Collingwood had made 'a Blunder and Mistake' in sailing beyond Jamaica, and that the slaves had been deliberately killed so their owners could claim compensation. They argued that this was a case of fraud and human error, and that therefore they should not be liable.

Strikingly, however, Gilbert's lawyers moved the argument beyond a mere insurance claim, emotively describing the affair as a 'Crime of the Deepest and Blackest Dye', and saying that the crew had lost 'the feelings of Men'.[6] The historian James Walvin has argued persuasively that the

somewhat alarming presence of Granville Sharp and his secretary in court had a significant bearing on the tone and language of this hearing. Murder had been on no one's mind at the Guildhall sessions two months before, but the word was used nine times at the King's Bench.[7] One of Gilbert's lawyers, the fierce Mr Pigot, who comes out of the case particularly well, made an assertion that made it very clear that this was much more than an insurance claim: 'The life of one Man is like the life of another Man whatever the Complexion is, whatever the colour.' He demanded that the grotesque acts that had taken place on board the *Zong* should lead to a retrial.

The turning point for Lord Mansfield appears to have been a shocking detail that had hitherto been undisclosed. He learned that the last group of thirty-six slaves 'were thrown overboard a Day after the Rain'. Mansfield's comments are most revealing: 'a fact which I am not really apprized of ... I am not aware of that fact ... I did not attend to it ... it is new to me. I did not know any Thing of it.' The whole case rested on the assumption that the slaves were killed out of necessity, yet it was now clear that the water supplies had been replenished. In an affidavit made by Kelsall it was reported that on 1 December it rained heavily for more than a day, allowing six butts of water (sufficient for eleven days) to be collected.[8] It was at this juncture that Lord Mansfield recommended a retrial: 'It is a very uncommon Case and I think very well deserves a re-examination.'

The three judges concluded that the case for necessity in jettisoning the slaves was not proven. Despite this turn-around, a second trial never took place. It seems that Gregson dropped his claim. One suspects that the syndicate knew they would lose, and that the negative publicity would be catastrophically damaging to the entire cause of the trade. Gregson and his colleagues did not win their compensation, which was a victory of some sort for Sharp and the early abolitionists, but neither were they prosecuted for murder.

Lord Mansfield comes out of this case somewhat ambiguously. On the one hand, he ordered the retrial of *Gregson v Gilbert* once he had learned that the heavens had opened and rain fell. But on the other, he did not refer the case to the Attorney General for a possible murder trial.

In 1785, two years after the *Zong* trial, Mansfield presided over another insurance case, where nineteen slaves had been killed in a munity and a further thirty-three had committed suicide. Mansfield said, 'This was not like the case of throwing Negroes overboard to save the ship. Here there was a cargo of desperate Negroes refusing to go into slavery and dying of despair.' The insurers, he ruled, should only be required to pay damages for the nineteen. To us, it seems shocking that a monetary value could in any circumstances be placed upon human beings, as if they were chattels. But for Mansfield, the law was the law. Clarity and certainty were, for him, more important than whether a particular law was good or bad:

'The great object in every branch of the law … is certainty, and that the grounds of decision should be precisely known.'[9]

The person who comes out of the *Zong* case most damnably is Solicitor General John Lee, who appeared at the hearing on behalf of the ship's owners, and stated:

> What is this claim that human people have been thrown overboard? This is a case of chattels or goods. Blacks are goods and property; it is madness to accuse these well-serving honourable men of murder. They acted out of necessity and in the most appropriate manner for the cause. The late Captain Collingwood acted in the interest of his ship to protect the safety of his crew. To question the judgement of an experienced well-travelled captain held in the highest regard is one of folly, especially when talking of slaves. The case is the same as if wood had been thrown overboard.[10]

As for the real hero of the story, once again that was Granville Sharp. After the trial he wrote countless letters to highly placed individuals, contacted the press with a copy of his trial minutes, and tried to bring murder charges against Kelsall and his crew. He lobbied the Prime Minister, the Chancellor of the Exchequer and the Lords Commissioners of the Admiralty.

The immediate impact of the *Zong* massacre on public opinion may have been limited. But in the longer term,

the breathtaking brutality of the murders, and the fact that drowned human beings could be reduced to an insurance claim brought home the urgency of abolishing the slave trade. It was because of Sharp's efforts that the *Zong* massacre became an important topic in abolitionist literature: the massacre was discussed by Thomas Clarkson, Ottobah Cugoano, James Ramsay and John Newton – most of the great abolitionists. His attempts to instigate a prosecution for murder were to have important consequences, bringing together like-minded individuals who would play a leading role in the British anti-slavery movement, formally established in 1787.

One of these men was Thomas Clarkson, who became perhaps the key founding member of the abolition movement. His definitive *History of the Rise, Progress and Accomplishment of the Abolition of the African Slave Trade by the British Parliament* used the *Zong* massacre to illustrate the atrocities of the trade. Strikingly, Clarkson's account puts forward yet another, and most compelling, theory of the motivation behind the killings, and one that has not been sufficiently explored: that the whole tale of the water shortage was a fabrication, and that the Africans thrown overboard were ill and diseased, and therefore worth more dead than alive.[11]

16
Changes at Kenwood

Dido Belle, amanuensis to the Lord Chief Justice

Life at Kenwood was as idyllic as ever, but the security that Dido Belle had known with the Mansfields was about to change in the years after the *Zong* massacre. The first change came with the death of Lady Mansfield in 1784. Despite her reserves of energy, her health had been precarious since the stress of the Gordon Riots. Her husband was indefatigable in his efforts to nurse her. Newspapers reported that he 'was most assiduous in the sick chamber, constantly administering what the physicians had ordered and sitting up several nights together'.[1] The Mansfields had always had a strong and happy marriage, despite their childlessness.

Lady Mansfield's death was a blow to her family, and it was said that her husband never got over her loss. Just a year later, there was another huge change in the family's circumstances when Elizabeth Murray left Kenwood on marrying her cousin, George Finch-Hatton. As Lord

Stormont's eldest daughter, it was Elizabeth's duty to make a good marriage, and she did not fail. George Finch-Hatton's father Edward was brother to Lady Mansfield. George was later MP for Rochester, and following their wedding in December 1785, he and his new bride moved to Eastwell Park in Kent, leaving behind Dido and the settled life of Kenwood.

Perhaps Dido felt the loss of Elizabeth even more than she did that of Lady Mansfield. After all, they had been friends and companions since they were small children. They had shared everything. But now Elizabeth was to embrace the life she had been bred for, as the wife and mistress of Eastwell Park. She would bear five children to George Finch-Hatton, and their son George would become the tenth Earl of Winchilsea and fifth Earl of Nottingham.

Furthermore, with Lady Mansfield departed to heaven and Miss Elizabeth to Kent, and with Lord Mansfield having reached eighty, Dido would have been acutely conscious that the time would soon come when Lord Stormont would inherit Kenwood. What would happen to her then? Viscount Stormont and his young second wife Louisa had a family of five children – Caroline, David, George, Charles and Henry. He was on the brink of succeeding to both the Mansfield and the Stormont lines of the Murray family, inheriting two titles and two fortunes. Kenwood would be his, and he would be unlikely to want Dido there.

Now, more than ever, Dido would have been aware of her peculiar position in the family. It was inconceivable that she could hope to make a similar marriage to Elizabeth. Not merely because of her skin colour, but also because she was illegitimate. Although her father acknowledged paternity and provided for her, there was no question of her taking the Lindsay name. She was Miss Belle. In such circumstances, similar to those of the mixed-race Chevalier de Saint-George, she was prevented from making a society marriage, no matter how beautiful and accomplished she was.

But Dido was not wholly alone with Lord Mansfield at Kenwood. Some time before Elizabeth's marriage, two of Mansfield's other nieces, Lady Anne and Lady Margery Murray, came to live at Kenwood. Spinsters in their middle years, it is possible that they came to help run the house. The account book kept by Lady Anne survives, dating from 1 Januuary 1785 to 2 April 1793. It gives an intriguing insight into the way Kenwood was run. All expenditure is accounted for: the farm, servants' wages, charitable gifts, letters and turnpike fees, food, drink and fuel. It's a reminder of the size of the community at Kenwood.

Not surprisingly, Lord Mansfield and Dido grew even closer after his wife's death and Elizabeth's departure. The Kenwood account book includes references to 'special presents by Ld M's order'. Dido received a quarterly allowance of £5, augmented by birthday and Christmas

presents. Her yearly allowance would thus have been £30 (for comparison, a kitchen maid was paid £8 per annum, the first coachman about £15).

It is clear that Dido's health was well attended to. She had two teeth extracted in 1789, at a cost of five shillings, and was given ass's milk when she was ill, at the not insubstantial cost of £3.4s.2d. The account book also has a description of her bedding being washed and 'reglazed', at a cost of twelve shillings. This involved scouring and cleaning the bed and drapery and then pressing the fabric between hot rollers, to give it a silk-like sheen.

After Elizabeth married, Mansfield added a codicil to his will, giving an extra £200 for Dido 'to set out with'. It seems from this that he was worried about what would become of her after his death. A few days later he had second thoughts: £200 was not enough. He added a further codicil: 'I think it right, considering how she has been bred, and how she has behaved, to make a better provision for Dido, I therefore give her Three Hundred Pounds More.' As ever, his affection and solicitude for her shine through.

Mansfield grew increasingly to rely on Dido, even using her as his amanuensis. In May 1786 she wrote out a letter to Justice Buller. It reveals that she had a clear, neat hand. The letter concerns a highly technical point in a marine insurance case, *Lockyer v Offley* – whether the clause in the policy which covered loss of a ship if seized

by His Majesty's Customs for barratry (a fraud committed by the master of a ship on the owners, in this case smuggling on his own account) was operative.[2] At the end of the message is a playful comment: 'This is wrote by Dido I hope you will be able to read it.' Mansfield knows only too well that the letter is eminently legible – the remark springs from his pride in Dido. It also reveals that Justice Buller must have been clearly aware who Dido was.

There was another death in the family in 1788. Sir John Lindsay's marriage to Miss Milner did not keep him at home in Scotland. Between 1769 and 1772 he was commodore and commander-in-chief in the East Indies, with, as his biography puts it, 'his broad pennant in the frigate *Stag*'. In June 1770 he had been appointed a Knight of the Bath, a considerable honour for a not very senior naval officer. He was subsequently recalled from the East Indies, apparently due to the hostility of the East India Company towards his investigation into its dealings with the Indian Nawabs. His career continued closer to home. He rose to become commander-in-chief of the Mediterranean fleet. In 1784 he entertained the King and Queen on board his ship at Naples, but soon after that his health began to fail and he returned to Britain. He was promoted, honorifically, to the rank of Rear Admiral in September 1787, but died on 4 June 1788 at Marlborough, on his way back to London from

Bath, where he had been staying on account of his poor health. He was just fifty-one. He was buried with full naval honours in Westminster Abbey,[3] laid to rest in the Henry VII chapel beside the body of Lady Mansfield, who had cared for his natural daughter for so many years. We do not know whether at any time in his later years he ever went to Kenwood and met his grown-up mixed-race daughter. There would have been no reason for him to stay away: Lord Mansfield was fond of his nephew, as can be seen from his original will, in which he left £1,000 to him 'in memory of the love and friendship I always bore him'.

Lindsay never had legitimate children with his wife, Mary, but his will mentioned two natural children, Elizabeth and John, to each of whom he left £500: 'I further give and bequeath unto my dearest wife Mary Lindsay, One Thousand Pounds in trust to be disposed by her for the benefit of John and Elizabeth my reputed son and daughter in such a manner as she thinks proper.' It is not clear whether 'Elizabeth' refers to Dido, or to another illegitimate daughter. 'John' seems to have been an illegitimate son, conceived in Scotland. But the only child mentioned in his obituary in the *London Chronicle* was Dido. She was described as 'a Mulatto who has been brought up in Lord Mansfield's family almost from her infancy, and whose amiable disposition and accomplishments have earned her the highest respect from all his Lordship's relations and visitants'.[4] This is the first mention

of Dido's existence in the public prints, and it is wholly laudatory. One only wishes that some 'visitant' to Bloomsbury or Kenwood, other than the appalling Hutchinson, had left a record of their encounter with her 'amiable disposition and accomplishments'.

17
The Anti-Saccharites

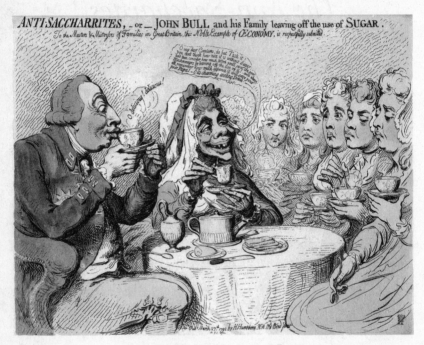

'Anti-Saccharrites', by James Gillray

> You no think, Massa, when you eat our
> sugar, you drink our blood?
>
> *Abolitionist pamphlet of 1826*[1]

As Dido Belle sipped her sweetened coffee in the company of Thomas Hutchinson, one wonders whether she spared a thought for the slaves who laboured to harvest and refine the sugar at such a huge cost to themselves. Towards the end of the eighteenth century there were many in England who were beginning to reassess the role of sugar in domestic life.

In 1787 the Society for the Abolition of the Slave Trade was formed, chaired by Granville Sharp. It was a coalition of various strands of anti-slavery factions, propelled by Thomas Clarkson and William Wilberforce as well as Sharp, but its roots were in the Quaker and Christian

evangelical Churches, and many of these abolitionists were women. They felt compassion and sympathy for African women who were torn from their families and sexually exploited by planters and slavers. They were the homemakers who purchased and served sugar to their families. As one newspaper article said, 'In the domestic department, they are the chief controllers [who] provide the articles for family consumption.'[2] Women may have been prohibited from voting in Parliament, but they could boycott the British sugar bowl.

One powerful abolitionist metaphor was of sugar tainted with blood. The Quaker William Fox wrote that 'for every pound of West Indian sugar we may be considered as consuming two ounces of human flesh'. The poet Samuel Taylor Coleridge joined in the furore: 'A part of that Food among most of you is sweetened with the Blood of the Murdered … will the father of all men bless the food of Cannibals – the food which is polluted with the blood of his own innocent children?'[3] Coleridge implored the women of England to consider their role: 'The fine lady's nerves are not shattered by the shrieks! She sips a beverage sweetened with human blood even while she is weeping over the sorrows of Werther or Clementina.'[4]

William Allen urged women, sipping their tea at home, to consider their responsibilities as consumers. And it wasn't just the upper classes: a white working-class abolitionist called Lydia Hardy wrote to Olaudah Equiano to tell him that in her village of Chesham more people drank

tea without sugar than with it.[5] So it was that women took the lead in the campaign to refuse to buy sugar or rum, another product of the plantations.

Lady Margaret Middleton hosted dinner parties at which she spoke and spread awareness of the horrors of the slave trade. The novelist, playwright and evangelical writer Hannah More joined forces with her, and wrote anti-slavery pamphlets and poems. The official seal of the abolitionists was Wedgwood's medallion bearing the figure of a manacled, kneeling slave and the slogan 'Am I not a man and a brother?' Women abolitionists wore the medallion on chains around their necks, as bracelets or as hair ornaments.[6] This was a visual symbol far more powerful than any pamphlet or newspaper article. Could Dido ever have slipped one around her neck?

Abstention from sugar was an equally powerful, if less ostentatious, force. It was a denial of luxury, a self-sacrificing act of generosity which drew attention to the virtue of anti-consumption and anti-commodification.[7] By the late 1790s the number of British abstainers from sugar seems to have risen towards half a million – and over half of them were women.[8]

The abstention campaign, said to be supported by Queen Charlotte, provided satirists with ample ammunition. James Gillray's 'Anti-Saccharrites – or John Bull and his Family leaving off the use of Sugar' (March 1792) depicts the royal princesses unhappily sipping unsweetened tea, urged on by their mother: 'You can't think how

nice it is without sugar,' and 'then consider how much work you'll save the poor Blackamoor by the leaving off the use of it'. Cruikshank followed with a print showing the Queen snipping off a tiny bit from the loaf with her sugar nippers and weighing it on scales, saying, 'Now my dears, only an ickle bit. Do but tink of de Negro girl dat Captain Kimber treated so *cruelly*.'[9]

It was Lady Middleton who persuaded the evangelical Christian MP William Wilberforce to take up the cause and lead Parliament towards the Abolition Act. The Middletons' home, Barham Court in Teston, Kent, was the heart of the movement, and it was there that Wilberforce was introduced to such leading supporters as James Ramsay and Thomas Clarkson. Wilberforce adored the house, and his time spent there in the autumn of 1786 was pivotal to his conversion to the cause of abolition. By the early months of 1787 he had become convinced to take up the cause, writing in his journal: 'God Almighty has sent before me two great objects, the suppression of the slave trade and the reformation of manners.'[10] Barham Court was used for planning the abolition campaign, with numerous meetings and strategy sessions attended by Wilberforce, Clarkson and others.

Margaret Middleton's impact was huge. In 1784 it was she who had persuaded James Ramsay to publish his account of the horrors of the slave trade, *An Essay on the Treatment and Conversion of African Slaves in the British Sugar Colonies*. This was the first time that the British

public had read an anti-slavery work by a mainstream Anglican writer who had personally witnessed the suffering of the slaves on the West Indian plantations. Christian Ignatius Latrobe, a leading figure in the evangelical Moravian Church who spent many years at Barham Court, wrote to his daughter that the abolition of the slave trade was the work of one woman, Margaret Middleton.[11] But the presence in another grand but more peaceful house – Kenwood – of another woman – Dido Elizabeth Belle – was also a hidden element in the story of abolition.

Lord Mansfield would not live to see the end of the slave trade. By the time that the abolitionist forces were gathering at Barham, he was growing frail. In 1785 he wrote to the Duke of Rutland: 'I go down hill with a gentle decay, and I thank God, without gout or stone.'[12] On 1 November that year, the *London Chronicle* reported that the Lord Chief Justice 'has been obliged to give up the pleasure of riding on horseback owing to a weakness in his wrists' – it was rather remarkable that he had stayed on a horse so long, given that he was eighty.

His popularity was waning. There were rumblings in the press that he was losing his judgement, and that retirement was overdue. Caricatures began to portray him as an old dodderer. One particular engraving even cast aspersions on his beloved dairy farm at Kenwood, which was presumably run by Dido alone now that Lady Mansfield had passed away. Entitled 'The Noble Higglers' and

published in the *Rambler's Magazine* on 1 February 1786, it shows four figures in a landscape, on a road leading from a country house. A judge, evidently Mansfield, carries a pair of milk pails on a yoke, while his companions bear pigs and poultry. It was published as an illustration to a letter about two peers, one of them Mansfield, who were in the habit of selling their dairy produce at Highgate. Surely, the letter suggests, they should be liable to the shop tax.[13]

Finally, in 1788, Mansfield retired from his role as Lord Chief Justice. He remained at Kenwood, looked after by Dido and his other nieces, the Ladies Anne and Margery Murray, for the last few years of his life. When Fanny Burney visited Kenwood in June 1792 she was unable to see Lord Mansfield, as he was too infirm. She was told by the housekeeper that he had not been downstairs for four years, 'yet she asserts he is by no means superannuated, and frequently sees his very intimate friends'. Burney says that the Miss Murrrays 'were upstairs with Lord Mansfield, whom they never left'. Fanny Burney asked after the Miss Murrays and left her respects. They had often invited her to Kenwood, and she expressed her sorrow that she hadn't taken up the offer before then. There is, however, no mention of Dido.

On Sunday, 10 March 1793, Mansfield did not feel like taking breakfast. He was heavy and sleepy, his pulse low. Vapours and cordials were given to him. He perked up a little on the Monday, but all he asked for was sleep. He

survived for another week, lying serenely in bed, but his silver tongue was silenced. He never spoke again.[14] He was buried in Westminster Abbey with great dignity. The obituaries described him as the greatest judge of the age, if not any age.

The story of Dido Belle and Lord Mansfield is about individuals who changed history. There are many heroes and heroines in this story – both ordinary and extraordinary. There is Mrs Banks, who spent so much of her own fortune on securing the release of Thomas Lewis; Elizabeth Cade, who refused Lord Mansfield's request to buy James Somerset and so avoid the issue of English slavery; Lady Margaret Middleton, who set up the abolitionists' headquarters in her own home. The many thousands of women who stopped buying sugar. Mary Prince, who published her memoir. The men, too. The lawyers on the Somerset case who refused payment; Lord Mansfield, who made the ruling; and Granville Sharp, who was propelled into the cause of his life by seeing the bloodied face of Jonathan Strong.

The woman we know so little about, Dido Belle, played her own part. Would Mansfield have described chattel slavery as 'odious', and have made his significant ruling in the Somerset case, if he wasn't so personally involved in the 'Negro cause' as a result of his adoption of Dido? His language in the case of the *Zong* massacre, his description of the comparison of slaves to horses as 'shocking', his constant concern for questions of 'humanity', are entirely

consistent with his personal affection and respect for her. His pride in bringing the two Princes of Calabar to London and his determination in freeing them makes evident his abolitionist sympathies. His confirmation of Dido Belle's freedom in his will reveals his absolute determination that there should be no possibility of the realisation of the awful possibility of her being somehow sold into slavery.

Mansfield's insistence on the limitations of his famous ruling seems to point more to his fastidious nature than anything else. He was scrupulous about following the letter of the law, and utterly focused on clarity and certainty within the law. Nevertheless, he knew what was at stake in the Somerset case. He seems to have felt genuine concern that his ruling would be perceived as favourable to the black cause because of his relationship with Dido: in the words of Thomas Hutchinson, 'He knows he has been reproached for showing his fondness for her.' Yet he let Somerset go free, and in Thomas Lewis's case threatened to bring into custody any man who 'dared to touch the boy'.

For much of English polite society before the Somerset case, slavery was not to be spoken about. It was out there, far away in the plantation fields and on the slave ships. It didn't have to be faced, especially if the consequence would mean the sacrifice of sugar. The Somerset case, and its widespread publicity and legal ramifications, brought slavery into the spotlight. Just as the planters feared, after Mansfield's ruling there was no going back.

On 25 March 1807 the Act for the Abolition of the Slave Trade received the royal assent and entered the statute books. William Wilberforce's face streamed with tears of joy. One month later, William Gregson's son James hanged himself at home in the Liverpool mansion built on the proceeds of slave labour.

Granville Sharp continued his battle for black freedom. His fame had spread, as is indicated by a letter he received from an African in Philadelphia who wrote, 'You were our Advocate when we had but few friends on the other side of the water.'[15] A committee for the Relief of the Black Poor was set up by Sharp in the years following the Somerset ruling, and he began work on his plan to return English slaves to Africa, dreaming of their resettlement in Sierra Leone. Granville Sharp died in 1813 and, like Mansfield, has a memorial in Westminster Abbey.

18
Mrs John Davinier

The marriage of 'John Davinie' and Dido Elizabeth Belle

What was to become of Dido now that Lord Mansfield was dead?

Overnight, she had become a woman of some means. Whether or not she was the 'Elizabeth' to whom her father John Lindsay had left a half share of £1,000, she now had the annuity of £100 a year for life in Lord Mansfield's original will, the sum of £200 'to set out with' in the first codicil, and the further £300 in the second. The consequence was clear: she had money of her own, so she could not expect to live at Kenwood with Lord Stormont and his family. Having been loved and cherished, living in splendour there all her life, she now had to face the harsh reality that she was to be turned out of her home. With Mansfield's death she had lost her friend and protector.

Dido had turned thirty, and no doubt would have considered herself past marriageable age. Her cousin, now Lady Finch, had two children, and was happily settled in

Kent. She apparently did not offer Dido a home. Dido would seem to have had little chance of meeting suitable men, yet within nine months of her uncle's death she was married. Her husband was a servant of French extraction called John Davinie, Davinière or, most commonly in the surviving documentary records, Davinier.[1]

How she met him remains a mystery. The likeliest possibility is that it was through Lord Stormont, the new Earl of Mansfield. As a result of his time as ambassador in Paris, and his close connection with the French court, Stormont had a number of French servants working for him in London and at Scone. Some of them may even have been well-born refugees from the French Revolution, to whom he gave shelter and employment. There is a surviving accounts book of Stormont's which lists numerous French servants, though none with the name Davinier. It seems highly probable that upon moving into Kenwood, Stormont took it upon himself to solve the problem of Dido by setting her up with one of his own men, or a French servant otherwise known to him.

Dido could never have made a match as brilliant as that of her cousin Elizabeth. Her status was uncertain. She was certainly more than a servant, and had noble blood in her veins, but as a 'natural' daughter, she could not expect the same privileges and opportunities as a child born in wedlock. Nevertheless, her inheritance set her well apart from the servant ranks. Financially, she was better off than many genteel women of her era. Dido also had her

beauty, her 'amiability and accomplishments'. She was educated. It was a good match for John Davinier.

On the marriage licence, it states that John Davinier was resident in St Martin-in-the-Fields, the parish of Lord Stormont's townhouse. The entry in the marriage register for St George's, Hanover Square, dated 5 December 1793, says that both bride and groom were of that parish. Dido signed with her full name, 'Dido Elizabeth Belle'. The witnesses were Martha Davinie, who was presumably John's mother or sister, and a man called John Coventry. The latter could conceivably have been the Honourable John Coventry, younger son of the Earl of Coventry, or perhaps it was a certain John Coventry, 'citizen and joiner', who held the freedom of the City of London.[2]

St George's was one of the most fashionable churches in greater London. The couple were married there by licence. This was more expensive than being married by banns, and was sometimes perceived as a status symbol. Often the upper classes were married by licence, to avoid the banns being read out three successive times in church. This meant you could be married more quickly, and was also convenient if you were from a different parish.

The following year Dido changed her surname on her banking account from Belle to Davinier. A year later, she gave birth to twin boys, Charles and John, though it appears that John did not survive infancy. The name Charles was presumably chosen because of a Davinier family connection, while John would have been either for

Dido's husband or her father, Sir John Lindsay. Another son, William Thomas, was born in 1800.[3] His first name was clearly chosen in homage to the memory of Lord Mansfield.

Land tax payments – the equivalent of modern property tax – reveal that John and Dido Davinier lived in Pimlico. An 1804 map of the area shows that it was largely fields at that time, though it was rapidly being built up. The ground was swampy, with creeks running from the Thames. It was essentially a middle-class area, not a fashionable one. The Daviniers lived on Ranelagh Street. This had long been an open roadway, with just a few houses on one side, but the north end had undergone development. A typical property was described as 'A neat leasehold house, very pleasantly situated ... containing two rooms on each floor, with convenient offices and a large garden.'[4]

One of Dido's neighbours was the miniature painter and engraver Charles Wilkin. Others in the street were a mixture of trade and professional people. There was an architect called George Shakespeare, a dentist, a vicar's daughter, a music seller (who went bankrupt), a herbalist called Mrs Ringenberig who, upon examination of morning urine, could provide surprising cures for female complaints (the offer of her services was a fixture in the classified ads of the London papers). Most were respectable types, but, as in any community, every now and then something untoward might lead to an unwelcome newspaper story. On one occasion a woman from Ranelagh

Street was taken to court for having 'put a live bastard child down the privy'.

Notable landmarks nearby were Locke's Lunatic Asylum and two popular pleasure gardens. Ranelagh Gardens in Chelsea was the more famous, boasting a superb rotunda, a Chinese pavilion and beautifully laid-out formal gardens. Dido's home was closer to the rather less salubrious 'Jenny's Whim', which was a popular tavern and tea garden in Pimlico.[5] The pleasure gardens were renowned as public spaces where different classes intermingled to walk, eat supper and attend musical concerts. They were also notorious as the haunts of prostitutes and the scenes of illicit assignations.

The district was only just becoming suburbia, and still had a rural feel. Much of the area was given over to market gardens. It was easily the largest area for vegetable produce on the north side of the river, so close to the densely populated streets of Westminster and the City of London.[6] Pimlico was a far cry from the splendours of palatial Kenwood and its luxuries, but Dido was now her own mistress, and mother to two boys. She had her own home, from which she could not be turned away, or hidden out of sight when visitors came. When she looked at her children it is probable that she felt a sense of belonging and kinship that was denied her at Kenwood. In the sugar islands, such children would have been categorised as 'quadroon', meaning they had three white grandparents and one black. But in London, Dido's children would have

something she never had: their legitimacy, and a home where they were raised by their own parents.

What was it like living in London as a mixed-race couple in the early years of the nineteenth century? In the absence of direct evidence about Dido's experience of married life, we must look to other marriages. One of the better-known is that of Francis Barber, the trusted manservant and friend of the childless Dr Samuel Johnson. Johnson educated Barber, and made him his heir. Johnson's opposition to slavery was well known: he once made a toast to 'the next insurrection of the negroes in the West Indies'.[7]

Johnson's devotion to Barber is well documented, and many resented what they perceived as his sway over Johnson, just as people gossiped that Lord Mansfield was in thrall to Dido. Barber was born into slavery in Jamaica, but was raised and educated in England by his owner Colonel Richard Bathurst, who brought him from the West Indies. In his will, Bathurst confirmed Barber's freedom, and left him a small legacy. Bathurst's son helped to arrange a job for Barber as Johnson's manservant, and he lived in Johnson's household for thirty-four years. Their relationship was complex: Barber ran away several times, but always returned. Johnson had him taught to read and write so that he could act as his secretary, taking care of his correspondence and his manuscripts. Barber asked to read the popular novel *Evelina*, by Johnson's friend Fanny Burney.

Barber, as Johnson noted with much amusement, was very popular with the female sex. One young woman, a haymaker, followed him to London from Lincolnshire 'for love'.[8] But he married a beautiful white woman called Elizabeth Ball, and the couple and their children lived in Johnson's house in Bolt Court, near Fleet Street.

Barber was fiercely jealous of his wife, and was only reassured of her fidelity when she produced a daughter 'of his own colour'.[9] However, evidence suggests that the child was actually light-skinned, leading to much speculation and gossip: Hester Piozzi, Johnson's great friend, noted cattily that Barber's daughter was 'remarkably *fair*'. It was rumoured that Elizabeth was a former prostitute, and that the children were not Barber's. Barber's jealousy of his pretty wife led Mrs Piozzi to refer to him and Elizabeth as Othello and Desdemona.

In fact, Frank and Elizabeth's marriage was a happy one, and they produced three children. Their son Samuel became a Methodist preacher, and all three of them married whites, as did Dido's children. Johnson expressed a desire that after his death the Barber family should live in his own home town of Lichfield, and their descendants still live there today.

Another mixed-race marriage was that of Olaudah Equiano (Gustavus Vassa), who married a local white woman called Susan Cullen in Soham, Cambridgeshire. They lived together happily and had two daughters. One of their children died, and the other, Joanna, married a

Congregational minister. She inherited £950 on her father's death, leaving her comfortably off. As the mixed-race daughter of a famous man, Joanna Vassa is the closest comparison to Dido that we have. Like Dido she married a white man and lived in London, although her first years were spent in Devon and Essex. She and her husband were seemingly devoted to one another, and were buried together.

The Barbers and the Vassas are examples of successful inter-racial marriages. One historian has noted that mixed-race marriages in the eighteenth and early nine-teenth centuries 'tended not to be seen as problematic to the English because they primarily occurred among the lower working classes'.[10] Most were between a black man and a white woman; unions between black women and white men were rare outside plantation life. The few examples tend to be found in the servant classes. Having money could actually be a disadvantage for a black woman in search of matrimony. A white footman named John Macdonald felt himself unworthy of a black woman called Sally Percival, not because of her race but because she was wealthy, having been left an inheritance by her former master.[11] Sally, Joanna and Dido were unusual because their relative wealth gave them status.

So what was Dido's status in Pimlico as Mrs John Davinier? It is unlikely that she became part of London's black community or even had black friends, as did Francis Barber. Her elder son Charles was sent to Belgravia House

School, a respectable white establishment. Having been given an education, he was in a position to apply for work that might lead to a position as a clerk. He duly applied to the East India Company in 1809, when he was fourteen, naming his parents as John and Elizabeth Davinier, and stating that he was born in 1795. Little is known of the life of the younger brother, who bore the Lord Chief Justice's Christian name.

Lady Margery Murray, one of the Mansfield nieces who had joined Dido in caring for the Earl in his final years, died in 1799, a 'spinster of Twickenham'. In her will, proved on 9 May of that year, she left the sum of £100 to 'Dido Elizabeth Belle as a token of my regard'. This will was written before Dido married, and a codicil dated September 1796 added an important modification: 'The sum of one hundred pounds left in my Will to Dido Elizabeth Belle, she being now married to Mr Davinier, I leave the said hundred pounds for her separate use and at her disposal.'[12] Lady Margery evidently wanted the money to go to Dido herself, not to Davinier. This was the age before the nineteenth-century Married Woman's Property Acts, so without such a stipulation the money would automatically have gone to Dido's husband. Was Lady Margery worried that John Davinier might prove to be a gold-digger, more interested in Dido's money than in loving and caring for her?

Dido did not live to see the abolition of the slave trade. She died in her early forties, in 1804, of unknown causes,

and was buried that July in the St George's, Hanover Square overspill burial ground on the Bayswater Road.

Four years later, John Davinier was living in spacious rooms above a baker's on Mount Street, Grosvenor Square – still in the parish of St George's, but at a more upmarket location than Ranelagh Street. The insurance policy for his property describes him as a 'Gentleman'.[13] When he married Dido he was a servant. Now that he was a widower, thanks to her money, he had risen to become a gentleman – someone who did not have to work for a living.

The following year, Davinier had a daughter, Lavinia, by a white woman called Jane Holland. Three years after that, in 1812, the couple had another child, a boy, although it was not until 1819 that Davinier married Jane. The last sighting we have of Dido's husband suggests that he returned to his native France: in 1843 his daughter Lavinia was married in St George's church, and a newspaper noted that her father, John Louis Davinier, was of 'Ducey, Normandy'.[14]

Dido's elder son Charles became an officer in the Indian army. Perhaps he was as brave and intrepid as his grandfather. He had a son, also christened Charles. But the Christian name that this boy used was the surname of Dido's father. In 1901 he signed an Attestation upon joining the Canadian Scouts, part of the Imperial Irregular Corps, at Durban in South Africa.[15] He mentioned his previous service in the Boer War, including participation

as a gunner in the Relief of Ladysmith. And he gave his name as Lindsay d'Avinière. While 'd'Avinière' is probably a reversion to the correct spelling of his surname, which had been phonetically rendered in English as the identical-sounding 'Davinier', the choice of 'Lindsay' as his Christian name suggests the family's pride in their noble and military heritage.

Dido's grave was moved in the 1970s, due to the redevelopment of the Bayswater area, and the location of the reburial of her remains is unknown. There is no grave to mark her life or death, and for many years she was utterly forgotten. The Kenwood portrait was moved to Scone Palace in Perth, and the family assumed that the beautiful black girl in the background was Elizabeth Murray's maid. But many visitors to Scone today are irresistibly drawn to Dido, and want to know her story. Who is she? What is she doing in the portrait?

It was only in the 1970s and '80s that research was undertaken, notably by Gene Adams, a local historian from Camden who immersed herself in documents associated with Kenwood, uncovering Dido's deep connection to the house and the family. Her presence in the household, and Lord Mansfield's adoption of her as a cherished daughter, ensured that he viewed the atrocities of the odious slave trade through a personal lens, through the eyes of a much-loved young black woman.

Jonathan Strong, James Somerset, Dido Elizabeth Belle. These were individuals, black people living in Georgian

London, who helped to change history, but have been largely neglected. Mansfield knew that the fate of thousands of black people rested in his hands: *Fiat justitia ruat caelum.*

The horrors of the slave trade have receded into the past, though they have not been entirely forgotten. Britain is still a nation of sugar consumers, but not at the expense of a barbaric practice that destroyed the lives of millions of Africans. The economy of the Caribbean sugar islands now chiefly depends on tourism. In Jamaica, guests can dine at the famous Sugar Mill restaurant. In Antigua, tourists can rent the Sugar Mill Villa. Ironically enough, Dido's last descendant, her great-great-grandson Harold Davinier, was traced to South Africa, where he died in 1975, during the apartheid era. He was classified as a white.

The 2014 feature film *Belle*, directed by Amma Asante and starring Gugu Mbatha-Raw, tells Dido's story for the twenty-first century. Like all historical-biographical movies, it takes considerable artistic licence even with the few facts that we know about Dido. The *Zong* case, being more dramatic, is made the centrepiece of the courtroom drama, although the Somerset case was really the more significant for the abolitionist cause. And John Davinier becomes an idealistic clergyman's son, with a little of the Granville Sharp about him, instead of a faceless French servant. But the spirit of the film is true to the astonishing story of Dido's bond with Lord Mansfield.

Dido's grave is lost, and she has no living descendants, but the painting once attributed to Zoffany remains as a testimony to her extraordinary legacy. Striding back from the orangery, perpetually in motion, gazing out boldly at the gazer, with her quizzical, dimpled smile, making no apology for her presence and her vitality. She lives on forever in this portrait, rising out of the darkness into the light.

APPENDIX
Jane Austen's Mansfield Connection

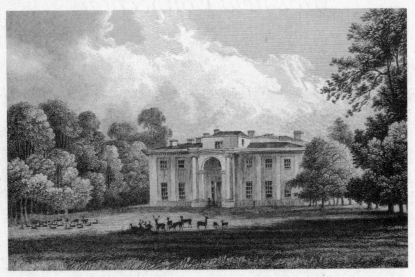
Eastwell Park, where Jane Austen met Dido's adoptive sister

We do not know whether Dido ever visited Eastwell Park in Kent, Elizabeth Murray's house after she was married. In order to make it a worthy home for a gentleman and his wife, in the 1790s George Finch-Hatton employed Joseph Bonomi, a pupil of the Adam brothers, to make improvements. Ground-floor wings were linked to the *piano nobile* of the main house by descending curved passageways.[1] With its high windows, classical portico and view out to picturesque landscaped grounds grazed by deer, the 'improved' Eastwell Park looks exactly like the kind of house in which we can imagine a Jane Austen novel being located – *Mansfield Park*, for example.

Jane Austen's brother Edward, who lived in Kent, was a friend of the Finch-Hattons, and when she was staying with him in 1805 she visited Eastwell Park.[2] She was disappointed with Dido's cousin: 'I have discovered that Lady Elizabeth, for a woman of her age and situation, has

astonishingly little to say for herself.' She was equally unimpressed by Elizabeth's daughter, but very much liked her young sons: 'George is a fine boy, and well-behaved, but Daniel chiefly delighted me; the good humour of his countenance is quite bewitching.' George grew up to be the rather impetuous young man who in 1829 challenged the Prime Minister, the Duke of Wellington, to a duel; both men deliberately fired wide.

Jane Austen met the Finch-Hattons on many occasions when she was staying with her brother at Godmersham. Although she found Elizabeth quiet and dull, to have known and been on friendly terms with Lord Mansfield's adopted daughter was of great interest to her. A young girl is brought to a large country house to be brought up with wealthy relations. Her status is somewhat ambiguous: is she a servant, or is she a fine lady? How should she be raised? Is the story of Dido Belle a shadow flickering in the background of the tale of Fanny Price, who rises from being the most lowly member of the household to the best-loved? It is hard to believe that it is no more than a coincidence that the Austen novel most connected to the slave trade is called *Mansfield Park*.

In this novel, Mansfield Park, the great English country house, has been overtaken by interlopers from the city. But the real corruption lies at the door of the flawed custodians, Sir Thomas and Lady Bertram, and Lady Bertram's sister Mrs Norris, who lives nearby. Mansfield Park is not an old English house, like Pemberley in *Pride*

and Prejudice. It is of comparatively recent construction, and is built on the fruits of the slave trade. Sir Thomas Bertram is an MP, the head of a respected family, and a planter.

The shadow story of *Mansfield Park* is slavery, to which the Austen family were fiercely opposed, despite their own connections with plantations. Opinions on the slave trade in Jane Austen's day were part of everyday conversation, as she suggests in *Emma*, where the subject is treated in a brutally casual way by the odious Mrs Elton: 'Oh my dear, human flesh! You quite shock me; if you mean a fling at the slave trade, I assure you Mr Suckling was always rather a friend to the abolition.' Mr Suckling has a seat near Bristol, and Mrs Elton (born Augusta Hawkins) is the daughter of a slave merchant: 'Miss Hawkins was the youngest daughter of a Bristol – merchant, of course, he must be called.' The dash of hesitation tells us that he is a slave trader. This is further hinted at by the fact that the Elizabethan mariner John Hawkins is often regarded as the father of the English slave trade.

It is in *Mansfield Park* that Austen shows her support for the abolition of slavery and her disapproval of sugar planters. Sir Thomas is having problems with 'poor returns' from his plantations in Antigua. Jane Austen was an obsessive realist, who always did her research. Though she does not state the reason for Sir Thomas's diminishing returns, she would certainly have had some in her mind. Was it because, under the influence of the anti-saccharites,

the British people had reduced their consumption of sugar and rum? Or because the American war of 1812 greatly disrupted the sugar trade? Or because Antigua, one of the oldest colonies, was suffering from soil exhaustion? *Mansfield Park* was published several years after the abolition of the slave trade, so perhaps Sir Thomas was suffering from a shortage of labour. And slave unrest was a huge problem in Antigua.

Three of Jane Austen's very favourite writers were Thomas Clarkson, the greatest of the abolitionists; William Cowper, the fervently evangelical poet whose verses became the war cry of the anti-slavery movement; and Dr Samuel Johnson, who was unshakable in his opposition to the evils of the plantations. The root of Clarkson's passion for abolition was his devout Christianity. He also argued that the slave trade was highly destructive and dangerous to the Royal Navy – in time of war there should be no distraction from the defence of the realm. Christianity and the navy were two things dear to Jane Austen's heart.

Austen was personally connected to the sugar plantations through family and friends. Her father's relations, and her cousins, the Hampsons and the Walters, had plantations in Jamaica; on her mother's side, the Leigh-Perrots had plantations in Barbados. Her brother James's first wife was the daughter of the Governor of Grenada. The Austens were great friends of the Nibbs family, who owned a 294-acre plantation in Antigua, of which Jane's father was a trustee.

Another family connection was with t
William Beckford of Fonthill.[3] His father, 'th
king of Jamaica', was the richest of all planta
Known as 'England's wealthiest son', Beckford inherited
£1 million at the age of ten (the modern equivalent would be
over £100 million). He lost this huge fortune, because he was
both a lavish spender (especially on his vast Gothic mansion,
Fonthill Abbey in Wiltshire) and an absentee proprietor: he
blamed his various agents and managers for cheating him in
his absence. Agents were notorious for their dissipated lives:
they drank, sexually exploited their female slaves, squan-
dered money and mired the plantations in debt. The man
Beckford principally blamed for his ruin was James Wildman,
whom he called an 'infernal rascal'. Wildman managed
Beckford's plantations in Jamaica, and purchased the
'Quebec' plantation from him. Beckford became convinced
that he had swindled him of his fortune.

Wildman fell in love with a woman called Fanny
Knight, who was Jane Austen's favourite niece. Fanny
entreated him to read her aunt's novels (one wonders
what he made of *Mansfield Park*), and Jane wrote,
teasingly, that she would like Fanny to live on his estate,
Chilham Castle in Kent. Fanny would have become a
plantation mistress, but in the end she refused Wildman.
He was eventually forced to sell Chilham Castle because
of his falling income after the emancipation of the slaves.

William Beckford was a prime example of the
absentee planter. One of the main themes of *Mansfield*

Park is absenteeism, which represented a considerable problem in plantation management for both planter and slave. Sir Thomas Bertram is an absentee sugar baron, who is forced to return to his suffering plantations, taking his unruly elder son with him. We are not told whether he is being cheated by his agent, but his visit is a necessity – most sensible absentees visited their estates once a year to prevent feckless agents from running them into the ground.[4] It was a known fact that slaves suffered badly and had increased mortality rates on absentee estates.[5]

In *Mansfield Park*, the absenteeism of Sir Thomas causes damage not only in Antigua, but on his estate in England. In his absence the house falls under the rule of the vicious bully Mrs Norris, Austen's most unremitting portrait of corrupted power. It is her unregulated power in the great house that causes the real damage to its inhabitants. It is one of the ironies of the novel that Sir Thomas goes out to his sugar plantations to sort out their problems, only for his own house to be thrown into moral chaos and subversion by his absence.

Sir Thomas comes to see the error of his ways. Like Shakespeare's Prospero, he acknowledges that Mrs Norris is his Caliban: 'His opinion of her had been sinking from the day of his return from Antigua … he had felt her as an hourly evil, which was so much the worse, as there seemed to be no chance of its ceasing but with life; she seemed a part of himself, that must be borne forever.'[6]

If the name of Mansfield was synonymous with the cause of abolition, then that of Norris was its opposite. Any reader familiar with Thomas Clarkson's great *History of the Rise, Progress and Accomplishment of the Abolition of the African Slave Trade* would have known of the infamous slave captain Robert Norris, who was a key figure in Clarkson's account. When Clarkson met him in Liverpool, Norris was initially charming and helpful, and claimed that he deplored the slave trade; but in fact he was a hypocrite, and when it came to a parliamentary inquiry, instead of testifying in support of the abolitionists he argued against them, brazenly claiming that the slave trade had positive effects. He argued that slaves had excellent, well-ventilated living quarters, ate delicious food, danced and sang, made necklaces out of African beads, and were given luxuries such as tobacco and brandy.[7] His captain's logbook told a different story, of a slave insurrection that Norris quelled with two deaths and twenty-four lashes each for the women who led it. The slaves then planned a mass suicide, 'by drowning or self-incineration'. Norris shot the ringleader. 'Norris seemed to have no ordinary sense of his own degradation,' wrote Clarkson, 'for he never afterwards held up his head, or looked the abolitionists in the face.'[8] His name thus became a byword for pro-slavery sympathies. It hardly seems a coincidence that the villainous Mrs Norris shares his name.

Austen knew the connection between slave-operated plantations and English high society. She provides a

critique of the English landed gentry and their wealth generated by slaves. To make clear the connection between the great house and Sir Thomas's ill-gotten gains in Antigua, the heroine, Fanny Price, describes Mansfield's grounds as 'plantations' – a not-so-subtle reminder of where the money for the estate came from. And it is Fanny alone, Austen's most timid, shy heroine, who is brave enough to ask the intimidating Sir Thomas about the slave trade:

> 'Did not you hear me ask him about the slave trade last night?'
> 'I did – and was in hopes the question would be followed up by others. It would have pleased your uncle to be inquired of farther.'
> 'And I longed to do it – but there was such a dead silence.'[9]

Fanny – a reader, a thinker, a true observer of the world – is no coward or weakling. She speaks truth to power, and asks of England the question that no one else in the novel dares to raise: 'We have no slaves at home – then why abroad?' Sir Thomas later acknowledges that it is his adopted daughter who is the true daughter of Mansfield Park.

In Jane Austen's unfinished last novel, *Sanditon*, there is a 'half-Mulatto' character called Miss Lambe, a wealthy heiress of seventeen who has been brought from the West

Indies to complete her education in England. 'Chilly' and 'tender' in the cold English weather, she 'had a maid of her own, was to have the best room in the lodgings, and was always of the first consequence'.[10] Just as it might be said that Dido was always of the first consequence to Lord Mansfield. Jane Austen died in the midst of writing *Sanditon*, so we will never know what would have happened to Miss Lambe.

Acknowledgements

My thanks to Arabella Pike, my fabulous commissioning editor at William Collins, and Damian Jones, producer of the motion picture *Belle*, for suggesting that I write this book. Also to Terry Karten and Jillian Verillo in New York and everybody on the team who saw the book through production so smoothly – Stephen Guise, Joseph Zigmond and especially my wonderful copy-editor Robert Lacey. Helen Ellis is the best of publicists.

Grateful thanks to the Earl of Mansfield, to Viscount Stormont, to William Murray (Master of Stormont), Sarah Adams (archivist) and Elspeth Bruce (administrator) for access to the Mansfield and Stormont Papers at Scone Palace; also to Caroline Brown in Special Collections, University of Dundee Library. Thanks also to the ever-helpful staff in the Public Record Office at Kew and the National Maritime Museum at Greenwich; also to Jenny Foot, from the curatorial team at Kenwood. Guy Holborn,

Librarian at Lincoln's Inn, kindly provided the image of Dido's letter and explanatory information about it. Professor David Armitage, Chair of the History Department at Harvard University, provided me with some valuable references.

As always, I was superbly looked after by Andrew Wylie, Sarah Chalfant and James Pullen at the Wylie Agency.

Thanks to Oxford High School and Mrs Anne Brazel, for giving me the opportunity to try out material. The girls were fantastic, especially Phoebe Cole and Hildie Leyser. Thanks, Ellie Bate, for not being too embarrassed by my presence.

On a more personal level, I want to express heartfelt thanks to my friends here at Oxford, in particular Laura Ashe, Kate Cooper, Steven Methven, Jo Quinn and Kate Tunstall. It's been an interesting year, and I'm not sure how I would have survived without your unstinting support, loyalty and friendship. Thanks also to Corinna Hilton.

Thank you Father Matthew Catterick for 'foot-stepping' Pimlico with me. Tom and Harry Bate, thank you for being so cheerful and low-maintenance. Grateful thanks to the delightful, hard-working and beautifully quiet Ewa Checinska.

As always I want to reserve very special thanks for Jonathan Bate. You're simply brilliant. I couldn't do this without you.

Paula Byrne
February 2014

Notes

Chapter 1: The Girl in the Picture

1 Mansfield and Stormont Private Family Archive at Scone Palace, NRAS776/volume 763, quoted by kind permission of Lord Stormont.

Chapter 2: The Captain

1 Unless otherwise indicated, all information in the opening pages of this chapter is derived from Lindsay's hitherto unexamined captain's log, National Archives, ADM 51/3994: Captain's Log, HMS *Trent*, 1 June 1760 to 9 September 1763, cross-checked with National Archives, ADM 52/1481: Master's Log (18 January 1760 to 9 September 1763, the master being the chief navigation officer). Also the *Trent's* Muster Rolls: ADM 36/6867–9.

2 See Isaac Schomberg, *Naval Chronology, or an Historical Summary of Naval and Maritime Events* (5 vols, 1802), 1, p.324.

3 Report by John Cleveland, Admiralty Papers, now in the John Caird Library, National Maritime Museum (ADM 354/165/28).

4 Archibald Duncan, *The British Trident, or Register of Naval Actions* (4 vols, 1805), 2, p.158.

5 *London Chronicle*, 5 January 1762.

6 R. Beatson, *Naval and Military Memoirs of Great Britain* (6 vols, 1790), 2, p.550.

7 What are the alternatives? That Lindsay arranged for Maria and the baby to be looked after in Port Royal, near the headquarters of the West Indian station, but then returned for them when he was ordered home? Or that he sent Maria to England on another ship? But he would not have entrusted her to a merchantman for fear of her being re-enslaved, nor to another ship of the line, given the irregularity of his having got her pregnant.

8 *Regulations and Instructions relating to His Majesty's Service at Sea* (1734 edn), p.31.

9 See http://www.marinersmuseum.org/sites/micro/ women/goingtosea/navy.htm, which is also the source for the quotation about the *Prince* in port.

10 See my *The Real Jane Austen* (2013), p.100.

11 *Persuasion* (1818), 1, p.70.

12 Quoted, http://www.marinersmuseum.org/sites/micro/ women/goingtosea/navy.htm.

13 See further, Suzanne J. Stark, *Female Tars: Women Aboard Ship in the Age of Sail* (1996), though this is mostly about women cross-dressed as serving sailors.

Chapter 3: The Slave

1 Marcus Rediker, *The Slave Ship: A Human History* (2007) is the best account of the Atlantic slave trade.

2 See Samuel Robinson, *A Sailor Boy's Experience Aboard a Slave Ship* (1867), pp.29–32.

3 John Newton kept a journal of his experiences as a slave trader. See *The Works of the Rev John Newton* (6 vols, 1808). Slave surgeon James Arnold gave evidence about the voyage to Parliament in 1788: 'It was Mr. Arnold's business to examine them before they were purchased for the vessel. If a man was ruptured, or a woman had a fallen breast, they never bought them. If they did not exceed four feet, they were refused.' See 'The Abolition Project', http://abolition.e2bn.org/slavery-44.html.

4 Thomas Aubrey, *The Sea-Surgeon, or the Guinea Man's Vade Mecum* (1729), pp.118–20.

5 See Donald R. Hopkins, *The Greatest Killer: Smallpox in History* (2002), p.216.

6 *The History of Mary Prince*, ed. Sarah Salih (2004). Prince's 1831 *History* is not straightforward. Her story is mediated by an amanuensis called Susanna Strickland, with an editorial supplement by Thomas Pringle and several appendices. Strickland excised parts of Mary's story that she deemed unsuitable, such as Mary's sexual relationship with a white captain. Editor Sarah Salih describes it as a 'collection of texts', but many parts appear to capture Mary's 'exact expressions and peculiar phraseology', in particular

the amazingly impassioned final pages, which include
native words and phrases.

7 *The History of Mary Prince*, p.21.

8 Ibid., pp.11–12.

9 Rediker, p.51.

10 Robert Walsh, 'Notices of Brazil in 1828 and 1829'
(1831), reprinted as 'Aboard a Slave Ship, 1829',
EyeWitness to History, http://www.eyewitnesstohistory
.com/slaveship.htm.

11 *The Posthumous Works of the Late Rev John Newton*
(1809), p.239.

12 Ottobah Cugoano, *Thoughts and Sentiments on the Evil
and Wicked Traffic of the Slavery and Commerce of the
Human Species* (1787), p.10.

13 John Newton's Journal, 24 June 1754.

14 Olaudah Equinao, *Interesting Narrative of the Life of
Olaudah Equiano, or Gustavus Vassa, The African*
(1789, 9th edn 1794), p.134.

15 *The Guinea Voyage* (1807 edn), p.31.

16 Ibid., p.37.

17 *Works of the Rev John Newton*, 5, pp.532–3.

18 Ibid., p.533.

19 Thomas Clarkson, *History of the Rise, Progress, and
Accomplishment of the Abolition of the African Slave
Trade* (2 vols, 1808), 2, p.43.

20 'It is unaccountable, but certainly true, that the moment
a Guinea Captain comes in sight of this shore, the
demon cruelty seems to fix his residence within him',

James Stanfield, *Observations on a Guinea Voyage* (1788), pp.15–18.

21 Alexander Falconbridge, *Account of the Slave Trade on the Coast of Africa* (1788), p.52.

22 William Butterworth, *Three Years Adventures of a Minor in England, Africa, the West Indies, South Carolina and Georgia* (1831), p.80.

23 Rediker, p.203.

24 Ibid., p.215.

25 See Elizabeth Abbott, *Sugar: A Bittersweet History* (2010), p.128.

26 Trevor Burnard, *Mastery, Tyranny, and Desire: Thomas Thistlewood and His Slaves in the Anglo-Jamaican World* (2004), p.175. I am much indebted to this excellent study.

27 Ibid., p.178.

28 Ibid., p.180.

29 Maria Nugent, *Lady Nugent's Journal of her Residence in Jamaica from 1801 to 1805* (1834), p.87.

Chapter 4: The White Stuff

1 Elizabeth Abbott, *Sugar: A Bittersweet History* (2011), pp.56–60.

2 Duncan Forbes, *Some Considerations on the Present State of Scotland* (1744), quoted, Richard B. Sheridan, *Sugar and Slavery: An Economic History of the British West Indies 1623–1775* (1974), p.28.

3 See Kim Wilson, *Tea with Jane Austen* (2011), p.17.

4 Austen, *Emma* (1815), vol. 3, ch.2.

5 Average sugar consumption in Britain rose from four pounds per head in 1700 to eighteen pounds in 1800, thirty-six pounds by 1850 and over one hundred pounds by the twentieth century. See Clive Ponting, *World History: A New Perspective* (2000), p.698, and Matthew Parker, *The Sugar Barons: Family, Corruption, Empire and War* (2012).

6 Abbott, p.53.

7 Ponting, p.510.

8 The decrease in slave population averaged about 3 per cent per year in Jamaica and 4 per cent per year in the smaller islands.

9 O. Senior, *Mirror, Mirror: Identity, Race and Protest in Jamaica* (2003), p.207. See also E. K. Brathwaite, *The Development of Creole Society in Jamaica, 1770–1820* (1971).

10 Abbott, p.87.

11 Relatively little 'white' sugar was imported to England, though Barbados had good sources of clay, and this produced more 'white' sugar. See Chuck Meide, *The Sugar Factory in the Colonial West Indies: An Archaeological and Historical Comparative Analysis* (2003).

12 Quoted in Abbott, p.89.

13 See *Mary Prince*, p.15.

14 Ibid., p.37.

15 The best accounts of Thistlewood can be found in

Burnard's *Mastery, Tyranny and Desire* and Parker's *The Sugar Barons.*

16 See Burnard, pp.166–7.

17 See my *The Real Jane Austen*, p.220.

18 Quoted in Abbott, p.124.

19 Quoted in ibid., p.72.

20 See David Richardson, 'The Slave Trade, Sugar, and British Economic Growth, 1748–1776', *Journal of Interdisciplinary History*, 17 (Spring 1987), 739–69.

Chapter 5: 'Silver-Tongued Murray'

1 See the superb Norman S. Poser, *Lord Mansfield: Justice in the Age of Reason* (2013), p.15.

2 Edmund Heward, *Lord Mansfield: A Biography of William Murray 1st Earl of Mansfield, 1705–1793, Lord Chief Justice for 32 Years* (1979), p.12.

3 Boswell, *Life of Johnson* (1791), entry for spring 1772.

4 His brother James wrote in 1763: 'I hear my brother has been made Lord Chancellor of England, but as I have not had a letter from home for thirty years, I know not if it be true or not.' Quoted, James Oldham, 'Murray, William, first Earl of Mansfield', *The Oxford Dictionary of National Biography* (2004).

5 Poser, p.26.

6 Ibid., p.24.

7 They attended different colleges, Pitt being a freshman when Murray was in his final year. Murray entered and

won the competition in 1727, just before he came down from Oxford.

8 Locke, *Of Government*, Bk 1, Chap. 1, opening sentence. See further, Stephen Usherwood, 'The Black Must be Discharged: The Abolitionists' Debt to Lord Mansfield', *History Today* 31.3 (1981).

9 Poser, p.28.

10 Frequently cited, e.g. by William Hazlitt, *The Eloquence of the British Senate* (1810 edn), 2, p.29, though I have not traced the original context in Pope.

11 Quoted in Poser, p.54.

12 Heward, p.24.

13 Quoted in Poser, p.64.

14 See ibid., pp.147–8.

15 *Private Papers of James Boswell*, 9 (1963), p.48.

16 Quoted in Poser, p.171.

17 *An Account of the Life of that Celebrated Actress Mrs Susannah Maria Cibber … Also the two Remarkable and Romantic Trials between Theophilus Cibber and William Sloper* (1887 edn), p.46.

18 Lord John Campbell, 'The Life of Lord Mansfield', in his *The Lives of the Chief Justices of England* (1849 edn), 2, p.343.

19 Quoted, Maynard Mack, *Alexander Pope: A Life* (1985), p.688.

20 Heward, p.38.

21 Poser, p.35.

22 Ibid., p.163.

23 *The Works in Architecture of Robert and James Adam* (1778), 'II. The Villa of Earl Mansfield, at Kenwood'.

24 Poser, p.165.

25 Coleridge to Henry Crabb Robinson, Highgate, June 1817.

26 The painting is traditionally dated 'c.1780'.

27 'Kenwood's Picturesque Landscape', http://www.english-heritage.org.uk/daysout/properties/kenwood-house/garden/landscape/.

28 *Works in Architecture of Robert and James Adam*, II.

29 James Oldham, *The Mansfield Manuscripts and the Growth of English Law in the Eighteenth Century* (2 vols, 1992), 1, p.25.

Chapter 6: The Adopted Daughters

1 Burnard, p.170.

2 Abbott, p.128.

3 Ibid., p.127.

4 *Mary Prince*, p.26.

5 Abbott, p.137.

6 Thomas Hutchinson, *The Diary and Letters of his Excellency Thomas Hutchinson* (2 vols, 1886), 2, p.276.

7 Quoted John Cornforth, 'Scone Palace, Part 1', *Country Life*, 11 August 1988, http://www.countrylife.co.uk/culture/article/531123/Scone-Palace-The-Seat-of-the-Earl-of-Mansfield-and-Mansfield-part-1-by-John-Cornforth.html.

8 Ibid.

9 Hastings MSS, 3.138, quoted, H.M. Scott, 'Murray, David' in *The Oxford Dictionary of National Biography*, http://www.oxforddnb.com/view/article/19600.

10 See *London Chronicle*, 10 June 1788.

11 Parish Register of St George's, Bloomsbury, 20 November 1766, photograph at http://www. caitlindavies.co.uk/wp-content/uploads/2012/12/Dido -baptism.jpg.

12 Quoted, Gene Adams, 'Dido Elizabeth Belle: A Black Girl at Kenwood', *Camden History Review*, vol. 12 (1984), 10–14.

13 Cumberland, *Memoirs* (2 vols, 1806), 2, p.344.

Chapter 7: Black London

1 See James Walvin, *Black and White: The Negro and English Society, 1555–1945* (1973), p.46, and Fallon Shyllon, *Black People in Britain 1555–1833* (1977), p.4.

2 As told to Boswell by the Earl of Pembroke, see Gretchen Holbrook Gerzina, *Black London: Life Before Emancipation* (1995), pp.14, 73.

3 See Gerzina, pp.54–5.

4 *Letters of Ignatius Sancho* (2 vols, 1782), 1, p.126.

5 Ibid., p.101.

6 Ibid., p.72.

7 See Abbott, pp.143–4; Gabriel Banat, 'Man of Music and Gentleman-at-Arms: The Life and Times of an Eighteenth-Century Prodigy', *Black Music Research Journal* (1990), 10 (2), p.180; Gabriel Banat, *The*

Chevalier de Saint-Georges: Virtuoso of the Sword and the Bow (2006); Alain Guédé, *Monsieur de Saint-George: Virtuoso, Swordsman, Revolutionary, a Legendary Life Rediscovered*, trans. Gilda M. Roberts (2003); Emil F. Smidak, *Joseph Boulogne Called Chevalier de Saint-Georges* (1996).

Chapter 8: Mansfield the Moderniser

1 Poser, p. 3.

2 Ibid., pp.194–5.

3 Todd Lowry, 'Lord Mansfield and the Law Merchant: Law and Economics in the Eighteenth Century', *Journal of Economic Issues*, December 1973, 7 (4).

4 See Heward, p.46.

5 Ibid., pp.104–5.

6 C.H. Fifoot, *Lord Mansfield 1705–1793* (1936), p.201.

7 Quoted in the excellent Steven M. Wise, *Though the Heavens May Fall: The Landmark Trial that Led to the End of Human Slavery* (2005), p.73.

8 *Black's Law Dictionary* (5th edn), p.851, and 'Recent Cases – Evidence – Divorce – Competency of Spouse to Testify as to Non-Access', *Mercer Beasley Law Review*, vol. 3, No. 1, January 1934, p.112.

9 Poser, p.208.

10 Quoted in *Though the Heavens May Fall*, p.66.

11 Quoted in Poser, p.205.

12 See *The Heart of Boswell: Six Journals in One Volume*, ed. Mark Harris, p.326. Also quoted in Poser, p.206.

13 I borrow this account from Rictor Norton (ed.), 'The
 Case of Chevalier D'Eon, 1777', *Homosexuality in
 Eighteenth-Century England: A Sourcebook*, 1 March
 2005 <http://rictornorton.co.uk/eighteen/deon.htm>.

Chapter 9: Enter Granville Sharp

1 'We are of the opinion, that a slave, by coming from the
 West Indies, either with or without his master, to Great
 Britain or Ireland, doth not become free; and that his
 master's property or right in him is not thereby
 determined or varied; and baptism doth not bestow
 freedom on him, nor make any alteration to his
 temporal condition in these kingdoms. We are also of
 opinion, that the master may legally compel him to
 return to the plantations.' See http://www.
 nationalarchives.gov.uk/pathways/blackhistory/rights/
 slave_free.htm.
2 See Heward, p.142.
3 See Peter Fryer, *Staying Power: The History of Black
 People in Britain* (1984), p.152.
4 Sharp, *A Representation of the Injustice and Dangerous
 Tendency of Tolerating Slavery* (1769), p.6.
5 See William Blackstone, *Commentaries on the Laws of
 England* (1765), p.123.
6 Why did he do this? Clearly, Blackstone did not want
 the passage used to support the doctrine that a master
 would automatically lose his right to the service of any
 slave brought to England. It has been suggested that

Mansfield prevailed upon him to excise the passage: Simon Schama, *Rough Crossings: Britain, the Slaves and the American Revolution* (2006), p.40.

7 See ibid., p.39.

8 See Walvin, *The Zong*, p, 122.

9 See Oldham, *Mansfield Manuscripts*, 2, pp.1225–6.

10 Sharp, *A Representation*, p.13.

11 Wise, p.89.

12 See Gerzina, p.112.

13 Wise, p.106.

14 Gerzina, p.114.

15 Ibid., p.111.

Chapter 10: The Somerset Ruling

1 This key point is made by Wise, p.115.

2 Schama, p.56.

3 J.H. Baker, 'Davy, William', in *The Oxford Dictionary of National Biography*, http://www.oxforddnb.com/view/article/7320.

4 A copy is held in the Guildhall Library, London, B:S 531.

5 Sharp, *A Representation*, p.109.

6 Ibid., p.57.

7 Wise, p.151.

8 Schama, p.58.

9 Ibid., p.171.

10 'An Argument in the Case of James Somersett' (*The Gentleman's Magazine*, 1 January 1773).

11 See *London Evening Post*, 6 and 11 June 1772, and
Public Advertiser, 13 June 1772.

12 *London Evening Post*, 11 June 1772.

13 There have been whole books dedicated to the ruling:
see Wise, *Though the Heavens May Fall*.

14 *Morning Chronicle*, 23 June 1772.

15 This is from the *General Evening Post*, 21–23 June 1772.
See also Oldham, *Mansfield Manuscripts*, 2, p.1230,
which states: '[Slavery] is so odious that it must be
construed strictly.' Schama takes his account from
Granville Sharp's papers.

16 *Capel Lofft, Reports of cases adjudged in the Court of
King's Bench from Easter term 12 Geo. 3. to Michaelmas
14 Geo. 3. (both inclusive) [1772–1774]: With some select
cases in the Court of Chancery, and of the Common
Pleas, which are within the same period. To which is
added, the case of general warrants, and a collection of
maxims.* Lofft's account provided the basis for the
version of the judgement printed in the official record
of *State Trials*.

17 Quoted in Randy J. Sparks, *The Two Princes of Calabar:
An Eighteenth-Century Atlantic Odyssey* (2004), p.98.

18 See *Morning Chronicle*, 23 June 1772.

19 See Abbott, p.221.

20 Cowper, *The Task* (1785), Bk 2, lines 37ff.

21 Clarkson, 1, p.66.

22 Thomas Hutchinson's journal, discussed in ch.13,
below.

23 Lord John Campbell, *Lives of the Lord Chancellors of England* (1858–59 edn), 2, p.359.

24 See *A letter to Philo Africanus: in answer to his of the 22d of November, in the General evening post; together with the opinions of Sir John Strange, and other eminent lawyers upon this subject, with the sentence of Lord Mansfield, in the case of Somersett and Knowles, 1772, with His Lordship's explanation of that opinion in 1786.* In this 1786 pamphlet, it is stated that Mansfield clarified his position on the Somerset ruling; see pp.37–40.

25 Gerzina, p.132.

Chapter 11: The Merchant of Liverpool

1 See Jane Longmore, 'Civic 1680–1800' in *Liverpool 800: Culture, Character and History*, ed. John Belcham (2007), p.129.

2 Celia Fiennes, writing as early as 1698.

3 William Moss, *The Liverpool Guide* (1796), p.1.

4 Longmore, p.148.

5 Jane Webster, 'The *Zong* in the Context of the Eighteenth-Century Slave Trade', *Journal of Legal History* (2007), 28 (3): 285–298. These figures derive from interrogation of D. Eltis, S.D. Behrendt, D. Richardson and H.S. Klein, 'The Trans-Atlantic Slave Trade Database' on CD-rom (1999).

6 See Longmore, 'Civic 1680–1800', p.123. Liverpool's black community dates from the building of the first

dock in 1715, and grew rapidly, reaching a population of 10,000 within five years.

7 See John Hughes, *Liverpool Banks and Bankers, 1760–1837* (1906), p.108.

8 Ibid., p.110.

Chapter 12: A Riot in Bloomsbury

1 *Letters of the Late Ignatius Sancho*, letter LXVII, 6 June 1780.

2 Campbell, *Chief Justices*, 2, p.529.

3 This account has been reconstructed from contemporary newspaper accounts in the *London Chronicle*, the *Public Advertiser*, the *General Evening Post* and the *Bristol Mercury and Evening Advertiser*.

4 See Julius Bryant, *Kenwood: Paintings in the Iveagh Bequest* (2012).

5 Sir J.W. Fortescue (ed.), *The Correspondence of King George III from 1760 to December 1783* (1928), p.135.

6 *Gazetteer and New Daily Advertiser*, 13 June 1878, and *General Evening Post*, 13 June 1780.

7 Heward, p.159.

8 Ibid.

9 Charles Dickens immortalised the Gordon Riots, and the attack on Mansfield's house, in his novel *Barnaby Rudge* (1841), which is subtitled *A Tale of the Riots of Eighty*: 'the mob gathering round Lord Mansfield's house, had called on those within to open the door, and receiving no reply (for Lord and Lady Mansfield were at that moment

escaping by the backway), forced an entrance according to their usual custom. That they then began to demolish the house with great fury, and setting fire to it in several parts, involved in a common ruin the whole of the costly furniture, the plate and jewels, a beautiful gallery of pictures, the rarest collection of manuscripts ever possessed by any one private person in the world, and worse than all, because nothing could replace this loss, the great Law Library, on almost every page of which were notes in the Judge's own hand, of inestimable value, – being the results of the study and experience of his whole life' (Chapter 66).

10 Sancho, Letter LXVIII, to J— S— Esq., from Charles Street, 9 June 1780.

Chapter 13: A Visitor from Boston

1 *Aurora and Universal Advertiser*, 22 February 1781.

2 Inference from Hutchinson Diary, discussed below.

3 The will was published in full, with its codicils, in several newspapers after Mansfield's death, e.g. *Diary or Woodfall's Register*, Saturday, 20 April 1793. The probate copy is in the National Archive at PROB 11/1230/206.

4 J.C. Loudon, *The Suburban Garden and Villa Companion* (1838), quoted on exhibition panel at Kenwood.

5 Quoted in Bryant, *Kenwood*, p.284.

6 In 1776 Jane Austen's friend Mrs Lybbe Powes took a tour of Wiltshire, visiting country houses in the area,

such as Fonthill House and Longford Castle. See Mark
Girouard, *Life in the English Country House: A Social
and Architectural History* (1993).

7 Fanny Burney, *Journals and Letters* (3 vols, 1972–73), 2,
p.346.

8 *Works in Architecture of Robert and James Adam.*

9 Burney, 2, p.346.

10 Scone Archive, NRAS776, Box 69, 30 March 1831.

11 See Benjamin L. Carp, *Defiance of the Patriots: The
Boston Tea Party and the Making of America* (2010),
and Benjamin Woods Labaree, *The Boston Tea Party*
(1964, repr. 1979).

12 *The Diaries and Letters of Thomas Hutchinson*, ed. Peter
O. Hutchinson, 2 vols (1883–86), account of visit to
Kenwood at 2, pp.274–7.

13 Samuel Richardson, *Pamela or Virtue Rewarded* (1740),
1, p.36.

14 James Oldham, *English Common Law in the Age of
Mansfield* (2004), p.320.

15 Sparks, p.91.

16 Ibid., p.94.

17 Ibid., p.99.

18 Hutchinson, 2, p.275.

19 Ibid., 2, p.277.

20 *A Letter to Philo Africanus, upon Slavery* (1788),
pp.39–40.

Chapter 14: The *Zong* Massacre

1 See Prince Hoare, *Memoirs of Granville Sharp* (1820). See also the definitive James Walvin, *The Zong: A Massacre, the Law and the End of Slavery* (2011), to which this chapter is much indebted.

2 See Walvin, p.57.

3 Putting a ship into the African trade was an expensive business, necessitating expenditure on the vessel and its fittings, the hire of a crew, the provision of foodstuffs for both crew and slaves, and the purchase of a cargo of trade goods to be exchanged for captives in Africa. By the late eighteenth century, the cost of putting a Liverpool ship to sea may have been as high as £12,000.

4 Walvin, p.71.

5 There was some confusion about the numbers killed: the legal hearing accepted 122 murdered, in addition to the ten who had jumped to their death. Walvin, p.98.

6 Dolben's Act of 1788 insisted that all slave ships should carry a surgeon. Some of them were promoted to captain slave ship surgeons.

Chapter 15: *Gregson v Gilbert*

1 The two other King's Bench judges were Mr Justice Buller and Mr Justice Willes.

2 Walvin, p.140.

3 Ibid., p.153.

4 See, for example, Jeremy Krikler, 'The *Zong* and the

Lord Chief Justice', *History Workshop Journal* (2007), 64 (1), 29–47.

5 Walvin, p.144.

6 Ibid., p.145.

7 Ibid., p.147.

8 See A. Lewis, 'Martin Dockray and the *Zong*: A Tribute in the Form of a Chronology', *Journal of Legal History* (2007), 28 (3), 357–70; Robert Weisbord, 'The Case of the Slave-Ship *Zong*, 1783', *History Today* (August 1969), 19 (8), 561–7.

9 Quoted in James Allan Park, *System of the Law of Marine Insurances* (1799 edn), p.154.

10 *Documents relating to the Ship Zong*, 1783, National Maritime Museum, Greenwich, REC/19, p.50.

11 From Clarkson's *History*: 'In this year, certain underwriters desired to be heard against Gregson and others of Liverpool, in the case of the ship *Zong*, captain Collingwood, alleging that the captain and officers of the said vessel threw overboard one hundred and thirty-two slaves alive into the sea, in order to defraud them, by claiming the value of the said slaves, as if they had been lost in a natural way. In the course of the trial, which afterwards came on, it appeared, that the slaves on board the *Zong* were very sickly; that sixty of them had already died; and several were ill and likely to die, when the captain proposed to James Kelsall, the mate, and others, to throw several of them overboard, stating "that if they died a natural death, the loss would

fall upon the owners of the ship, but that, if they were thrown into the sea, it would fall upon the underwriters". He selected accordingly one hundred and thirty-two of the most sickly of the slaves. Fifty-four of these were immediately thrown overboard, and forty-two were made to be partakers of their fate on the succeeding day. In the course of three days afterwards the remaining twenty-six were brought up on deck to complete the number of victims. The first sixteen submitted to be thrown into the sea; but the rest with a noble resolution would not suffer the officers to touch them, but leaped after their companions and shared their fate.

'The plea, which was set up in behalf of this atrocious and unparalleled act of wickedness, was, that the captain discovered, when he made the proposal, that he had only two hundred gallons of water on board, and that he had missed his port. It was proved, however, in answer to this, that no one had been put upon short allowance; and that, as if Providence had determined to afford an unequivocal proof of the guilt, a shower of rain fell and continued for three days immediately after the second lot of slaves had been destroyed, by means of which they might have filled many of their vessels with water, and thus have prevented all necessity for the destruction of the third.

'Mr Sharp was present at this trial, and procured the attendance of a shorthand-writer to take down the

facts, which should come out in the course of it. These he gave to the public afterwards. He communicated them also, with a copy of the trial, to the Lords of the Admiralty, as the guardians of justice upon the seas, and to the Duke of Portland, as principal minister of state. No notice however was taken by any of these, of the information which had been thus sent them.

'But though nothing was done by the persons then in power, in consequence of the murder of so many innocent individuals, yet the publication of an account of it by Mr Sharp in the newspapers, made such an impression upon others, that new coadjutors rose up' (1839 edn, p.81).

Chapter 16: Changes at Kenwood

1 *Whitehall Evening Post*, April 1784.
2 Explanation kindly provided by Guy Holborn, Librarian at Lincoln's Inn, where the letter survives in Lincoln's Inn Library Dampier MSS B.P.B. 437, where it was discovered by the legal scholar James Oldham.
3 This account is borrowed from J.K. Laughton, revised by Clive Wilkinson, 'Lindsay, Sir John (1737–1788), naval officer', *The Oxford Dictionary of National Biography*, http://www.oxforddnb.com/view/article/16710.
4 *London Chronicle*, 7 June 1788.

Chapter 17: The Anti-Saccharites

1 The quote comes from an 1826 abolitionist pamphlet, *What does your sugar cost?*, quoted in Charlotte Sussman, 'Women and the Politics of Sugar, 1792', *Representations* 48 (1994), p.57.

2 'Women and the Politics of Sugar', p.62.

3 Samuel Taylor Coleridge, 'Lecture on the Slave Trade' (1795).

4 See Elizabeth Eger (ed.), *Women, Writing and the Public Sphere, 1700–1830* (2001), p.146.

5 Abbott, p.241.

6 See Kate Davies, 'A Moral Purpose: Femininity, Commerce and Abolition, 1788–92', in Eger, p.140.

7 Ibid., p.144.

8 See Sussman.

9 See John R. Oldfield, *Popular Politics and British Anti-Slavery: The Mobilisation of Public Opinion against the Slave Trade* (1998), p.178. See also http://www.britishmuseum.org/research/collection_online/collection_object_details.aspx?objectId=1477504&partId=1.

10 See William Hague, *William Wilberforce: The Life of the Great Anti-Slave Trade Campaigner* (2008), p.141.

11 Christopher Leslie Brown, *Moral Capital: Foundations of British Abolitionism* (2006), p.349.

12 *The Manuscripts of his Grace the Duke of Rutland* (1894), p.268.

13 Dorothy George, *Catalogue of Political and Personal
 Satire Preserved in the Department of Prints and
 Drawings in the British Museum*, no. 7075.

14 'Life and Character of the Earl of Mansfield', in *The New
 Annual Register* (1797), p.54.

15 *The Inquirer*, 1 (1822), p.148.

Chapter 18: Mrs John Davinier

1 Several modern sources give Davinier's status as a
 'gentleman's steward'. The steward was the highest-
 ranking male servant in a household, akin to the butler
 in Victorian and Edwardian times, but I have not traced
 the evidence for this claim. The key documents are the
 Allegation and Bond in the London Guildhall Library
 Manuscripts Section, *Bishop of London's Marriage
 Allegations*, 3 November 1793: 'John Davinier of the
 parish of St Martin in the Fields in the County of
 Middlesex, bachelor, above the age of twenty one years,
 intendeth to marry Dido Elizabeth Belle of the parish
 of St George Hanover Square in the same County,
 spinster, above the age of twenty one years … in the
 church of St George Hanover Square' (GL Ms
 10091/169). The bond adds that John Davinier's
 occupation is 'Servant' (GL Ms 10091E/106). See http://
 www.history.ac.uk/gh/baentries.htm.

2 Freedom of the City Admission Papers, London
 Metropolitan Archive, COL/CHD/FR/02/1079
 –1086.

3 Sarah Minney, 'The Search for Dido', *History Today*, vol. 55, no. 10 (October 2005).

4 Advertisement in the *Morning Post*, 28 August 1800.

5 See further 'Pimlico', in Edward Walford, *Old and New London* (1978), 5, pp.39–49, http://www.british-history .ac.uk/report.aspx?compid=45221.

6 See Isobel Watson, *Westminster and Pimlico Past* (2002), p.72.

7 Quoted in Gerzina, p.45.

8 Ibid., p.47.

9 Ibid., p.49.

10 Ibid., p.21.

11 Ibid., p.72.

12 National Archive, Kew, PROB 11/1324/97.

13 Sun Life Fire Insurance Records, Guildhall Library Manuscripts Section, MS 11936/445/814109, 3 February 1808.

14 *London Observer*, 1843: 'Marriage: *On April 25th 1843 at St. George, Hanover Square, Louis Henri Wohlegemuth to Lavinia Amelia Daviniere, only daughter of John Louis Daviniere of Ducey, Normandy*'.

15 Available online at http://trees.ancestry.co.uk/tree/ 13644389/photox/4c4fcc7e-bcd1-4943-8ccd- 4ed07a7b3e60.

Appendix: Jane Austen's Mansfield Connection

1 See Peter Meadows, *Joseph Bonomi: Architect* (1988), p.178.

2 This Appendix draws on, and adds new research to, my *The Real Jane Austen: A Life in Small Things* (2013).

3 Austen described Beckford's daughter Margaret as her 'cousin', but the exact nature of the relationship is unclear.

4 Abbott, p.163.

5 Parker, *The Sugar Barons*, pp.333–4.

6 Austen, *Mansfield Park* (1814), vol. 3, ch.17.

7 See Rediker, *The Slave Ship*, pp.31–2.

8 Clarkson, 1, pp.181–2.

9 *Mansfield Park*, vol. 2, ch.3.

10 Austen, *Sanditon* (left unfinished, 1817), ch.11.

Bibliography

This bibliography is confined to the principal sources for the lives of Dido Belle and Lord Mansfield. Contextual reading on slavery and abolition is cited in the notes.

Adam, Robert and James, *The Works in Architecture of Robert and James Adam*, 'II. The Villa of Earl Mansfield, at Kenwood' (1778)

Adams, Gene, 'Dido Elizabeth Belle, a Black Girl at Kenwood: an account of a protégée of the first Lord Mansfield', *Camden History Review*, vol. 12 (1984), 10–14

Bryant, Julius, *Finest Prospects: Three Historic Houses: a Study in London Topography* (1986)

—, *Kenwood: Paintings in the Iveagh Bequest* (2012)

—, *The Landscape of Kenwood* (1990)

Campbell, Lord John, 'The Life of Lord Mansfield', in his *The Lives of the Chief Justices of England* (1849)

'Charles Daviniere', www.ancestry.co.uk

Cornforth, John, 'Scone Palace, Part 1', *Country Life*,
 11 August 1988

'Dido Elizabeth Belle', www.ancestry.co.uk

English Heritage (pub.), *Slavery and Justice: The Legacies of
 Dido Belle and Lord Mansfield* (2007)

Fifoot, C.H.S., *Lord Mansfield 1705–1793* (1936)

Gerzina, Gretchen Holbrook, *Black London: Life Before
 Emancipation* (1995)

'Gordon Riots', *Public Advertiser*, 12 December 1780

Heward, Edmund, *Lord Mansfield: A Biography of William
 Murray 1st Earl of Mansfield, 1705–1793, Lord Chief
 Justice for 32 Years* (1979)

Hutchinson, Thomas, *The Diary and Letters of his
 Excellency Thomas Hutchinson, Esq. … compiled from the
 original documents still remaining in the possession of his
 descendants by Peter Orlando Hutchinson*, vol. 2 (1886)

'Inside Out: Abolition of the British Slave Trade', http://
 www.bbc.co.uk/london/content/articles/2007/02/27/
 insideout_abolition_special_feature.shtml

'John Louis Daviniere', www.ancestry.co.uk

King, Reyahn, 'Belle, Dido Elizabeth', *Oxford Dictionary of
 National Biography* (2004)

Laughton, J.K., revised by Clive Wilkinson, 'Lindsay, Sir
 John', *Oxford Dictionary of National Biography* (2004)

'Life and Character of the Earl of Mansfield', in *The New
 Annual Register* (1797)

Mansfield and Stormont Private Family Archive at Scone
 Palace, NRAS776

Minney, Sarah, 'The Search for Dido', *History Today*, vol.
 55, no. 10 (October 2005)

'Obituary of Sir John Lindsay', *London Chronicle*, 10 June
 1788

Oldham, James, *English Common Law in the Age of
 Mansfield* (2004)

—, *The Mansfield Manuscripts and the Growth of English
 Law in the Eighteenth Century* (2 vols, 1992)

—, 'Murray, William, first earl of Mansfield', *Oxford
 Dictionary of National Biography* (2004)

Poser, Norman S., *Lord Mansfield: Justice in the Age of
 Reason* (2013)

Scott, H.M., 'Murray, David' in *Oxford Dictionary of
 National Biography* (2004)

'The Earl of Mansfield's Will', *Diary or Woodfall's Register*,
 20 April 1793

Usherwood, Stephen, 'The Black Must be Discharged: The
 Abolitionists' Debt to Lord Mansfield', *History Today*,
 vol. 31, no. 3 (1981)

Walvin, James, *The Zong: A Massacre, the Law and the End
 of Slavery* (2011)

Wise, Steven M., *Though the Heavens May Fall: The
 Landmark Trial that Led to the End of Human Slavery*
 (2005)

BOOKS BY PAULA BYRNE

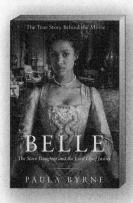

BELLE
Available in Paperback and eBook

Based on a painting that shocked 18th century England, Paula Byrne's biography and the film, *Belle*, tell the tale of one of the most powerful men of the 18th century and his controversial adoption of a mixed race girl. The portrait was commissioned by Lord Mansfield, whose name was synonymous with the campaign against slavery, and the presentation of a black girl, expensively dressed and on equal footing with her white sibling, was a stunning statement for society.

MAD WORLD
Evelyn Waugh and the Secrets of Brideshead
Available in Paperback

This brilliantly original biography unlocks for the first time the extent to which Waugh's great novel encoded and transformed his own experiences. In so doing, it illuminates the loves and obsessions that shaped his life, and brings us inevitably to the great writer's own tragic secret.

THE REAL JANE AUSTEN
A Life in Small Things
Available in Paperback and eBook

This new biography explores the forces that shaped one of our most beloved novelists: her father's religious faith; her mother's pedigree; her eldest brother's adoption; her other brothers' military experiences; her relatives in the East and West Indies; her cousin who lived through the French Revolution; the amateur theatricals; her love of the seaside; and her determination to become a published author.